PABLO PICASSO

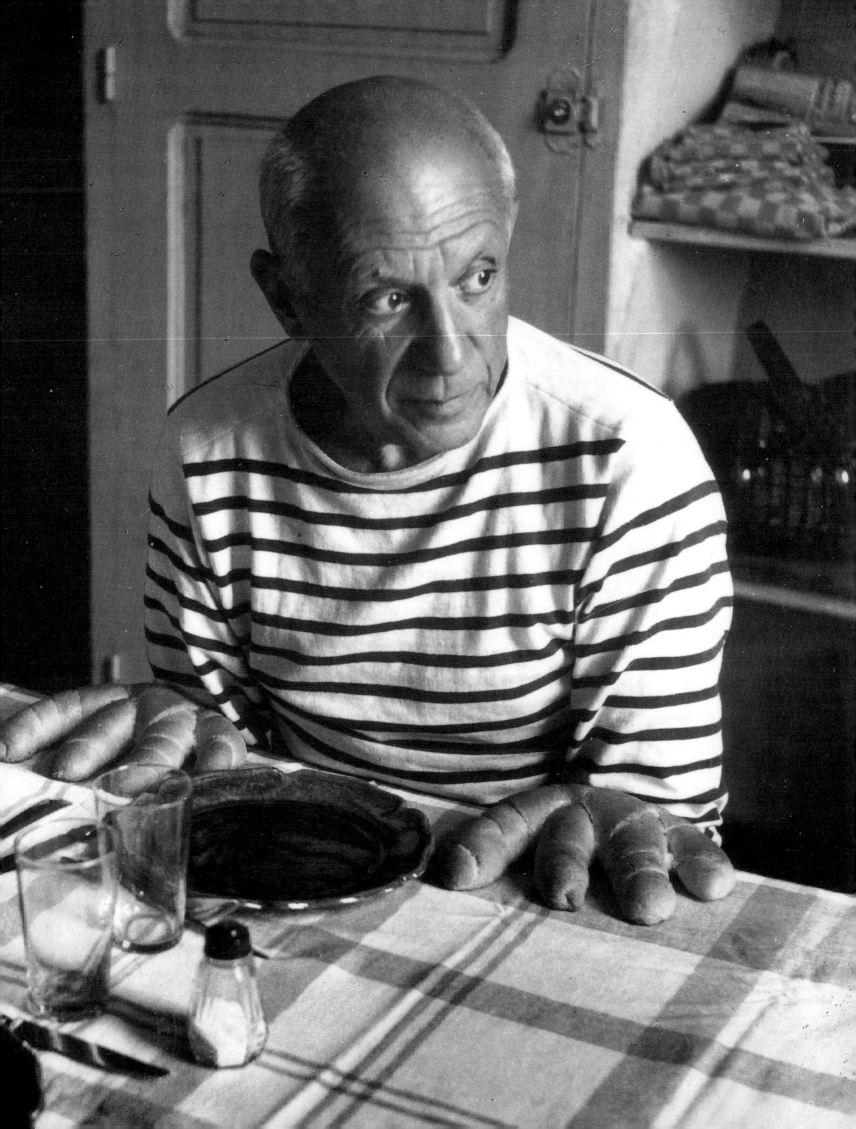

Carsten-Peter Warncke

PABLO PICASSO

1881 – 1973

LOWE & B. HOULD

Published by Borders Group, Inc.
100 Phoenix Drive, Ann Arbor, Michigan, 48108. All rights reserved
Lowe & B. Hould, Publishers is a registered trademark of Borders Properties, Inc.
By arrangement with Benedikt Taschen Verlag GmbH
1998 Borders Press

© 1998 Benedikt Taschen Verlag GmbH
Hohenzollernring 53, D–50672 Köln
© Succession Picasso / VG Bild-Kunst, Bonn 1997
Edited by Ingo F. Walther, Alling
Produced by Juliane Steinbrecher, Cologne
English translation by Michael Hulse, Cologne
Cover design by Angelika Taschen, Cologne

Printed in Spain
ISBN 0–681–07582–1
10 9 8 7 6 5 4 3 2 1

Contents

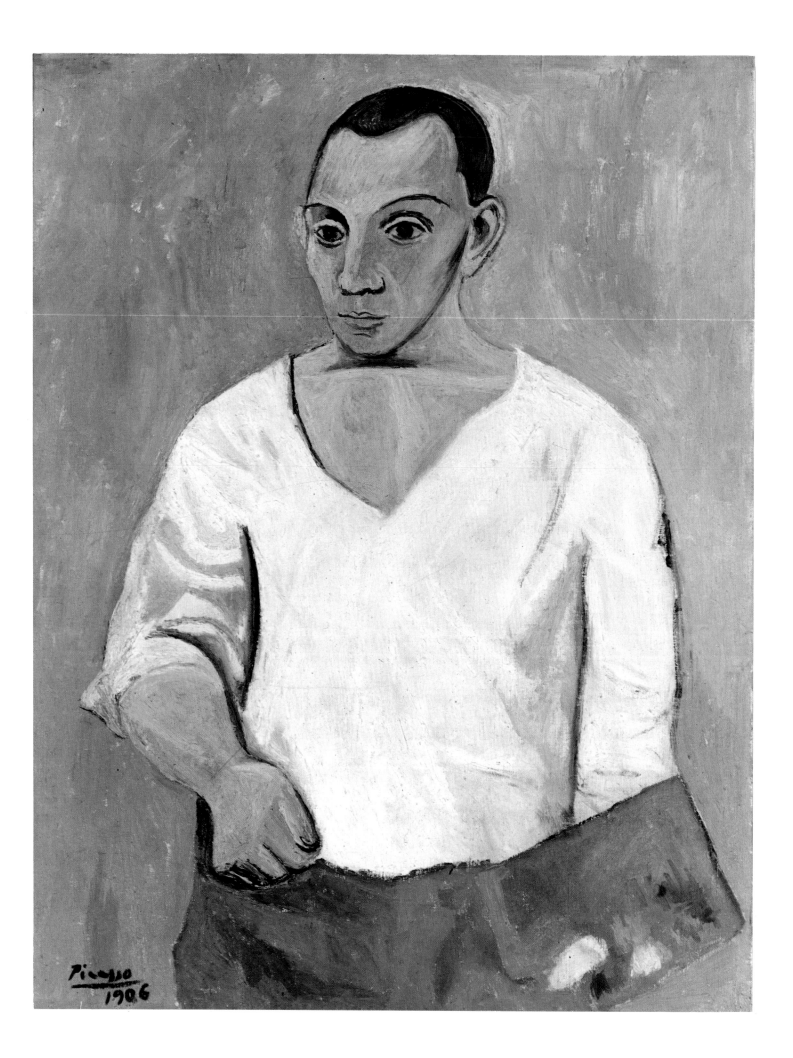

1 Picasso the Legend

Picasso is not just a man and his work. Picasso is always a legend, indeed almost a myth. In the public view he has long since been the personification of genius in modern art. Picasso is an idol, one of those rare creatures who act as crucibles in which the diverse and often chaotic phenomena of culture are focussed, who seem to body forth the artistic life of their age in one person. The same thing happens in politics, science, sport. And it happens in art.

Even idols, of course, are subject to change. They come and go. Some, however, remain untouched by time and become classics; and one such is Picasso. Just as it now seems inconceivable that a Michelangelo or Rembrandt, a Caesar or Napoleon, an Einstein or Galileo should ever be forgotten, so too it seems impossible that the name of Picasso should ever vanish from sight.

Indeed, even in his own lifetime Picasso was already the most famous living artist. Now, twenty years after his death, his artistic achievement has gone down in history, his fame is as secure as ever, and his work and person still possess all their charismatic fascination for succeeding generations. Like all classics, Picasso is reviewed by the judgement of following periods. But unlike some of the greats of earlier eras, it is impossible to pass easy verdicts on him. For that, he is still too close to us. Much that needs accounting for still remains subject to speculation. Those who become idols, in art as in any other field of endeavour, do not do so purely on the strength of their achievements. Idols are social phenomena, and at least as much projections of society's wishes and ideas as the embodiment of their own personal concerns. Picasso the classic merits sociological scrutiny: one imagines that he himself would be a marginal figure in the resulting study. It would also be good to know more about how Picasso's pioneering innovations, and the details of his works, have affected and influenced other artists, in order to assess the Picasso phenomenon fully. A great deal has been written on this subject, but there is no remotely comprehensive overview. And what is true of these ancillary matters is most assuredly true of the heart of the matter, Picasso's art.

There is no doubt that the reason for the massive global pull of Picasso, the reason why crowds flock to exhibitions of his work year in year out, the reason why millions buy books about him, the reason why is impact is so widely felt, is quite simply the sheer exceptional diversity of his work. Picasso was pre-eminent as painter and graphic artist, as sculptor, many-talented craftsman and stage set designer. The mere scope of his output makes it next to impossible to engage with it all, and his tens of thousands of works have not yet all been catalogued, described, analysed, or indeed

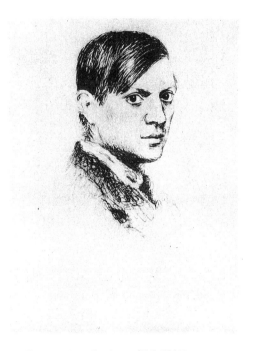

Self-Portrait at the Age of 36, 1917
Autoportrait à l'âge de trente-six ans
Pencil on paper, 34 x 26.8 cm
Maya Ruiz-Picasso Collection

Self-portrait with a Palette, 1906
Autoportrait à la palette
Oil on canvas, 92 x 73 cm
Philadelphia (PA), Philadelphia Museum
of Art, A. E. Gallatin Collection

even made accessible, in every case, to critical scrutiny or to the public eye. Whatever we say about Picasso must remain provisional for the time being.

For that reason it seems wise, if one is to convey even a hint of Picasso's growth and accomplishment as an artist, his significance and stature, to restrict one's view to the essentials: to a generous selection of works, to be sure, but a rigorously chosen selection that affords a concentrated overview and thus a well-informed point of access to his oeuvre. In the present volume, therefore, the stages in his development are documented and illustrated with the works that most illuminate Picasso's artistic qualities at that point in his career. The range covers his very earliest childhood efforts and the last work of the aged Picasso, and includes a compressed but nonetheless fully representative choice of his paintings, ceramics, sculptures, graphics and drawings. Preliminary studies and sketches make it possible to follow the creation of famous works from the first idea to the mature execution. Picasso's distinctive technique of variation, as he repeatedly rethought and reshaped subjects and forms, is clearly evidenced. And Picasso's art is placed in the context of the age. This book attempts to explain what Picasso was and what he still is for the art public of today, both as individual and as social phenomenon.

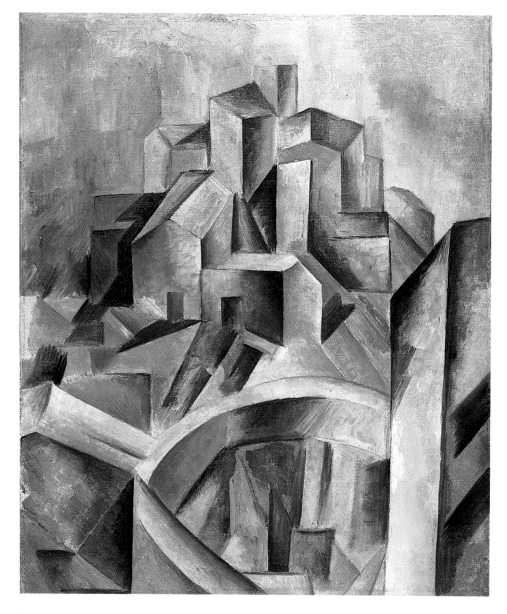

The Reservoir (Horta de Ebro), 1909
Le Réservoir (Horta de Ebro)
Oil on canvas, 60.3 x 50.1 cm
New York, Mr. and Mrs. David Rockefeller
Collection

Seated Old Man, 1970
Vieil Homme assis
Oil on canvas, 144.5 x 114 cm
Paris, Musée Picasso

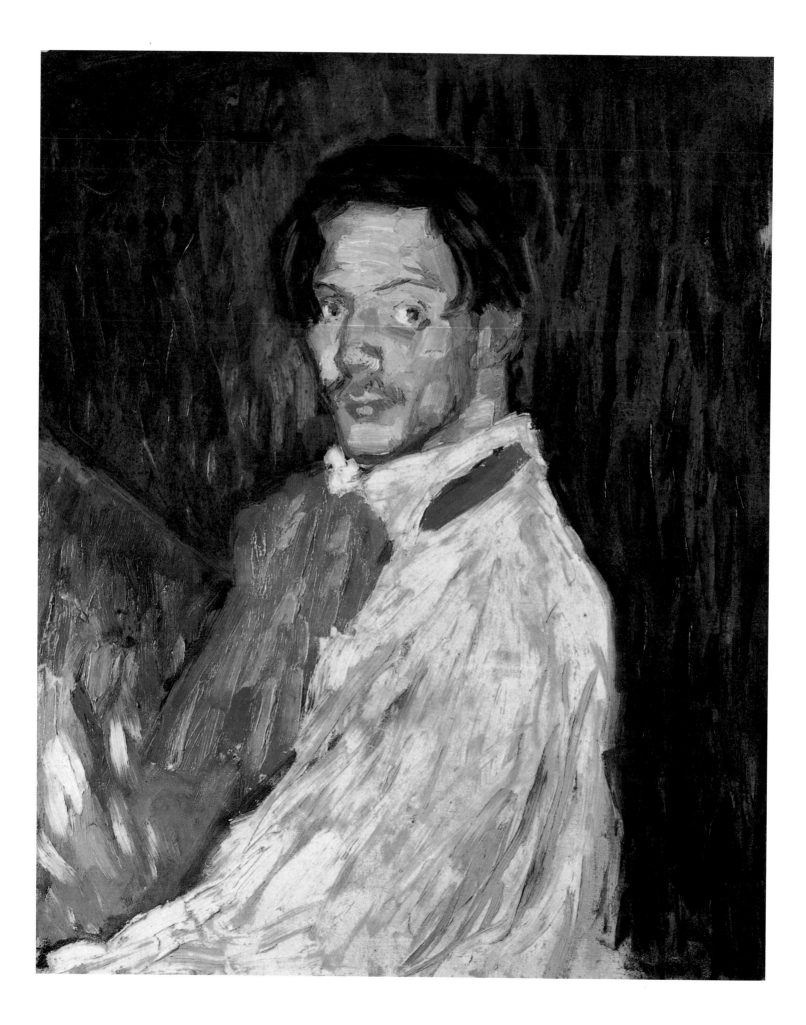

2 The Early Years 1890–1901

Youth is the period in life that leaves a permanent imprint, and artists are of course no exception. But there are few artists about whose early years we know much at all in sufficient detail. Their early attempts to express themselves artistically are very rarely preserved. Not so in Picasso's case. In this, too, he was an exception. There can be no other artist in history whom we can so closely observe developing an artistic personality on the twin basis of training and a natural gift, and establishing the foundation upon which his future brilliance in so many areas of art would be based.

Evidently Picasso's family recognised his extraordinary talent when he was very young, and not only supported him but also saved documentary evidence that now shows us how he approached the terrain before him as a youngster. No fewer than 2,200 works dating from his childhood and early youth have survived, more than have come down to us in the case of any other major artist. These are now the core of the Barcelona Museu Picasso's holdings. Notable for its extent alone, this material is also impressive in its accomplishment. There are sketches and painted studies of the kind that were routinely prepared in the course of academic tuition, but also doodles in school exercise books. There are works done in practically every technique of painting and drawing. They are instructive, revealing both the playful adventuresomeness of the child and his early endeavour to meet the demands of professional training.

It is striking, and comes as something of a surprise, that the essential traits of Picasso the artist are already present in these early works, in all their diversity, and can indeed be detected in the pencil drawing *Hercules with His Club* (p. 11) done in 1890 by the nine-year-old Pablo. Assuredly it is an awkward study, and unoriginal, being copied from a painting in the parental home. But what is staggering, given that it was drawn by a child, is the unchildish manner of the portrayal, and the clearly apparent effort to achieve the copy in the spirit of the professional rules. Wherever we look in the works of Picasso's youth, they have the same quality.

But it would be wrong to take this as infallible proof of above-average maturity or even genius. Picasso the artist was moulded by the educational and academic ideas that then prevailed, as we can clearly see from his juvenilia. The education he was given was the making of a genius. Picasso started school in Málaga in 1886, aged five. None of his drawings of that time survive. But we have a reliable witness to what they were like: Picasso himself recalled drawing spirals at school in those days. This suggests that art instruction at that Málaga primary school was designed along lines adopted and adapted by teachers throughout the world. Linear drawing was the in-

Hercules with His Club, 1890
Hercule avec sa massue
Pencil on paper, 49.6 x 32 cm
Barcelona, Museu Picasso

Self-portrait: "Yo Picasso", 1901
Autoportrait "Yo Picasso"
Oil on canvas, 73.5 x 60.5 cm
Private collection

variable point of departure: children were encouraged to think and create in geometrical terms. Then they were taught to abstract forms from the world about them. And only then did they move on to the representation of actual things.

Children in the 19th century learnt to perceive a repertoire of stock shapes in all things, and to reduce individual forms to variations on geometrical themes. The drawbacks of this method are plain: individual characteristics are subordinated to unbending principles of representation. But we must not overlook a salient advantage. Anyone who had been schooled in this way, and (of course) possessed a certain amount of native talent, would thereby gain the lifelong ability to register and reproduce objects and motifs quickly and precisely. Picasso benefitted from the training of his boyhood till he was an old man. It was that early training that gave him his astounding assurance in his craft.

It is small wonder that his school training remained so emphatically with Picasso, since professional tuition followed the same principles. After his family had moved to La Coruña when his father took up a new position, the boy first attended general secondary school but then in September 1892 moved to La Guarda art school (where his father was teaching) at the beginning of the new school year. By 1895 he had taken courses in ornamental drawing, figure, copying plaster objects, copying plaster figures, and copying and painting from Nature. It was a strict academic education according to the Madrid Royal Academy of Art's guidelines. This meant that he once again studied drawing and painting in terms of copying models. And the constant repetition of the same task did provide the art student with an available repertoire of representational methods.

Self-portrait with Close-Cropped Hair, 1896
Autoportrait aux cheveux courts
Oil on canvas, 46.5 x 31.5 cm
Barcelona, Museu Picasso

Head of a Man in the Style of El Greco, 1899
Tête d'homme à la Greco
Oil on canvas, 34.7 x 31.2 cm
Barcelona, Museu Picasso

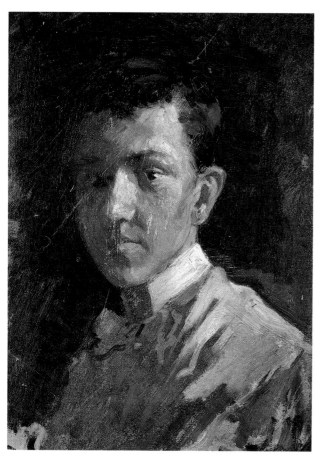

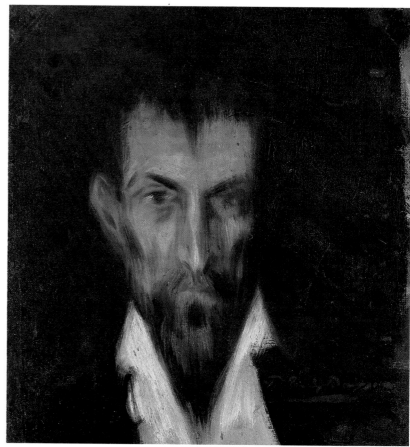

What was more, students were also taught the essentials of art history; the models they followed in their exercises were the masterpieces of ages past. So it was that in his early youth Picasso was familiar with the sculptures of antiquity. He had to copy them over and over. His lifelong engagement with the art of antiquity was thus as firmly rooted in his early training as his assured technique and his idiosyncratic manner of approaching a subject. For Picasso, drawing always came first, irrespective of whether he was working in oil, printed graphics, sculpture or ceramics.

He was exposed to his schooling not only in extreme youth, but also repeatedly. The tuition he received at art college in Barcelona (1895 to 1897) was essentially the same again. His oils of that period treated relatively few subjects over and over, in a fairly uniform style. There are a striking number of human heads, of every age and walk of life and of both sexes. These studies are done in broad, expansive pastose, using monochrome earthy browns or ochre yellows and sparing local colour to model the light and shadow on faces. The use of brush and paint followed preliminary training in drawing and priming. As with drawing, training proceeded in stages: first copying from existing designs, then from genuine objects, and finally the rendering of living models. This training was rigorously formal and designed to drive out the spontaneity in an artist, and inevitably had considerable disadvantages.

Portrait of the Artist's Father, 1896
Portrait du père de l'artiste
Oil on canvas on cardboard, 42.3 x 30.8 cm
Barcelona, Museu Picasso

Portrait of the Artist's Mother, 1896
Portrait de la mère de l'artiste
Pastel on paper, 49.8 x 39 cm
Barcelona, Museu Picasso

PAGE 14:
First Communion, 1896
La Première Communion
Oil on canvas, 166 x 118 cm
Barcelona, Museu Picasso

PAGE 15:
The Barefoot Girl, 1895
La Fillette aux pieds nus
Oil on canvas, 74.5 x 49.5 cm
Paris, Musée Picasso

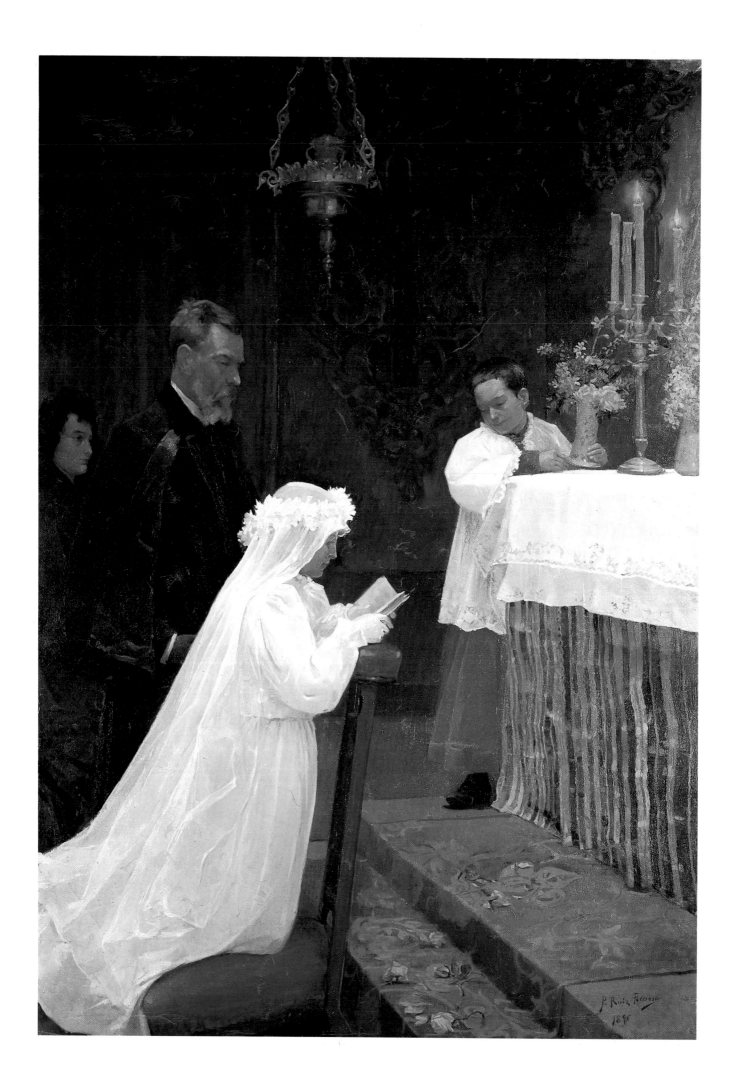

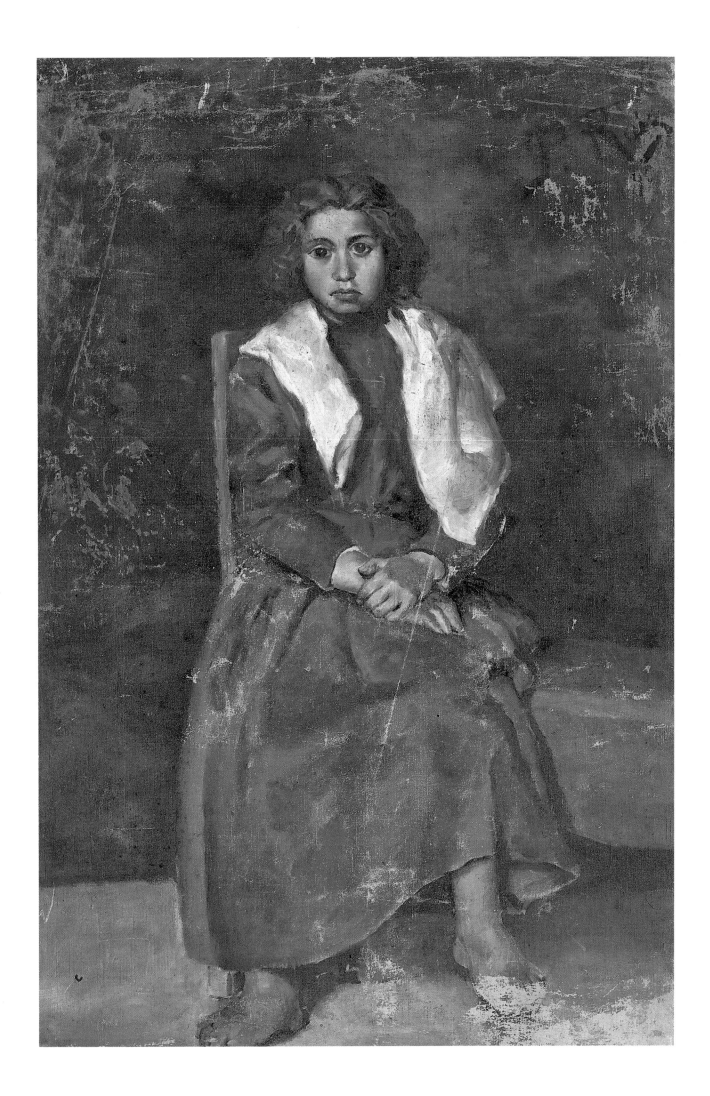

Science and Charity, 1897
Science et charité
Oil on canvas, 197 x 249.5 cm
Barcelona, Museu Picasso

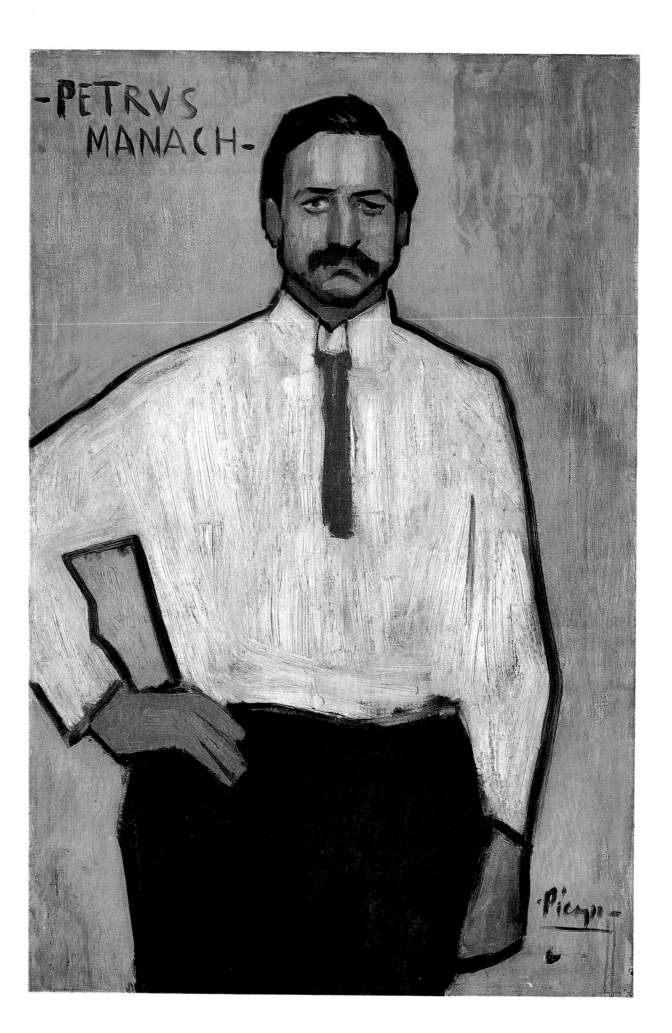

Autonomous values of colour, so important to new movements such as Impressionism, were played down. Colour established form, confirming the contour established by the drawn line. This sense of colour stayed with Picasso till the end of his career: colour was intimately connected with form, and could be used to intensify or defamiliarize it. Still, Picasso's academic training alone could never have made him what he became, much as he owed it in later life.

Picasso's father was unremitting in moulding his son along his own lines. He wanted him to be the academic painter par excellence. He himself painted animal scenes and genre paintings, the kind of work traditionally considered of secondary value; and he wanted his son to paint figure and history paintings, which were then valued above all else. This culminated in two paintings the father prompted the son to do in 1896 and 1897, *First Communion* (p. 14) and *Science and Charity* (p. 16/17). Picasso's father sat for the doctor whose skill and knowledge will determine the patient's fate. And his father also influenced the reception of the pictures by using his contacts with newspaper critics. He was omnipresent in the young Picasso's life. The boy's whole education took place in schools and colleges where his father was on the staff.

Deliberately though Picasso's training was steered by his father, however, and intelligent though it was, it was also outdated. Elsewhere in Europe, this academic method had been superseded. So a crisis was inevitable in Picasso's life. In 1897, when his father sent the sixteen-year-old to the Royal Academy in Madrid, it was a great mistake. The legend-makers have tended to claim that Picasso attended none of his courses at all – but he did in fact go to those of Moreno Carbonero. Still, he was profoundly disappointed by studies at the Academy, and concentrated on copying the old masters in the Prado. In June 1898 he gave up his Madrid studies for good.

A letter he wrote to a friend on 3 November 1897 shows how much he craved good instruction in Madrid. In it he complains bitterly of the backwardness and incompetence of his teachers and says he would rather go to Paris or Munich, where the art tuition was the best in Europe. Munich would even be best, he said – although he was going to go to Paris – because in Munich people didn't bother with fashionable stuff such as pointillism! In other words, Picasso was longing for the kind of academic training given by the likes of Franz von Stuck (in Germany); but he was not interested in the methods and ideas that were currently considered avant-garde.

Though it may seem astonishing or paradoxical, the fact is that Picasso did not become Picasso under the influence of progressive ideas but because an old-fashioned milieu was imposing superannuated notions on him. He found it impossible to make do with routine and mediocrity. Fully aware that the decision to quit the Academy would seriously damage relations with his father, for whom Madrid still represented the gateway to desired success, Picasso made a radical break – despite the total uncertainty of his new future. Not yet seventeen, he set about achieving his independence in every respect. And from now on he went his own way.

But first the upheaval of having to leave everything behind produced an immediate and visible result: he fell ill. In spring 1898 in Madrid he came down with scarlet fever, and was quarantined for forty days. After recovering he returned to Barcelona and embarked on his independent career in art. The Catalan metropolis was his base till his definitive final move to France in 1904. Those were restless years. In 1898, through its colony Cuba, Spain

Portrait of Pedro Mañach, 1901
Portrait de Pedro Mañach
Oil on canvas, 100.5 x 67.5 cm
Washington (DC), National Gallery of Art

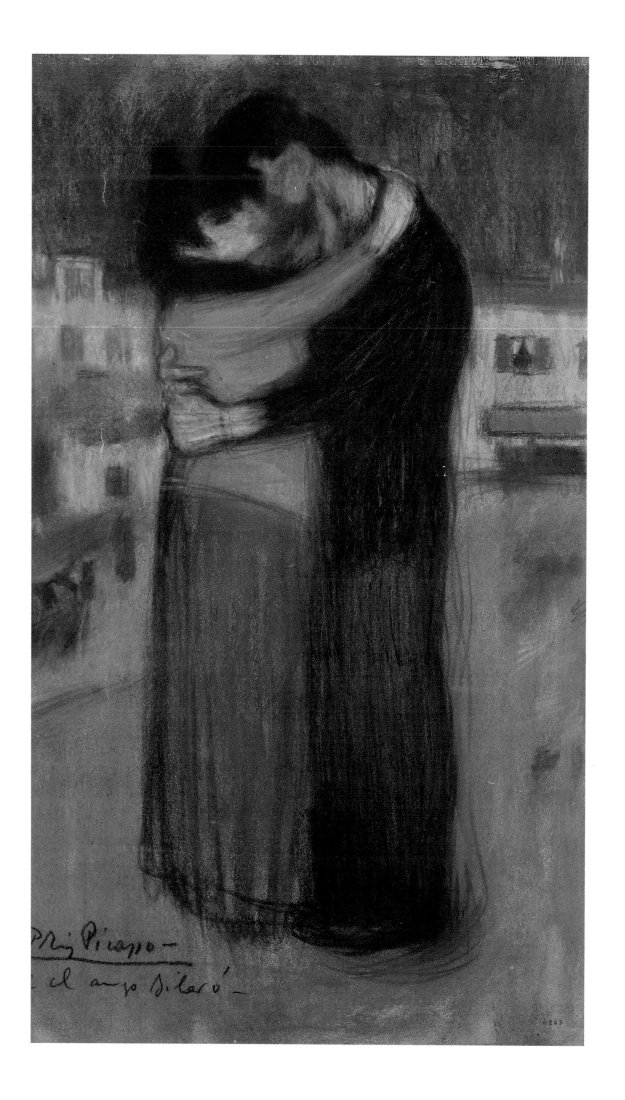

became involved in a war with the USA. Defeat spelt the end of what remained of Spain's colonial empire and claims to be a world power. It was a turning point, and brought profound political, social and cultural insecurity with it.

In such a period, the seventeen-year-old Picasso had considerable capital, albeit not of a financial kind. He was confident, talented and young. He had contacts. And he had unlimited energy. In 1896 *First Communion* (p. 14) was exhibited in Barcelona. This was the third arts and crafts exhibition to be held there (after 1891 and 1894), a major event intended to showcase contemporary Catalan culture. To be exhibited in that show was a triumph for a fifteen-year-old, even if his father's contacts had helped. A year later he painted the grand *Science and Charity* (p. 16/17), a work well in line with the anecdotal realism which was then a popular variety of historical painting. Picasso submitted it to the Madrid General Art Exhibition, and it was taken by a jury that included the painter Antonio Muñoz Degrain, a friend and colleague of his father's to whom the youth had already given a portrait study. *Science and Charity* received an honourable mention at the exhibition, and subsequently a gold medal in Málaga.

Frenzy, 1900
Pastel, 47.5 x 38.5 cm
Private collection

The Embrace in the Street, 1900
Les Amants de la rue
Pastel on paper, 59 x 35 cm
Barcelona, Museu Picasso

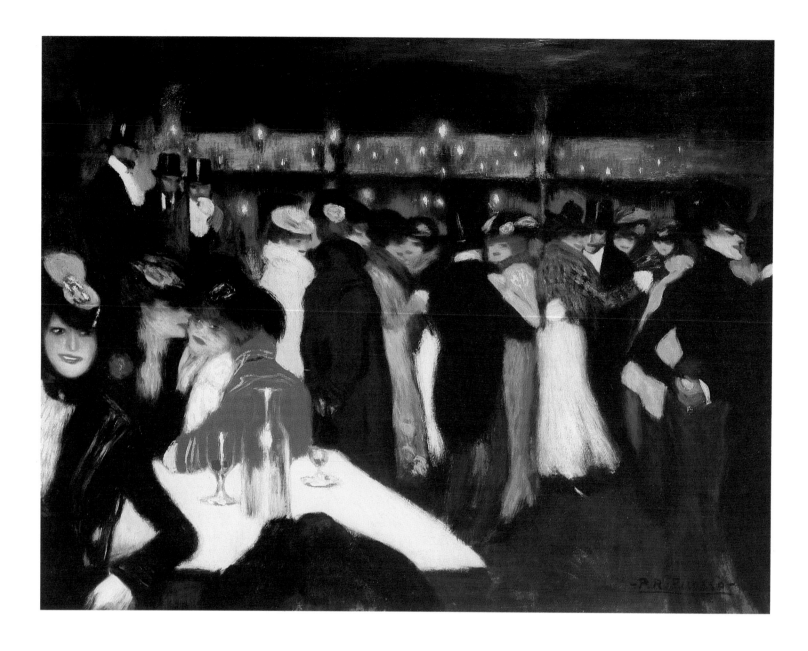

Le Moulin de la Galette, 1900
Oil on canvas, 90.2 x 117 cm
New York, The Solomon R. Guggenheim
Museum, Justin K. Thannhauser Foundation

So Picasso was known to those who followed contemporary art when he set out on his own way. And Barcelona was a good place for it, a progressive city where Spanish art nouveau was based, in the form of a group of artists known as the modernists; and in Barcelona too were their successors and antagonists, the post-modernists. In June 1897 the Barcelona café "Els Quatre Gats" (The Four Cats) opened its doors. It was an artists' café and hosted changing exhibitions; in its short life it was the hub of Catalonian artistic life. Leading "Modernistas" helped establish it. It cannot have been too difficult for Picasso to join these circles, since they would have heard his name; and belonging to them was a good start for his career. In the art world as in any other, talent and energy need personal contacts to help them on their way.

And it was contacts that helped decide Picasso for Paris. Though he was impressed by what he had heard about Munich, it was to Paris that he made his move. The French capital had an established Catalan community, including a number of artists temporarily living and working in the city. Through them he was introduced to the industrialist and art dealer Pedro Mañach, who afforded him a first secure foothold. Mañach signed a contract with Picasso guaranteeing to take his pictures for two years and to pay 150 francs

per month by way of fixed income. He also floated the idea of a first Paris Picasso exhibition at the Galerie Vollard in 1901.

To Picasso, this was no more than an entrée into the art market. For the moment, Spain seemed the better territory for his ambitions. In early 1901 he went to Madrid and started an art magazine together with a young writer, Francesc de Asis Soler. Contributions were squarely in line with the "Modernista" spirit. When failure became inevitable, Picasso returned to Barcelona, and subsequently devoted his attention to Paris.

The line-based art of art nouveau presented no problem to him. The menu he designed for *Els Quatre Gats* (p. 28) in 1899 is a good example. Every shape is rendered in clear line. Figures and background details work in plain zones of monochrome colour, or else are offset from each other by minor, stylized details. The illustration shows the speed and assurance with which Picasso had adopted a "Modernista" approach. He did not confine himself to the repertoire of art nouveau, however. He was omnivorous in his taste for new aesthetic trends. Some of his drawings and paintings (cf. p. 12) show him reworking the formal idiom of El Greco.

The Blue Dancer, 1900
Pierrot et danseuse
Oil on canvas, 38 x 46 cm
Private collection

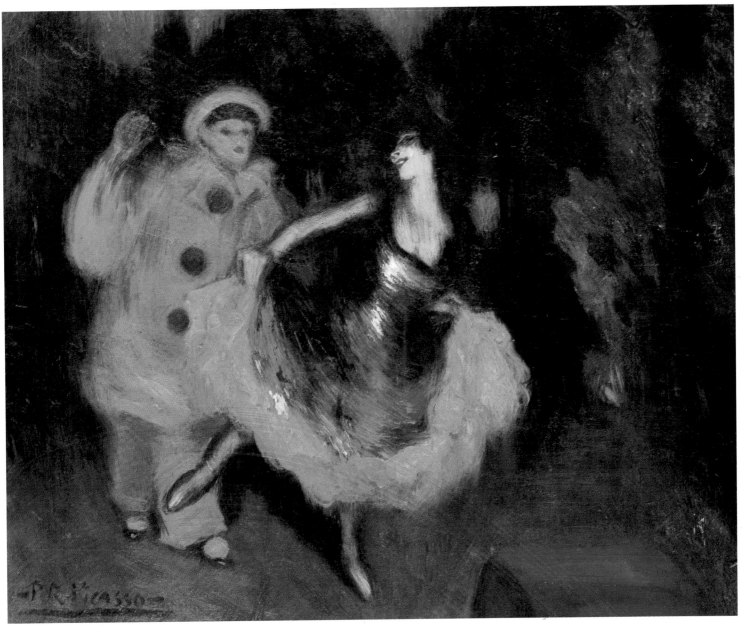

The Two Saltimbanques (Harlequin and His Companion), 1901
Les Deux Saltimbanques (Arlequin et sa compagne)
Oil on canvas, 73 x 60 cm
Moscow, Pushkin Museum

Harlequin Leaning on His Elbow, 1901
Arlequin accoudé
Oil on canvas, 82.8 x 61.3 cm
New York, The Metropolitan Museum of Modern Art

Lady in Blue, 1901
Femme en bleu
Oil on canvas, 133.5 x 101 cm
Madrid, Museo Español de Arte
Contemporáneo

But it was Henri de Toulouse-Lautrec who made the most powerful impression on the youthful Picasso. His posters and paintings, draughtsmanlike in manner, economical, precise, often on the verge of being caricatures, held a particular appeal for Picasso. In 1900, Picasso's interest in Toulouse-Lautrec peaked in his painting *Le Moulin de la Galette* (p. 22). Inside, there is a crowd; further on, beyond a diagonally cropped group of women seated at a table to the left, we see dancing couples as in a frieze. The subject and the treatment are reminiscent of a Toulouse-Lautrec done in 1889, which in turn was a reworking of Pierre-Auguste Renoir's 1876 painting of the merriment at the famous Moulin, transposing the colourful fun from the garden to the interior and to night. Picasso follows Toulouse-Lautrec, and intensifies the effect by using the gas lighting to establish an atmosphere of half-light, a uniform duskiness in which the figures appear as patches of colour against a dark background. Correspondingly, the style of brushwork is more

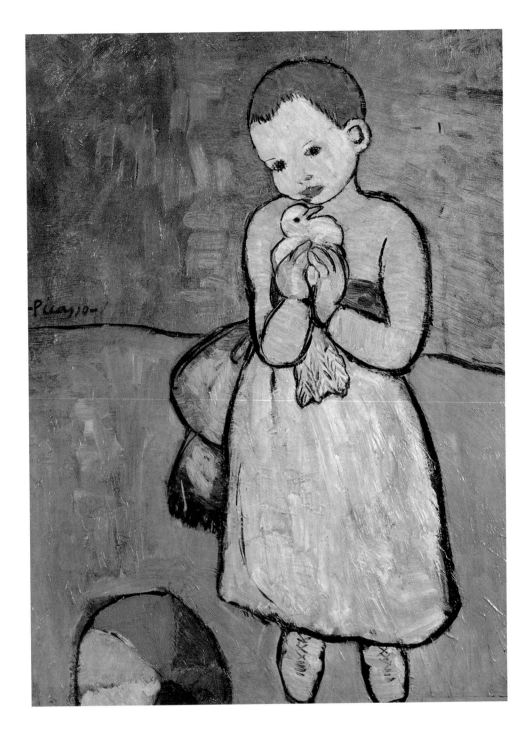

Child Holding a Dove, 1901
L'Enfant au pigeon
Oil on canvas, 73 x 54 cm
London, National Gallery)

summary, working in large blocks and pinpointing only a few characteristics of the people shown. The people have in fact been stripped of their individuality and are merely props to illustrate social amusement.

Picasso was not merely imitating. He also tried to reconceive the originals he copied. Very soon he was trying to rework diverse influences in a single work. A good example painted on cardboard in 1901 is *Pierreuse* (p. 29). A young woman wearing a red top and a decorative hat is seated at a blue table, leaning on both elbows, her right arm crooked to clasp her left shoulder. Her attitude is one of protective barring and signals that she is withdrawn within herself. Dreamily she gazes away into an undefined and indistinct distance. A sense of transported absence is conveyed not only by the woman's pose but also by Picasso's compositional subtlety. The woman is leaning across to the left side of the picture, establishing a falling diagonal and thus introducing a quality of movement into the work. But it is

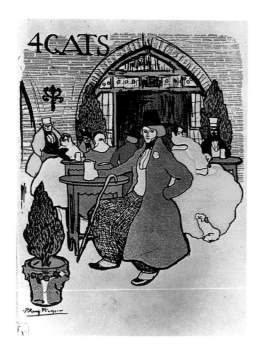

Menu of "Els Quatre Gats", 1899
Menu des "Quatre Gats"
Pencil and India ink, coloured, 22 x 16.5 cm
Whereabouts unknown

movement that is meticulously counterbalanced and neutralized by the composition as a whole. The use of spatial areas is richly ambivalent. Inclining across the table, the woman seems to be coming nearer to us, and with her hat cropped more than once by the picture edge it is as if she were on the point of stepping out towards us. At the same time, though, her position on the other side of the table emphasizes inaccessibility. It is a painting of mood, and the contrastive use of colour, with the dichotomy of flat areas and broken-up form, serve to underline its mood. Picasso was using techniques borrowed from the pointillists, Vincent van Gogh, Paul Gauguin and the Nabis all in one, to make a style of his own. The same applies to his portrait of Pedro Mañach (p. 18).

Of course contemporary critics were quick to notice Picasso's adoption of current avant-garde artistic styles. Reviewing the work shown in 1901 at the Galerie Vollard, Félicien Fagus wrote that Picasso had plainly been influenced by "Delacroix, Manet, Monet, van Gogh, Pissarro, Toulouse-Lautrec, Degas, Forain, perhaps even Rops". The only thing wrong with this assessment is that it misses out an important name or two, such as that of Gauguin. But the sheer number of influences on Picasso at that time need not only be seen in a negative light. It is normal for young artists to be influenced as they try to find their own style. And Picasso was not merely copying; he was quickly able to harmonize various influences into new wholes. If this had not been so, it would be hard to understand his early success on the art market. He had an excellent memory for formal qualities, one which stored them so deeply that they became part of his own way of thinking. He was imitating, yes – but he did so in order to find a style entirely his own.

Pierreuse, 1901
Pierreuse, la main sur l'épaule
Oil on cardboard, 69.5 x 57 cm
Barcelona, Museu Picasso

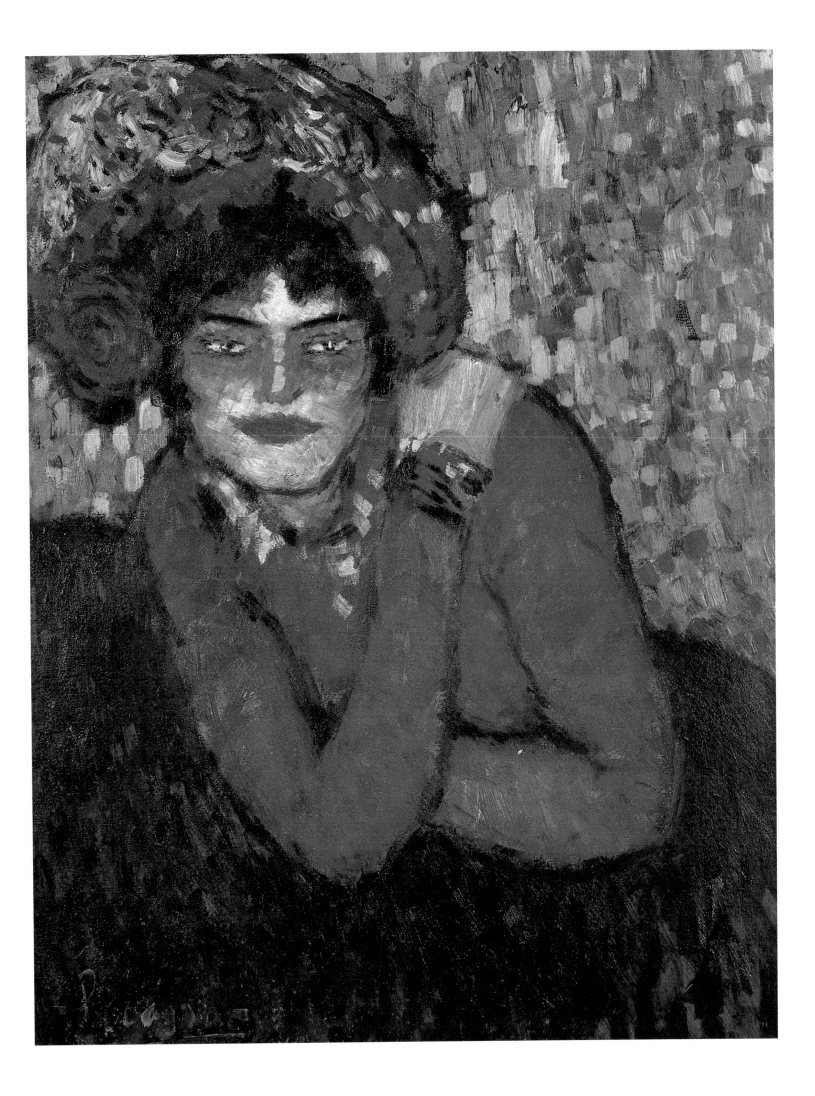

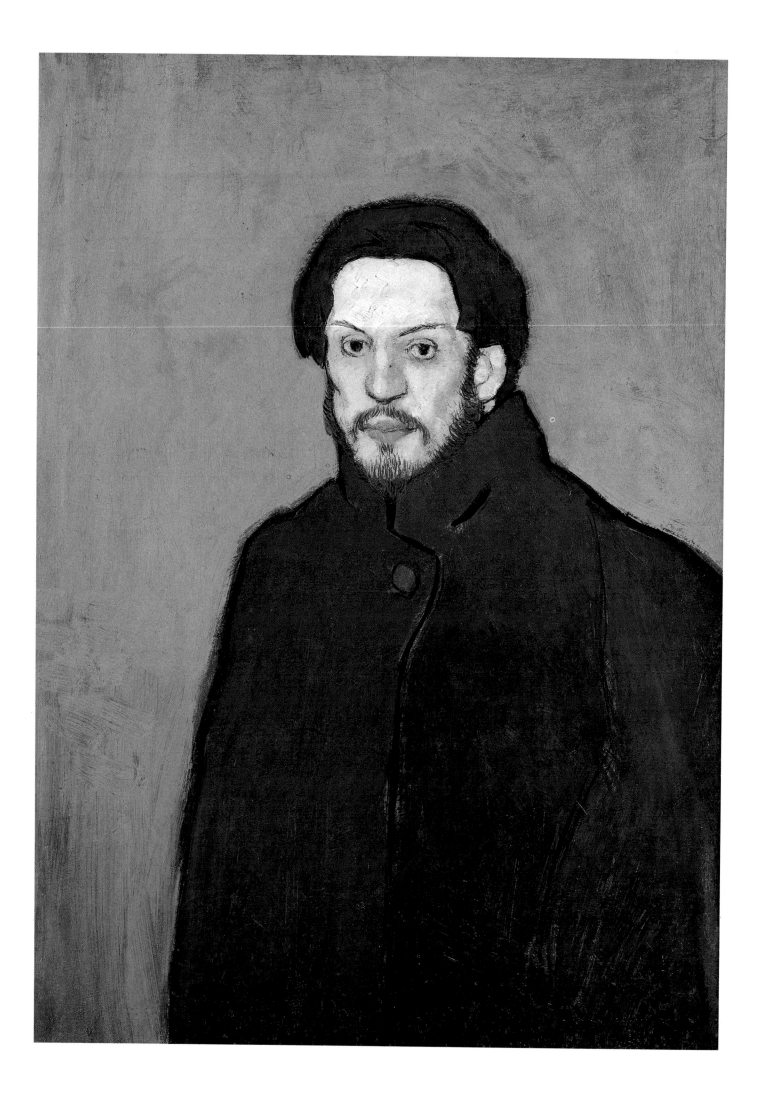

3 The Blue and Rose Periods
1901–1906

In the year 1901 Picasso was already in a position to create something new of his own – the long series of works known as his Blue Period. These works constitute no less than a résumé of European artistic progress since the mid–19th century – though Picasso did forgo the newly-discovered potential of colour. In this respect he was diametrically at odds with Fauvism, which flourished at the same time. Though the fundamentals of the Blue Period were evolved in Paris, Barcelona remained the centre of Picasso's actual labours till he finally moved to the French capital in April 1904. In fact his work in Catalonia was interrupted only by a brief (and commercially dismal) stay in Paris from October 1902 to January 1903. His pictures, not merely melancholy but profoundly depressed and cheerless, inspired no affection in the public or in buyers. It was not poverty that led him to paint the impoverished outsiders of society, but rather the fact that he painted them made him poor himself.

All Picasso invented was his treatment; otherwise he was squarely in the avant-garde line of development since the mid–19th century. Gustave Courbet's realism had located subjects in everyday village life. Courbet liked to give plain physical work the full monumental treatment, knowing the subject had hitherto not been taken seriously. In Honoré Daumier's drawings, society's weaknesses were lampooned, but Daumier also took the lives of smiths, butchers or washerwomen seriously in paintings and graphic art that owed no slavish debt to any classical norm. And Impressionism, of course, would be radically misunderstood if we saw it purely as formal virtuosity, games played with colour, and atmospherics. The Impressionists also discovered the modern city as a source of subjects. If they recognised no hierarchy of formal values, they also knew no precedence of subjects. There were no taboos in their approach to the new reality, no refusal to face subjects that were beneath their dignity. Smoke-filled railway stations and cathedrals, boulevard life in Paris and night clubs and the gloom of drinkers and whores, all appeared in their work. Picasso's Blue Period portrayals of beggars and prostitutes, workers and drinkers in bars, took up this line. His absinthe drinkers had antecedents in Degas and Toulouse-Lautrec; his arresting *Woman Ironing* (p. 44) was also a product of a recent tradition, with affinities to works by Daumier and Degas.

We should also remember that the Paris milieu was not the sole influence on Picasso's Blue Period. Spanish culture played a considerable part too. Of the various ideas that were imported into the country at the time, anarchism was particularly influential; the Barcelona literary and artistic circles Picasso moved in were very interested in the tenets of anarchism, albeit in

Study for "The Visit", 1902
Etude pour "L'Entrevue"
Pencil on paper 45.9 x 32.8 cm
Paris, Musée Picasso

Self-portrait with Cloak, 1901/02
Autoportrait
Oil on canvas, 81 x 60 cm
Paris, Musée Picasso

conjunction with other ideas too. A self-portrait Picasso painted in the winter of 1901/1902 (p. 30) captures the mood. It is as if Fyodor Dostoyevsky's novels, Friedrich Nietzsche's ideas and the theories of Mikhail Bakunin had stood godfather to the painting.

The influence of anarchist literature and of Isidre Nonell's socio-critical art is apparent in many of Picasso's works of 1899 and 1900. But his new style of the Blue Period neither simply continued this line nor conformed with his sources. His formal approach was different for a start. Whereas Nonell (and Picasso himself in his "Arte Joven" days) had done compositions involving several figures and having a narrative character, the Blue Period works established just a handful of emphatic motifs. In Nonell's panoramic works, human misery was seen as a slice of real life in its real environment and implied comment on larger societal conditions. But in Picasso's case fate was an individual thing, endured in isolation.

The Absinthe Drinker (p. 33), an emotionally arresting painting, draws its power from this. Everything seems stony: the glass, the bottle, the woman herself. A sense of volume is conveyed by juxtaposing variant tones of the same colour within purely linear spaces. Spatial values are produced less by perspective than by the overlapping of forms. It is a meticulous, clear, balanced composition, with lighter and darker echoes of the skin tonalities uni-

The Visit (Two Sisters), 1902
L'Entrevue (Les Deux Sœurs)
Oil on canvas on panel, 152 x 100 cm
St. Petersburg, Hermitage

Crouching Beggar, 1902
Miséreuse accroupie
Oil on canvas, 101.2 x 66 cm
Toronto, Art Gallery of Ontario

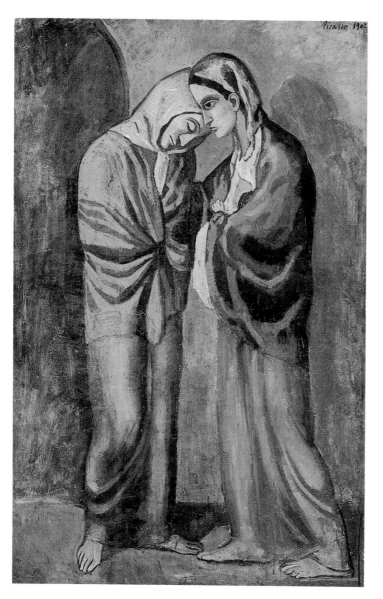

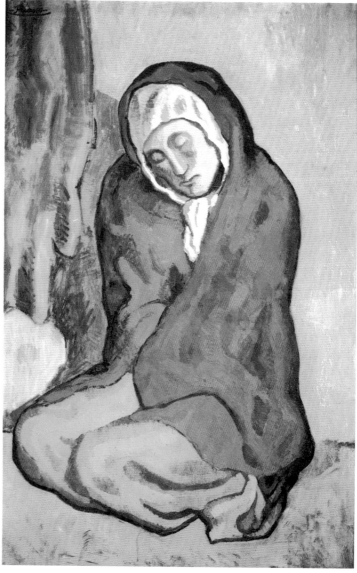

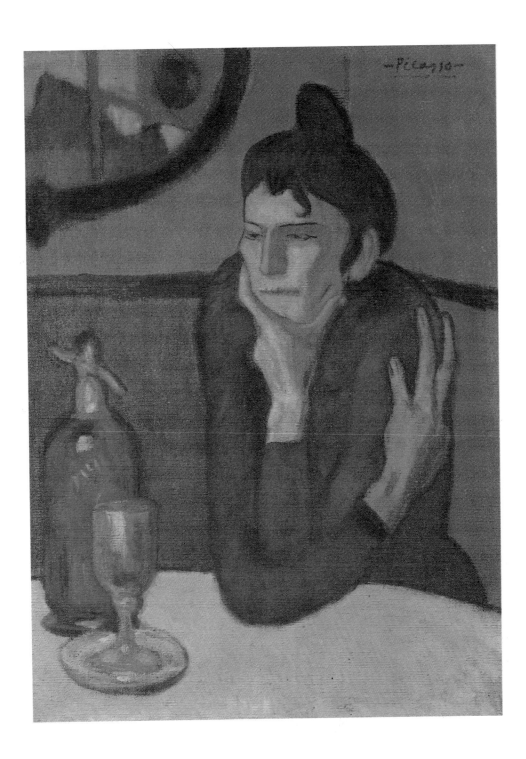

The Absinthe Drinker, 1901
La Buveuse d'absinthe
Oil on canvas, 73 x 54 cm
St. Petersburg, Hermitage

fying the effect. The tonal differences are so slight that the impression borders on the monochrome, serving solely to intensify the atmospheric charge. The draughtsman's forms make a more powerful impact than the painter's colouring. The long, talon-like hands gripping the angular face and upper arm, with the overall elongation of proportions, serve to emphasize the isolation and introspectiveness of the sitter.

But the Blue Period Picasso did not merely pursue one-sided variations of an expressive approach. He produced very varied work, monumental, smoothly-constructed pieces alternating with detailed work the brushwork of which is nervy and dabbed. It is not only an art of considerable artifice, it is also an art which portrays an artificial world. For Picasso, confrontation with social reality was only a motivation; it was not an end in itself. For him it was more important to experiment, to try and test new visual approaches. In *The Absinthe Drinker* the subject is not only the melancholy pub atmos-

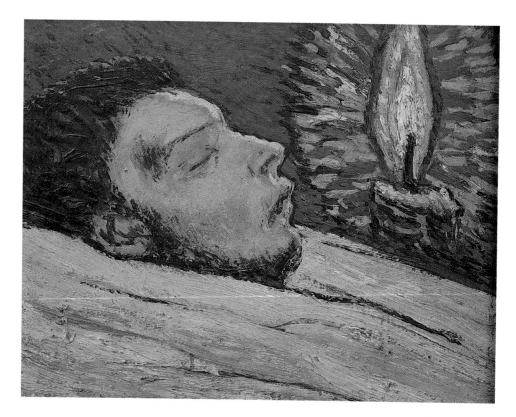

PAGE 35:
Evocation (The Burial of Casagemas), 1901
Evocation (L'Enterrement de Casagemas)
Oil on canvas, 150.5 x 90.5 cm
Paris, Musée d'Art Moderne de la Ville
de Paris

The Death of Casagemas (Casagemas in His Coffin), 1901
La Mort de Casagemas (Casagemas dans son cercueil)
Oil on cardboard, 72.5 x 57.8 cm
Estate of the artist

phere and the dreariness of alcohol. The painting's meaning also lies in the autonomy of formal means. The erosion of defined spatiality, the abandoning of perspective construction, is only the most striking of several interesting features. It must be taken together with the accentuation of compositional fundamentals such as plenitude and emptiness, density and weight, emphasis and its lack.

Ex-centricity and centralization were constants in this period. *The Blind Man's Meal* (p. 40) has a blind man up against the right of the composition, reaching across the table with unnaturally elongated arms, so that the rest of the picture seems somehow to be in his embrace or province. The radically monochromatic blue is married to a kind of formal crisscross procedure: the composition uses striking echo techniques, the pallor in the blind man's neck answered by parts of the table, the paler blue patches on his clothing corresponding to the pale blues on the rear wall. Though there is no clear line of evolution, certain Blue Period motifs and formal groupings do recur. In essence, Picasso was working within a limited range: men and women seated at tables, alone or in twos, meals being eaten, figures crouching or hugging themselves as they stand or sit, people with head in hand or arms crossed – this modest repertoire, in variations, accounts for the Blue Period work.

Of course, if there were no more to it, those with no prior interest would no longer have any particular reason to be interested in these pictures. In fact Picasso was a master of intensifying contrast and evocative effects. His mastery came from his assured grasp of certain formal and thematic antecedents, and of the various media (such as drawing, graphics or paint). One of his earliest etchings was *The Frugal Repast* (p. 42), done in 1904 and one of the masterpieces of 20th-century printed graphic art. In it, Picasso's approach to line etching resembles his handling of colour tones in the paintings. Velvety black zones fade to grey and to bright clarity. As in *The Blind Man's Meal* Picasso plays with formal correspondences; but the cylindrical thinness of

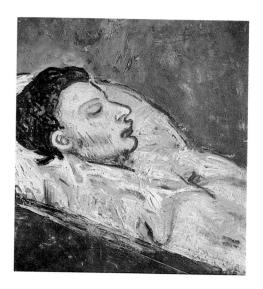

The Death of Casagemas, 1901
La Mort de Casagemas
Oil on panel, 27 x 35 cm
Paris, Musée Picasso

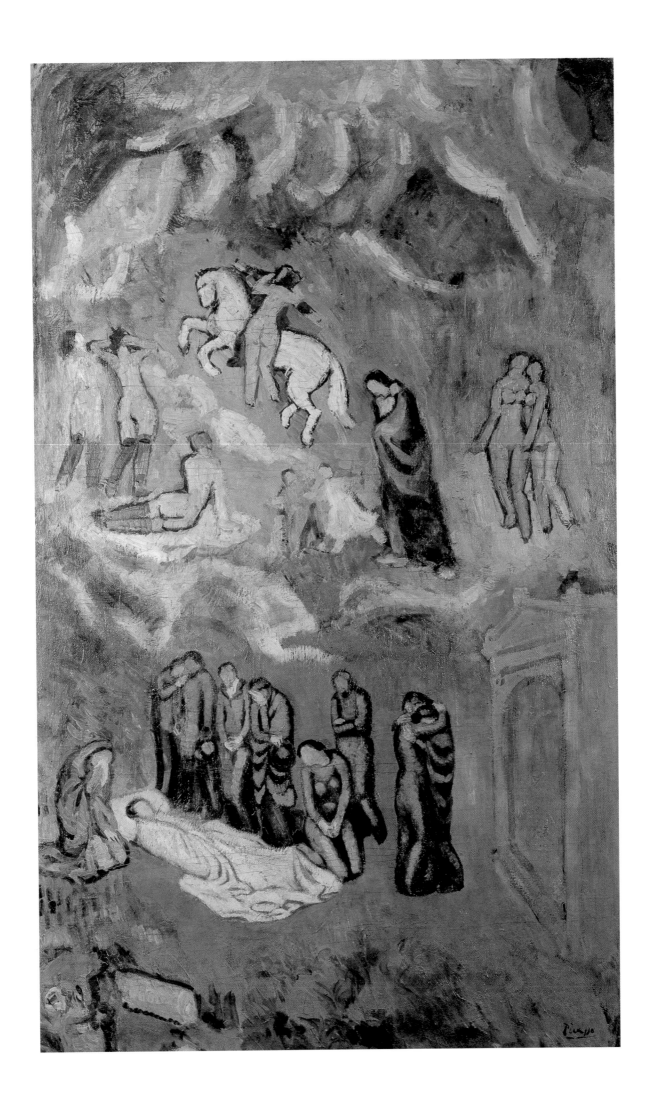

the arms, the elongated spread fingers, and the bony angularity of the figures with their dark and light areas, all recall El Greco. Not that the conspicuous influence of El Greco was the only presence in the Blue Period. Other artists also influenced Picasso's monochrome style. Indeed, it was a widely followed approach at the turn of the century, used by Symbolists, Impressionists and even Classicists.

The colour blue was important in these experiments. Its melancholy mood was often discussed in theoretical writings on art and in literature at the time. Blue not only denotes melancholy; it also carries erotic charges. And it has a long tradition in Christian iconography, in which it stands for the divine. German Romanticism gave blue the task of representing the transcendent, albeit in secular fashion. Ever since the first third of the 19th century there had been a regular mania for blue, as it were, which peaked in 1826 in the tourist discovery of the Blue Grotto on Capri. As early as 1810, Johann

Angel Fernández de Soto with a Woman,
c. 1902/03
Angel Fernández de Soto avec une femme
Watercolour and India ink on paper,
21 x 15.2 cm
Barcelona, Museu Picasso

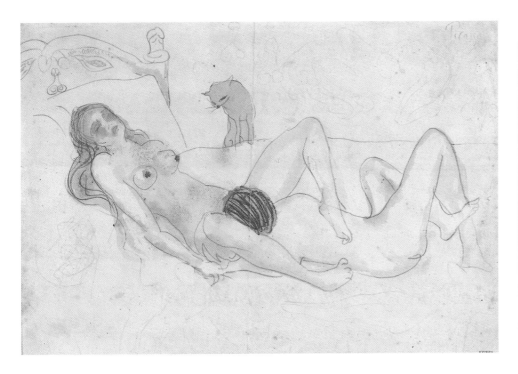

Wolfgang von Goethe had advocated the use of dominant colours to set moods: blue light could be used for mourning, and one could look at one's surroundings through tinted glass in order to marshal divergent colours in a single tonality. In 1887 the French Symbolist painter Louis Anquetin actually adopted this method.

Picasso's *The Visit* (p. 32) shows how consciously he was gathering these traditional values into a new synthesis. The attitudes and gestures of the figures are straight from Christian iconography. The visitation of Mary was portrayed in this way; and blue is the colour symbolically associated with the Virgin, the Queen of Heaven. But Picasso was also at work on personal material in the painting. The women's heads are covered, as they are in many of his paintings of that period – and as they were at the women's prison of St. Lazare in Paris, to which Picasso had access in 1901 through a doctor he knew. It was a dismal place, full of women whose fates were desolate; and it made a profound impression on the young Spanish artist.

The Blue Period peaked in *La Vie* (p. 39), a major composition which Picasso completed in May 1903. In many respects it is not only the major work of this phase but also the very sum of Picasso's art. At first the structure seems straightforward, but in fact the history and message of the painting are complex. There are two groups of people, an almost naked couple and a mother with a sleeping babe, separated by half the picture's breadth. Between them we can see two pictures leaning against the wall, the lower showing a crouching person with head on knee, the upper – a kind of variant on the other – a man and woman crouching and holding each other. The overall impression is of an artist's studio, so that we are tempted to see it as a representation of the life of the artist. But neither the subject nor the import of the work is easy to interpret. It is too fractured; nothing is what it seems. The location itself remains undefined, uncertain. The perspective angles are at odds with one another, the architectonic details ambiguous. Picasso has used Blue Period compositional techniques we can see in various pictures in one single, intense piece; and the same is true of his subjects. *La Vie* is a kind of pastiche of Picasso's Blue Period.

Two Figures and a Cat, c. 1902/03
Deux Nus et un chat
Watercolour and pencil on paper, 18 x 26.5 cm
Barcelona, Museu Picasso

The Mackerel (Allegorical Composition),
c. 1902/03
Le Maquereau (Composition allégorique)
Coloured India ink on cardboard, 13.9 x 9 cm
Barceona, Museu Picasso

PAGE 38:
Poor People on the Seashore, 1903
Les Pauvres au bord de la mer
Oil on panel, 105.4 x 69 cm
Washington (DC), National Gallery of Art,
Chester Dale Collection

PAGE 39:
La Vie (Life), 1903
Oil on canvas, 196.5 x 128.5 cm
Cleveland (OH), The Cleveland Museum
of Art

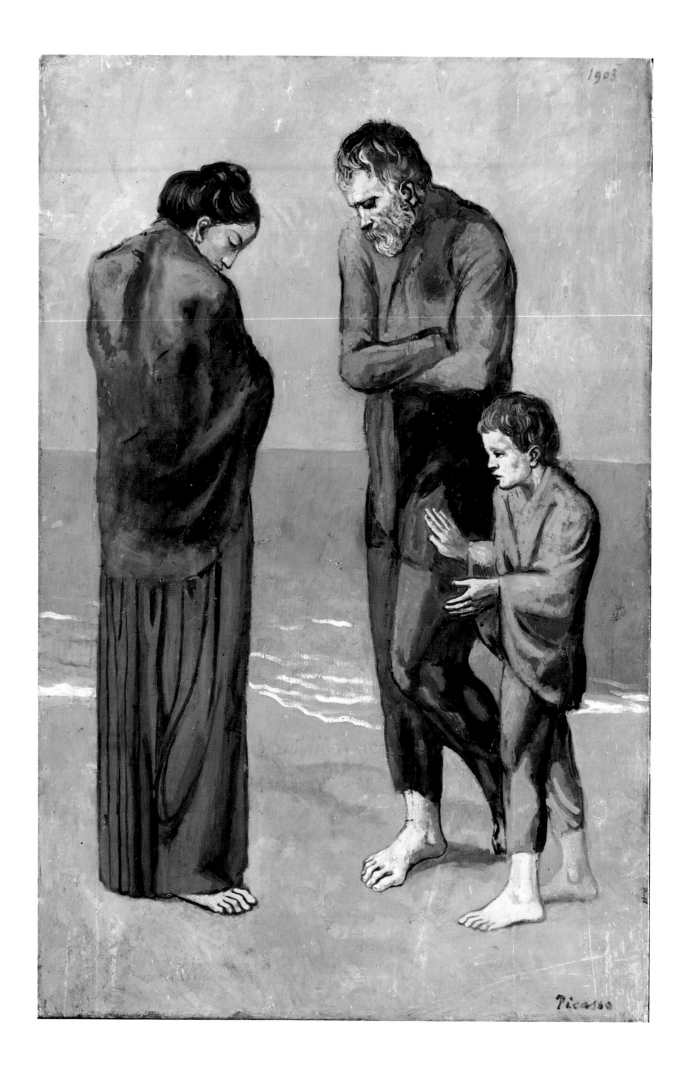

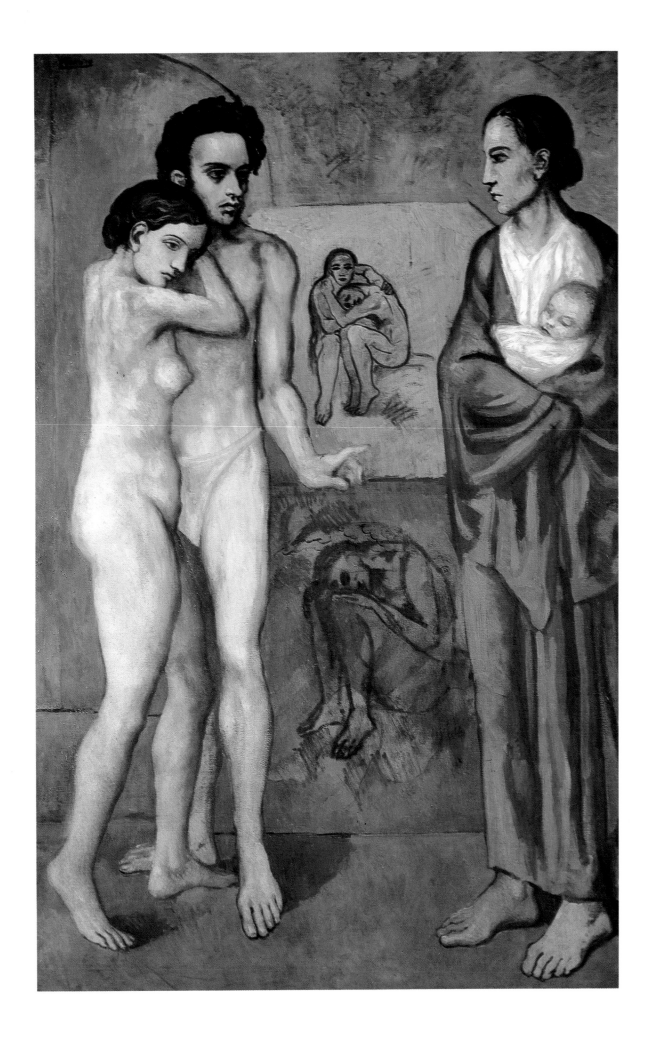

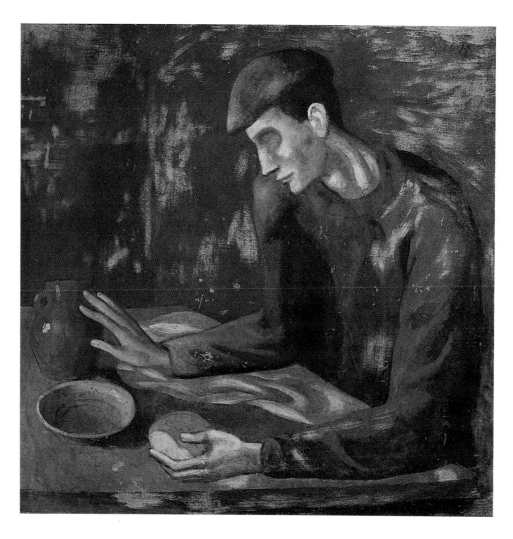

The Blind Man's Meal, 1903
Le Repas d'aveugle
Oil on canvas, 95.3 x 94.6 cm
New York, The Metropolitan Museum of Art

The male figure in *La Vie* was his sometime friend Carlos Casagemas, who committed suicide in Paris in the year 1901 while Picasso was back in Spain. When Picasso heard the news in Spain, he was deeply affected. That same year he started to paint works that dealt with the dead man and his own relations with him (pp. 34 and 35). They were fictive, heavily symbolic paintings. The fact that Picasso returned to Casagemas in the great 1903 composition suggests that the existential impact on him was profound. The painting was also in line with an artistic preoccupation of the times; the subjects of early death, despair of one's vocation, and suicide were frequently addressed and much discussed in Barcelona's artistic circles. Casagemas evidently stood for Picasso himself. X-ray examination has revealed that Picasso used a canvas on which something had already been painted – and not just any canvas, but in fact his painting *Last Moments*, seen at the Paris World Fair in 1900 and in other words a thematically and biographically extremely significant picture.

It is idle to want to read an exact message into *La Vie*. Yet Picasso's meaning is clear enough. All that mattered in biographical, artistic, creative and thematic terms in those years is present in this one picture. The melancholy and existential symbolism of that period in Picasso's life are richly expressed in this ambitious work. Picasso's technique of veiling the painting's meaning is in fact one of its signal qualities. He has managed to sidestep the vapidness of one-sided allegory; we are involved in this painting, drawn into it and – meditatively – into ourselves. The process opens up entirely new dimensions to historical painting.

Celestina or *Woman with a Cast*, 1904
Celestina
Oil on canvas, 81 x 60 cm
Paris, Musée Picasso

Looking back, we can see the Blue Period works as a progression towards this goal, even though they were not specific preliminary studies, of course. For the first time we see in Picasso's art something that will strike us repeatedly in the sequel, a notable tension between the autonomy of the single work and the endeavour to gather the fruits of a line of development into one sum. *La Vie* is the first of a number of Picassos that stand out from the

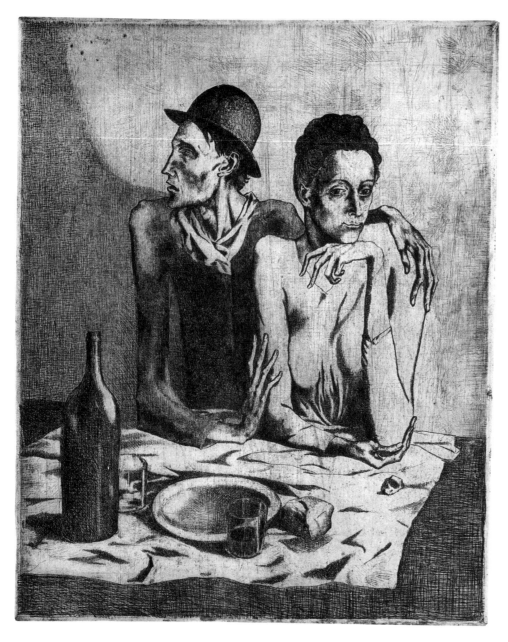

The Frugal Repast, 1904
Le Repas frugal
Etching, 46.5 x 37.6 cm

œuvre by virtue of unusual formal and thematic complexity and an extraordinary genesis. The painting was both an end and a beginning: it was a prelude to paintings even more strictly monochromatic in their use of atmospheric blue and even more concerned with existential depths.

After three years of portraying the poor and needy and lonely, Picasso struck out in new directions. *Woman with a Crow* (p.45) shows him doing so. It is made entirely of polarities. The dynamic contour, the contrasting black and red and blue, the large and small, open and closed forms, the emphasis on the centre plus the lateral displacement, light juxtaposed with dark and the white paper gleaming through, the deep black of the crow's plumage

Mother and Child, 1905
Mère et enfant (Baladins)
Gouache on canvas, 90 x 71 cm
Stuttgart, Staatsgalerie Stuttgart

42

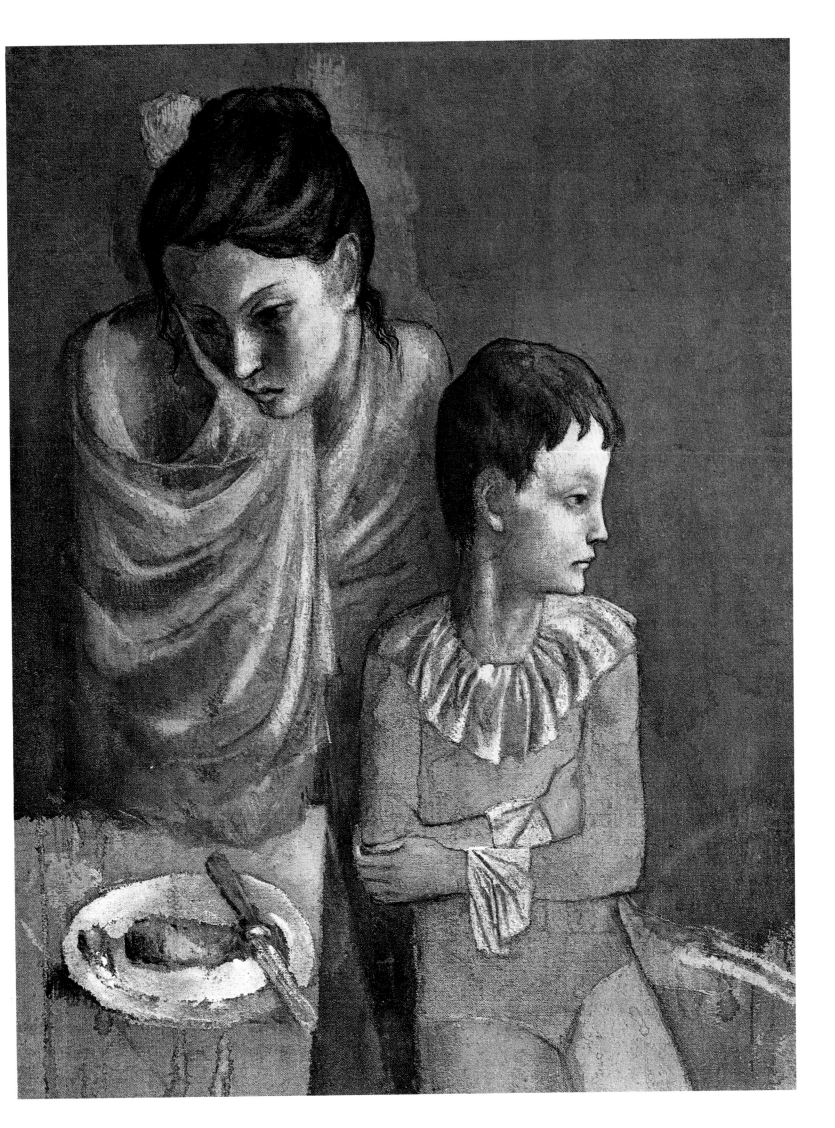

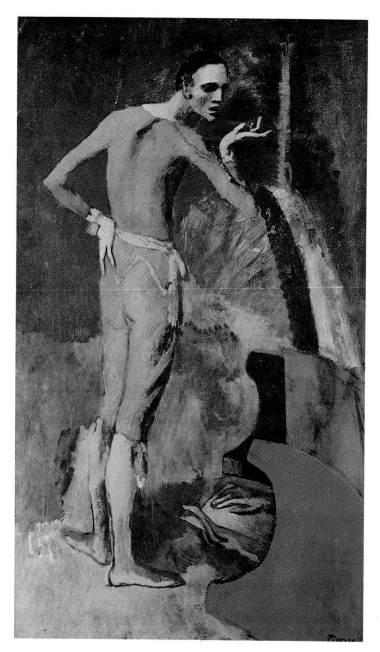

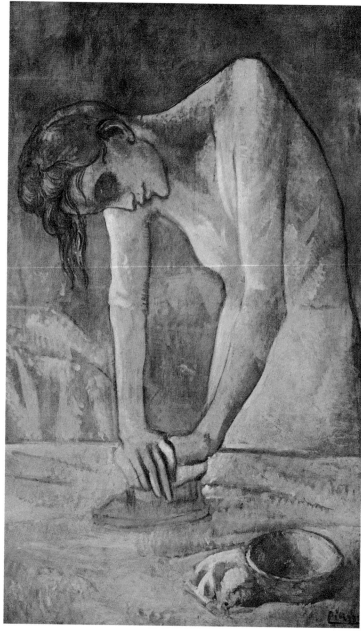

against the woman's chalk-white face – all of these features are extraordinarily evocative. The figures seem almost engraved. The delicacy of the heads and the long, slender fingers of the woman emphasize the intimacy of gesture. It is a decorative picture, a work of arresting grace and beauty. Painted in 1904, it also records Picasso's new approach: in the period ahead, he chose subjects to match his newly aestheticized sense of form. Connoisseurs and friends dubbed his new phase the "Harlequin Period". Harlequins are outsiders too. But they have something to compensate for their low social rank – their artistry. Picasso avails himself of their colourful costumes and graceful, decorative lines to create what can only be created by art: beauty.

He had made his final move to France in April 1904, taking a Montmartre studio on the Place Ravignan in May. It was one of a number in a barrack-like wooden building nicknamed the "bateau lavoir" from its similarity to the washboats on the Seine. Of course Picasso did not move solely among the artists of Montmartre and his old Spanish colony friends. He also knew the literary avant-garde in Paris. And he was increasingly establishing rewarding contacts with art dealers and collectors.

The Actor, 1904
L'Acteur
Oil on canvas, 194 x 112 cm
New York, The Metropolitan Museum of Art

Woman Ironing, 1904
La Repasseuse
Oil on canvas, 116.2 x 73 cm
New York, The Solomon R. Guggenheim Museum

Woman with a Crow, 1904
Femme à la corneille
Charcoal, pastel and watercolour on paper, 64.6 x 49.5 cm
Toledo (OH), The Toledo Museum of Art

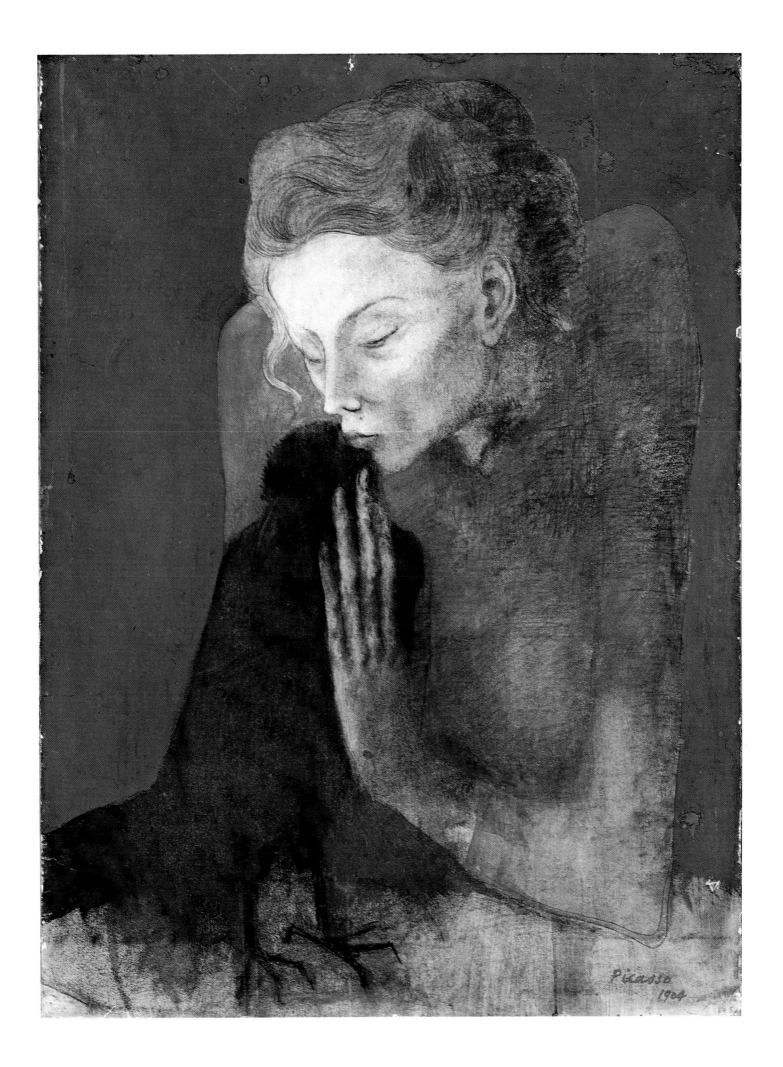

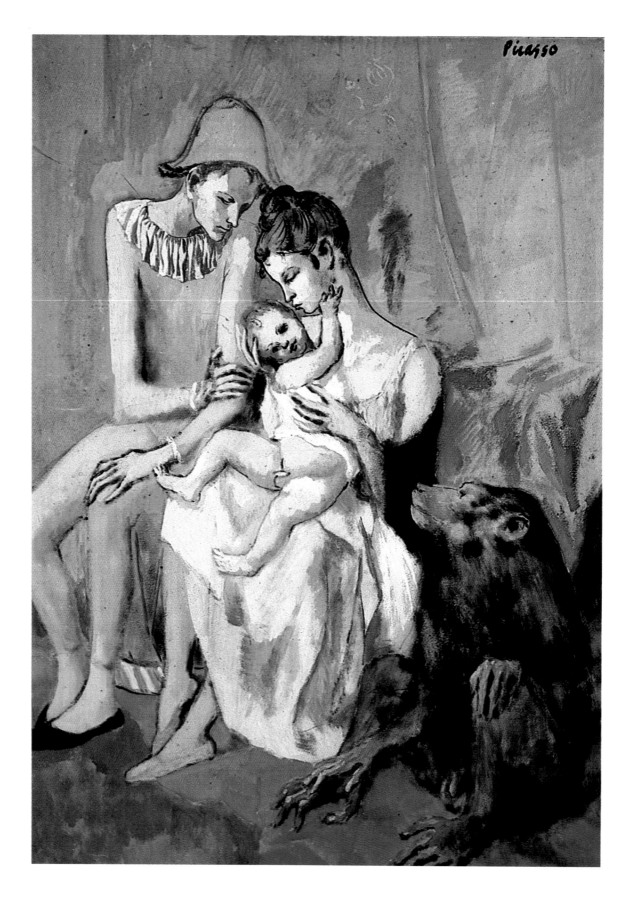

Picasso

The Acrobat's Family with a Monkey, 1905
Famille d'acrobats avec singe
Gouache, watercolour, pastel and India ink
on cardboard, 104 x 75 cm
Göteborg, Göteborgs Konstmuseum

PAGE 47 BOTTOM:
The Death of Harlequin, 1906
La Mort d'arlequin
Gouache on cardboard, 68.5 x 96 cm
Private collection

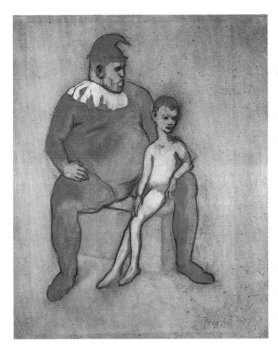

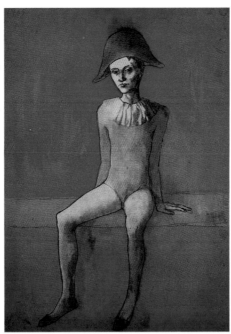

Clown and Young Acrobat, 1905
Bouffon et jeune acrobate
Charcoal, pastel and watercolour on paper,
60 x 47 cm
Baltimore (MD), The Baltimore Museum of Art,
Cone Collection

Seated Harlequin, 1905
Arlequin assis
Watercolour and India ink;
dimensions unknown
Private collection

Harlequin on Horseback, 1905
Arlequin à cheval
Oil on cardboard, 100 x 69,2 cm
Upperville (VA), Mr. and Mrs. Paul Mellon
Collection

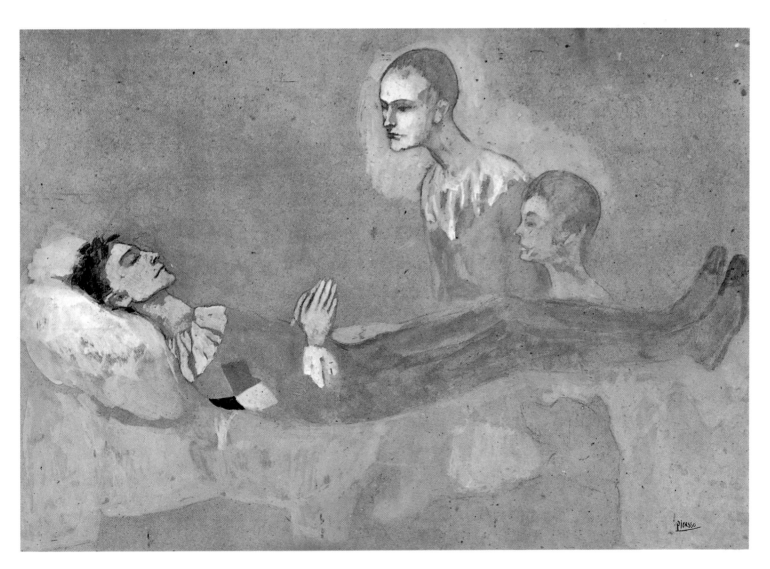

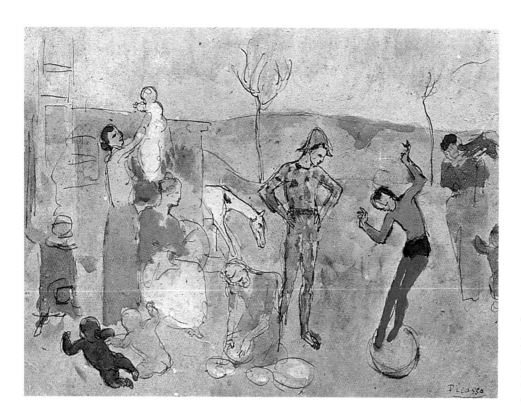

Circus Family (The Tumblers), 1905
Famille de bateleurs
Watercolour and India ink on paper,
24.3 x 30.5 cm
Baltimore (MD), The Baltimore Museum of
Art, Cone Collection

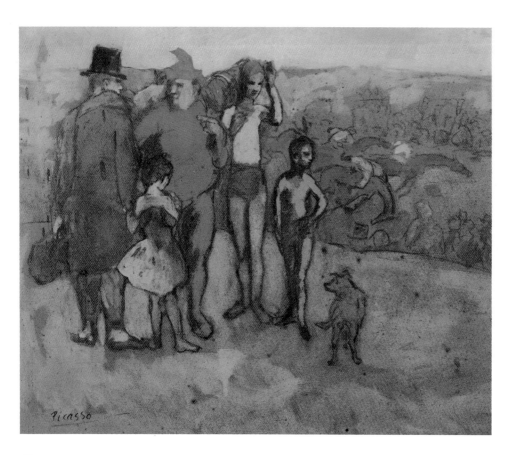

The Acrobats (Study), 1905
La Famille de saltimbanques (Etude)
Gouache and charcoal on cardboard,
51.2 x 61.2 cm
Moscow, Pushkin Museum

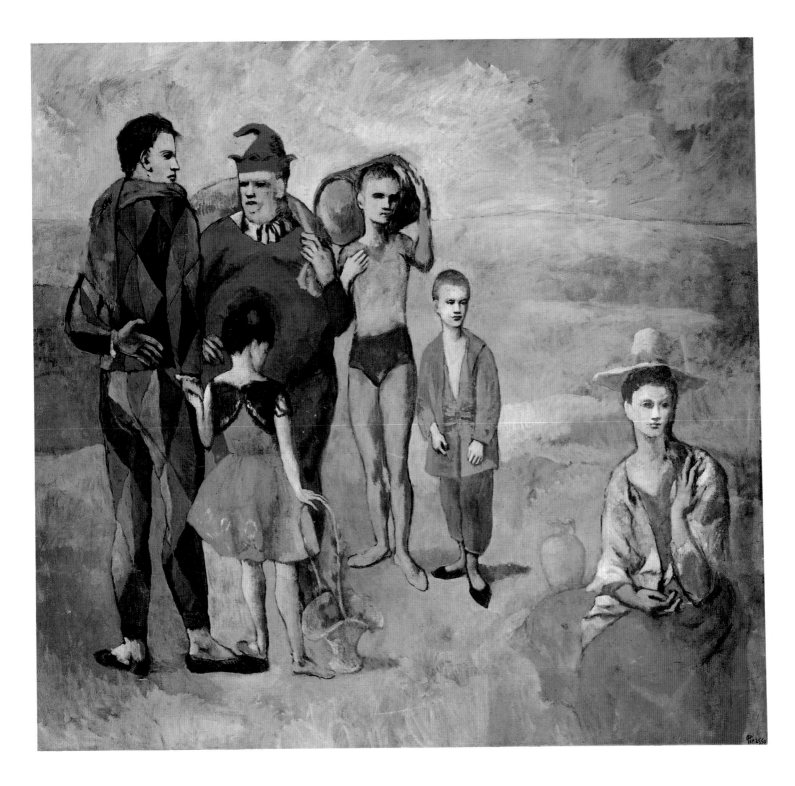

The Acrobats, 1905
La Famille de saltimbanques (Les Bateleurs)
Oil on canvas, 212.8 x 229.6 cm
Washington (DC), National Gallery of Art,
Chester Dale Collection

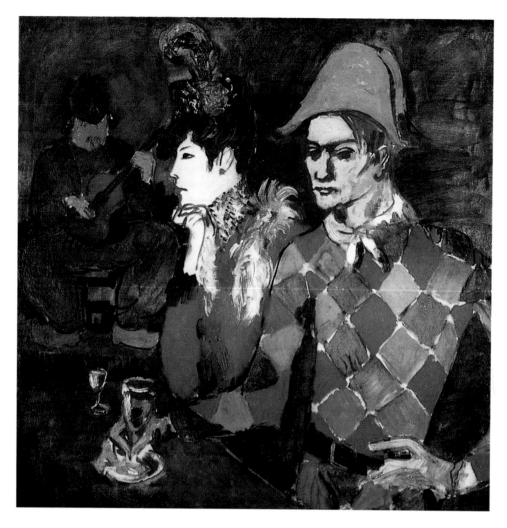

Even so, the Rose Period pictures are not merely records of a pleasant time in the artist's life. Nor are they straight representations of everyday reality. *At the "Lapin agile"* (p. 50) is a variation on an approach he had already used in his Blue Period for works such as *The Absinthe Drinker* (p. 33), with people gazing listlessly into vacancy, their bearing expressive of wearied lack of contact. The harlequin costume suggests that it is all a masquerade set up by an intellectual process. His *Woman with a Crow* (p. 45) is not so much a portrait as a type study, stylized beyond individuality. The harlequins, street entertainers and other artistes of the Rose Period all enact the process of grasping the role of the artist. They were the product of complex reflection inspired not least by Picasso's relations with the literary world in Paris; he was now a regular at the "Closerie des Lilas", a Montparnasse café where the Parisian literary bohemia liked to meet. Under poet Paul Fort they met on Tuesdays for discussions, which were of particular interest to up-and-coming artists.

Picasso's friend Guillaume Apollinaire was a prominent member of this group. His consistent aesthetic radicalism strengthened Picasso's position. The poet repeatedly drew the public's attention to the Spaniard's work and so played an important part in Picasso's early recognition. And one of Apollinaire's interests was directly related to Picasso's work: he liked to collect and edit erotica and pornographic literature. Apollinaire and Picasso shared this taste to an extent. Picasso's early work often included erotic or downright pornographic scenes (pp. 36 and 37). In old age he returned to these themes, though not till then. It is not so much a reflection of Picasso's own

life in a promiscuous milieu (though it is that too) as an extension of basically political convictions. Taboos set up by mindless social convention are breached by the freedom of art.

Anarchist ideas prompted the rejection of traditional social structures and put unbridled individualism in their place. This individualism was expressed in a stylized role as outsider and artist. The Blue and Rose Period pictures of beggars, isolated people, harlequins, artistes and actors were a way of keeping "official" artistic values at arm's length, both thematically and formally. The choice of an artistic milieu for the Rose Period works was a deliberate rejection of conventional subject matter. Moreover, the fool or clown traditionally has a licence to utter the unvarnished truth and so hold up a mirror to the mighty. During the Enlightenment the fool's fortunes were at their nadir; but, as the age of the middle classes took a firmer grip, the harlequin, pierrot or clown acquired a new and higher value. In France in particular he was seen as the epitome of the rootless proletarian, the People in person. After the 1848 revolutions, the new symbolic figure of the sad clown became familiar.

Just as in the Blue Period a number of sketches, studies and paintings culminated in a major work, *La Vie* (p. 39), so too the harlequin phase produced the huge canvas *The Acrobats* (p. 49). It was Picasso's definitive statement on the artistic life. And, tellingly, it was another artist, the Austrian poet

***Two Acrobats with a Dog**, 1905*
Deux Saltimbanques avec un chien
Gouache on cardboard, 105.5 x 75 cm
New York, The Museum of Modern Art

***Acrobat and Young Equilibrist**, 1905*
Acrobate à la boule (Fillette à la boule)
Oil on canvas, 147 x 95 cm
Moscow, Pushkin Museum

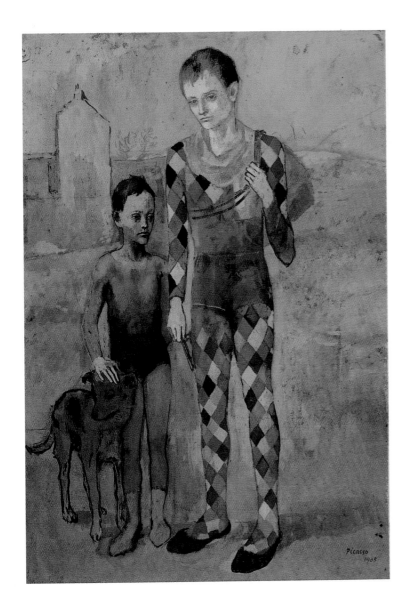

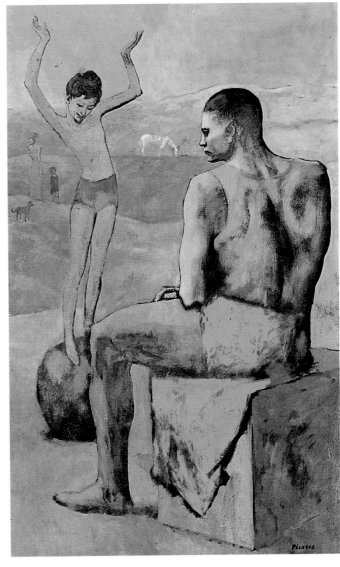

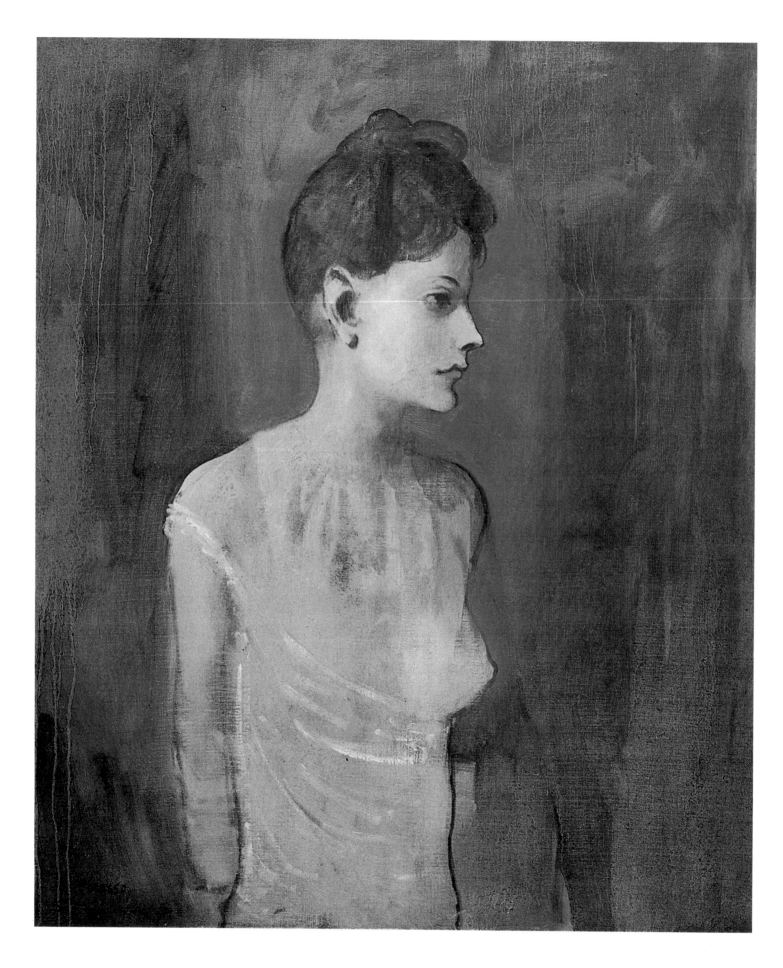

Woman Wearing a Chemise, 1905
Femme à la chemise
Oil on canvas, 73 x 59.5 cm
London, Tate Gallery

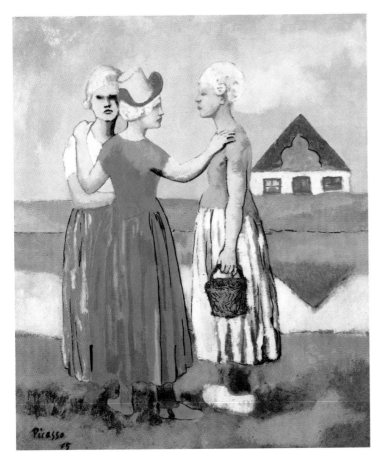

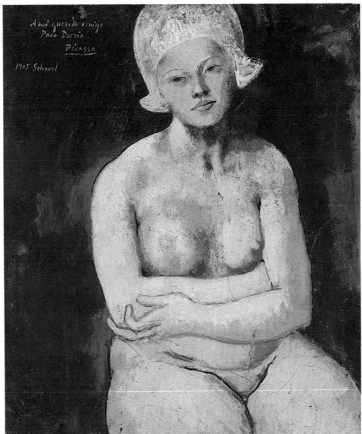

Rainer Maria Rilke (who in 1916 spent some months in the home of the then owner of the painting), who found the aptest words to convey an impression of the work, in the fifth of his *Duino Elegies*: "But tell me, who are they, these wanderers, even more / transient than we ourselves…"

X-ray examination has shown that the final picture was the fruit of long, painstaking labours, of frequent new starts and changes. It was begun at the start of the Rose Period in 1904. That composition, later painted over, was like a study now in the Baltimore Museum of Art (p. 48). All of the characters, even specific gestures and poses, appear in other Rose Period pictures, most famously *Acrobat and Young Equilibrist* (p. 51). But Picasso was dissatisfied with the result, turned the canvas round, and painted over it. Through a set of preliminary studies he hit on a strategy that combined all three of the approaches he had been toying with, as we can see from a gouache now in the Pushkin Museum in Moscow (p. 48). Four male acrobats, standing, now provide the focus – among them Tio Pepe and, from the first version, the young girl. In due course Picasso painted over the canvas for a fourth time, at long last arriving at the version we now have. He put the man on the left in harlequin costume, replaced the boy's dog with a flower basket for the girl, and dressed the boy in a blue and red suit rather than a leotard. At bottom right he added a young seated woman. She too derived from a previously used motif (cf. p. 58). In other words, much as *The Acrobats* (p. 49) may make a unified impression, as if it had been achieved in one go, it in fact constitutes a synthesis of the motifs Picasso liked to paint during his Rose Period.

There are now six people; the background is not exactly defined. There are two blocks: the left-hand group, accounting for some two-thirds of the picture's breadth, consists of five people, while at right the young woman is

Three Dutch Girls, 1905
Les Trois Hollandaises
Gouache and India ink on paper on cardboard, 77 x 67 cm
Paris, Musée National d'Art Moderne, Centre Georges Pompidou

Dutch Girl (La Belle Hollandaise), 1905
Hollandaise à la coiffe (La Belle Hollandaise)
Oil, gouache and blue chalk on cardboard on panel, 77 x 66 cm
Brisbane, Queensland Art Gallery

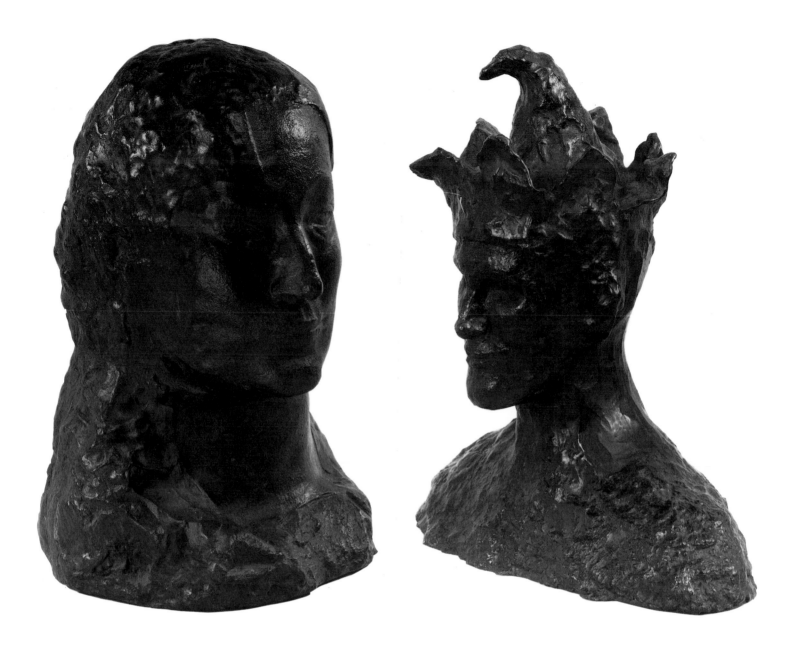

Head of a Woman (Fernande), 1906
Tête de femme (Fernande)
Bronze, 35 x 24 x 25 cm
Paris, Musée Picasso

The Jester, 1905
Le Fou
Bronze (after a wax original),
41.5 x 37 x 22.8 cm
Paris, Musée Picasso

The Toilette, 1906
La Toilette
Oil on canvas, 151 x 99 cm
Buffalo (NY), Albright-Knox Art Gallery

sitting on her own. The contrast is heightened by subtle compositional means. The positioning of three of the figures at left very close together conveys a sense of weight and unity, and the Mallorcan woman at right scarcely provides an effective counterbalance.

Picasso's palette consists basically of the three primary colours, plus shadings in black and white to enrich the detail. The reds and blues are graded in different degrees of brightness, but yellow only appears mixed with blues and browns, in unrestful presences that lack much formal definition. Thus various degrees of sandy yellow account for the unreal, spatially undefinable landscape. The other colours are caught up in similar spatial vagaries; depending on how bright or aggressive or foregrounded they are, they are coupled with darker, heavier shades that fade into the background. Only at first glance does this make an evenly balanced impression. As soon as we look more closely, things start to perplex us.

Take Tio Pepe, for instance, in whom Picasso's strategy of contrastive destabilization is most assertively seen. The massive red-clad man is conspicuous – and conspicuously lacks the lower half of his right leg! A defect in a figure of such thematic and formal importance serves to destabilize the entire compositional logic, and, once alerted, we see that it is unreal through

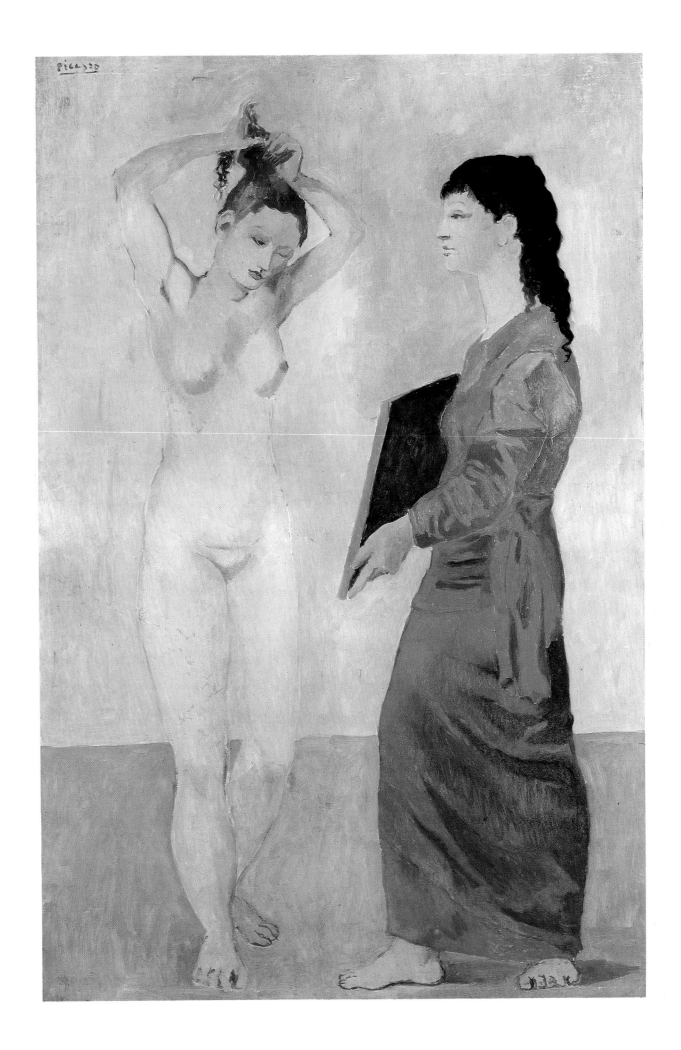

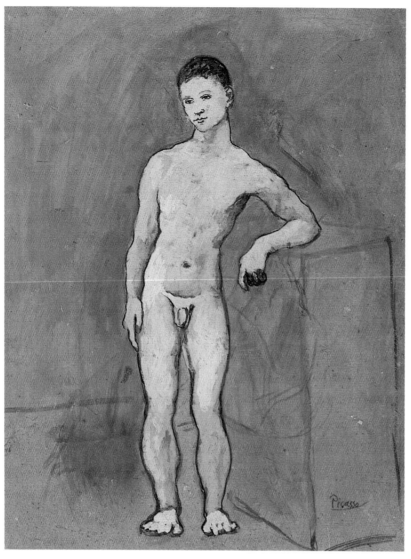

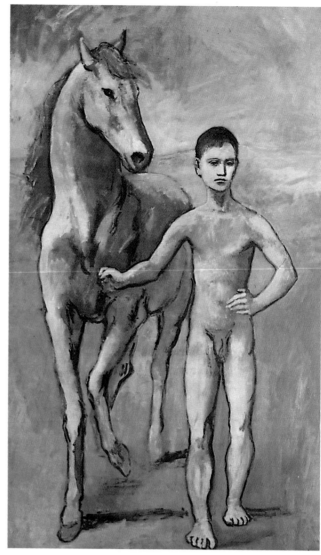

Naked Youth, 1906
Garçon nu
Tempera on cardboard, 67.5 x 52 cm
St. Petersburg, Hermitage

Boy Leading a Horse, 1906
Meneur de cheval nu
Oil on canvas, 220.3 x 130.6 cm
New York, The Museum of Modern Art

The Two Brothers, 1906
Les Deux Frères
Gouache on cardboard, 80 x 59 cm
Paris, Musée Picasso

Spanish Woman from Majorca, 1905
(Study for *The Acrobats*)
Espagnole de l'île de Majorque
Gouache and watercolour on cardboard,
67 x 51 cm
Moscow, Pushkin Museum

and through. The picture lacks a single point of view: the figures are spatially placed in a curiously all-round way, as if each zone of the picture were subject to its own perspective. Picasso is in fact once again telling us that artistic viewpoints are relative. And he is doing it in a narrative mode that would well suit a historical picture. His de-clarified world is precisely the one these melancholy, uncommunicative characters would inhabit. And Picasso's departure from the laws of Nature is apt since it matches the manner in which acrobats earn their living by defying the law of gravity. The harlequin theme offered not only a visual means of approaching the life of the artist but also a pretext to review formal fundamentals.

The tendency to experiment formally grew upon Picasso throughout the Rose Period. In summer 1905, at the invitation of writer Tom Schilperoort, he made a journey. The writer had inherited some money, and asked Picasso to join him on the homeward trip to Holland. For Picasso it was an encounter with an entirely new landscape and way of life. The few drawings and paintings he did on the trip were markedly different from the acrobat pictures. They drew on classical sources and ancient forms. *Three Dutch Girls* (p. 53) was the most important fruit of his journey. It readily betrays its model: even if the young women are wearing Dutch national costume, they are still grouped as the *Three Graces* traditionally were. Picasso was casting about for new bearings. In numerous new studies and paintings, the colourful palette of the acrobat pictures was replaced by a monochrome red. Not only the male nudes in other paintings but even portraits done at the time make a three-dimensional impression, abstracted and simplified, like sculptures transferred to canvas. At this time Pablo Picasso began to give greater attention to other media such as printed graphics or sculpture.

He had made an early attempt at sculpture in 1902, and *The Frugal Repast* (p. 42) in 1904 had shown him a master etcher at a date when he had only recently been taught the technique by the Spanish painter Ricardo Canals. Just as printed graphics had helped the pictures of acrobats on their way, so too three-dimensional work in wax or clay (cf. p. 54) informed the formal vocabulary of the pictures that concluded the Rose Period. Picasso was developing in a new direction again.

Boy with a Dog, 1905
Garçon au chien
Gouache and pastel on cardboard,
57.2 x 41.2 cm
St. Petersburg, Hermitage

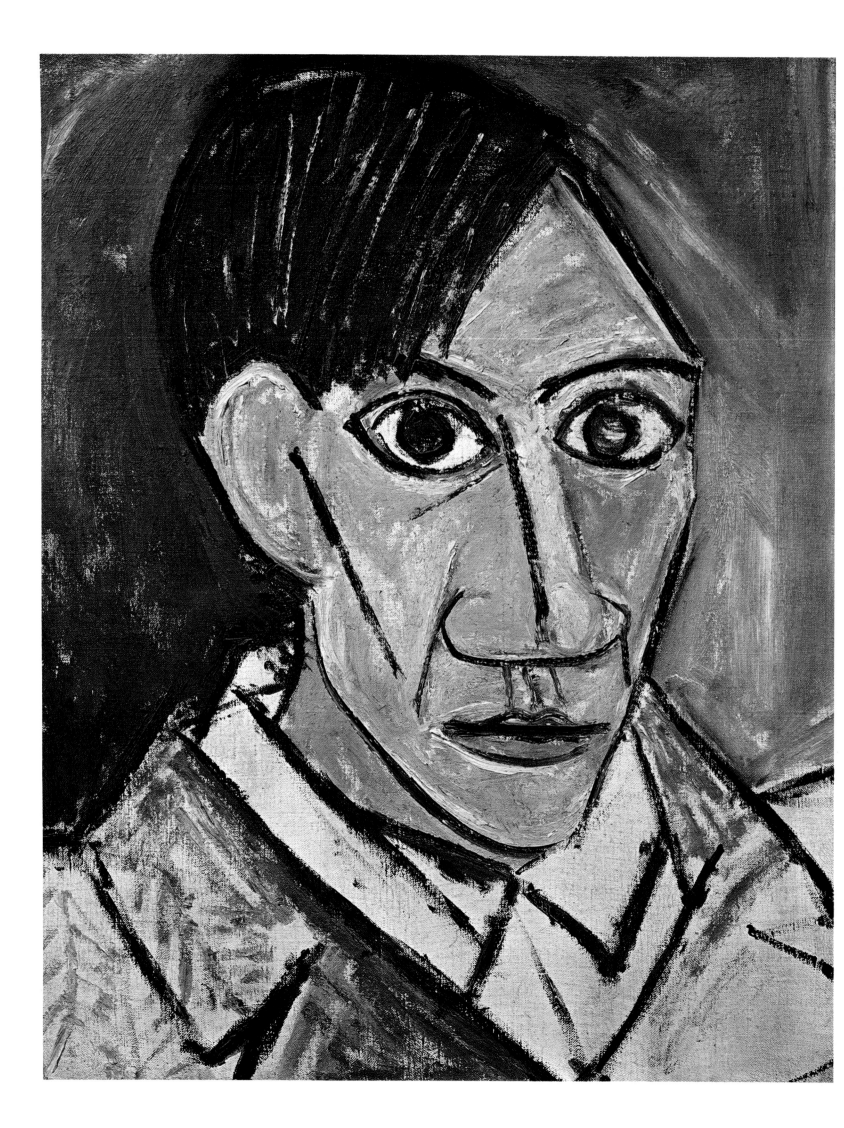

4 Cubism 1906–1915

From the winter of 1905 on, Picasso did nothing but experiment. Increasingly he was seeing the human form in terms of its plastic volume. He simplified it, stripped it down to essentials, to a very few blocks, stylizing it into something that was less and less naturalistic. Any infringement of natural proportion he accepted with a shrug, even accentuating it in order to highlight the independence of art. Picasso deliberately abandoned professional technique, and placed his outlines and areas of colour rawly and inchoately before us, making no attempt to flesh out an appearance of a living person. There were no illusions in these lines and this paint. They were simply there on the canvas to do the job of establishing a form.

Picasso pursued this path in a lengthy series of studies. In summer 1907 they culminated (at least for the time being) in the famous *Demoiselles d'Avignon* (p.67). It has long been recognised as a key work in modern art. It took Picasso a full three-quarters of a year to complete it. And the intensity of his labour can be proven by statistics: no fewer than 809 preliminary studies! Not only scrawls in sketchbooks but also large-scale drawings and even one or two paintings. This degree of preparatory toil is unparalleled in the history of art. Thanks to this material, we can follow Picasso's method clearly enough. There were two strands of evolution, one formal, one thematic. In Picasso's mind they were distinct, as we can see from the fact that most of the sketches only ever tackle one formal or one thematic problem. At irregular intervals he would then sketch combinations of distinct lines of development; they record solutions to problems; the yokings become ever more radical till at last the goal is in sight. The final stage involves work at the canvas itself.

As we can now see, in most of the individual sketches Picasso was striving for clear insight into the nature of artistic mimesis. The value of the endeavour lay in recognising the twin poles of mimesis: on the one hand the ideal coincidence of object and representation, and on the other hand the complete absence of any representational value. Every mimetic drawing contains elements of both extremes. Picasso's conclusion, like all things of genius, was in essence very simple, but it has been of revolutionary importance for 20th-century art: the mimetic image is a compound of elements that do not intrinsically belong together. Their yoking is dictated by chance. So it must be possible to mix them quite differently and thus create forms that can still, it is true, be understood as representational in some sense, but which are pure art rather than a mimetic imitation of Nature.

The images we have of things already constitute an abstraction; so it takes little to draw a generalized representation of an object. In sketches done dur-

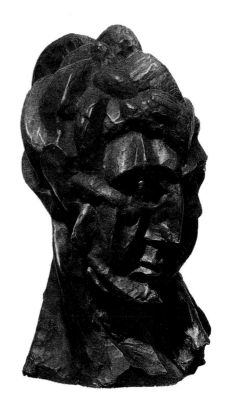

Head of a Woman (Fernande), 1909
Tête de femme (Fernande)
Bronze, 40.5 x 23 x 26 cm
Paris, Musée Picasso

Self-portrait, 1907
Autoportrait
Oil on canvas, 50 x 46 cm
Prague, Národni Galeri

61

Two Nudes, 1906
Deux Femmes nues
Oil on canvas, 151.3 x 93 cm
New York, The Museum of Modern Art

Two Nude Women Arm in Arm, 1906
Deux Femmes nues se tenant
Oil on canvas, 151 x 100 cm
Switzerland, Private collection

Seated Nude with Crossed Legs, 1906
Femme nue assise, les jambes croisées
Oil on canvas, 151 x 100 cm
Prague, Národni Galeri

ing the winter of 1906, the method Picasso used to draw a face was a simple, indeed conventional one. Two irregular lines indicated the breadth and shape of a nose, and parallel hatched lines on one side conveyed its size by means of shadow. The same procedure was then applied to other parts of the face (p.65). Now all that was required was to stylize all the principal and secondary lines, in a mechanistic fashion, and a far more artificial impression would be conveyed.

In May and June of 1907 he resumed this quest, to see how relatively minor alterations could change a faithful copy of Nature into something remote from it. He drew the bridge of the nose in strictly parallel lines, which devolved the hatched areas into a graphic autonomy. Then he angled the elliptical eyes and constructed a head out of unnatural straight lines and arcs. Picasso also used this same method of free combination of formal fundamentals in his use of colour in his oil studies. In the process, he travelled a great distance along the road of combining the colourist's and the draughtsman's evolutionary techniques (pp. 64 and 65).

The final oil version of *Les Demoiselles d'Avignon* (p.67) brought together the results of Picasso's experimentation in such a way that we can trace the entire spectrum of his options from the central figures out to the

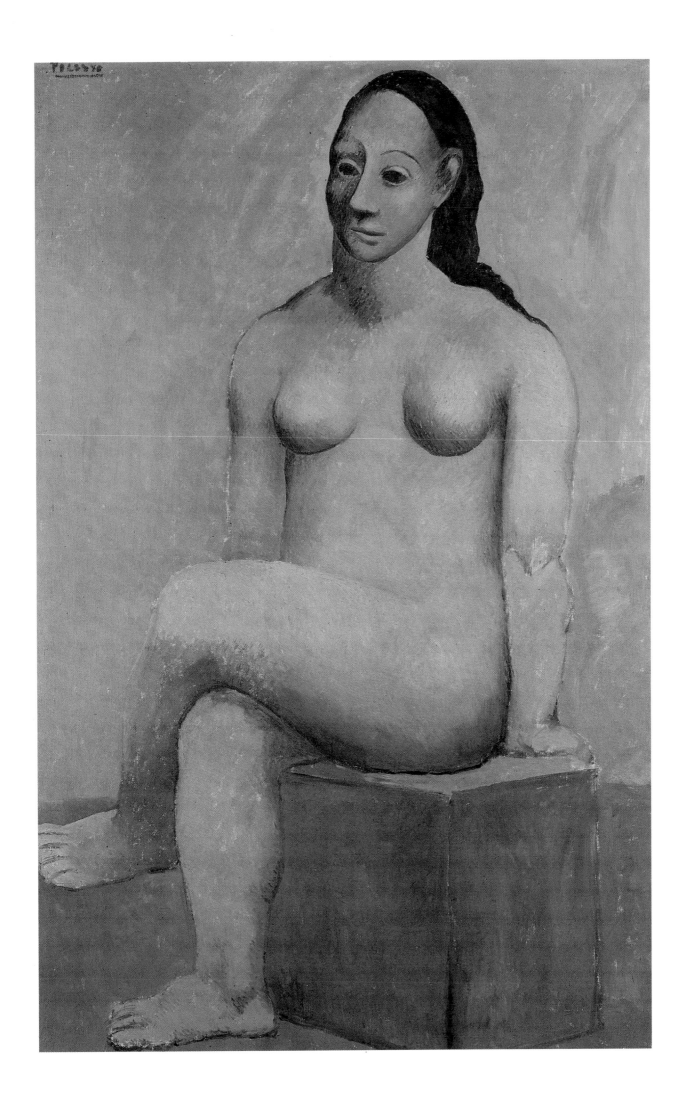

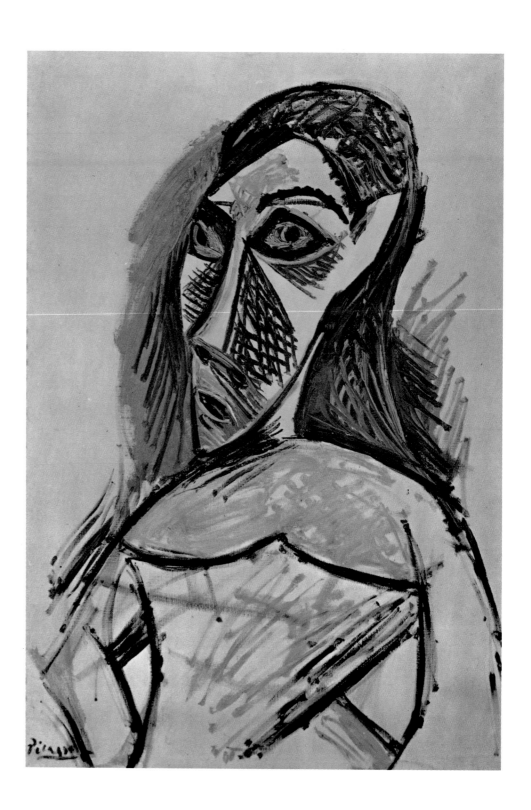

sides. It is the programmatic statement of a new formal vocabulary, created from the systematic scrutiny of conventional representational approaches and the development of a new synthesis out of them. The colour scheme is a synthesis of the monochromatic and the contrastive. The figures are painted in colours ranging from whitish yellow to brown, as are areas of the background; this contrasts with the blue that divides the right group from the left. Compositionally, the placing of the subjects breaches conventional ideas of clarity and order. We can identify three zones, increasing in size from left to right: first the woman at far left, then the two frontally positioned women against the whitish-grey background, and then, seemingly split off by a harsh colour contrast, the two at the right. But this irregular tripartite scheme is at odds with a more orderly spatial division marked by the still life at the

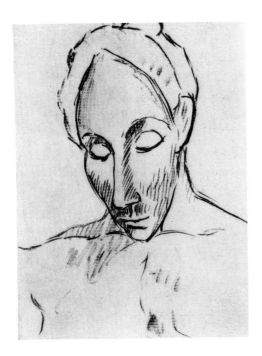

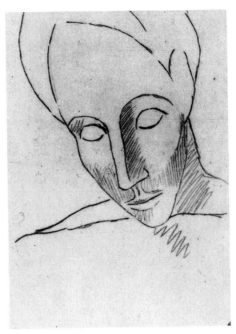

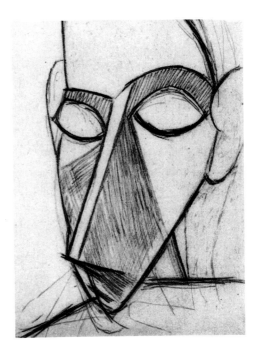

Head of a Woman, 1906
Study for *Les Demoiselles d'Avignon*
Tête de femme
Pencil on paper, 31 x 24 cm
Private collection

Head of a Woman, 1906
Study for *Les Demoiselles d'Avignon*
Tête de femme
Pencil on paper, 32 x 24 cm
Estate of the artist

Head of a Woman, 1906
Study for *Les Demoiselles d'Avignon*
Tête de femme
Pencil on paper, 14.7 x 10.6 cm
Paris, Musée Picasso

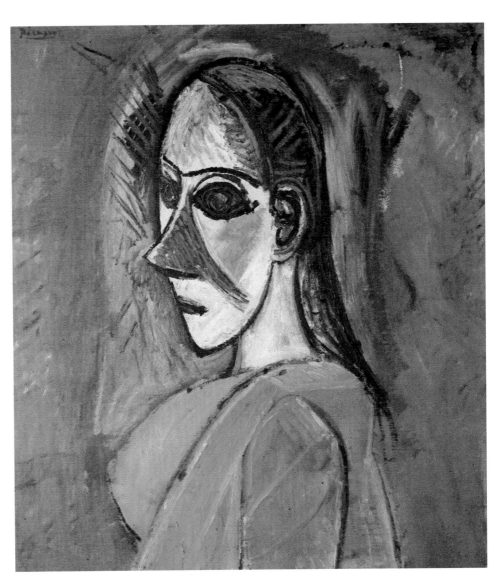

Bust of a Woman, 1907
Study for *Les Demoiselles d'Avignon*
Buste de femme
Oil on canvas, 65 x 58 cm
Paris, Musée National d'Art Moderne,
Centre Georges Pompidou

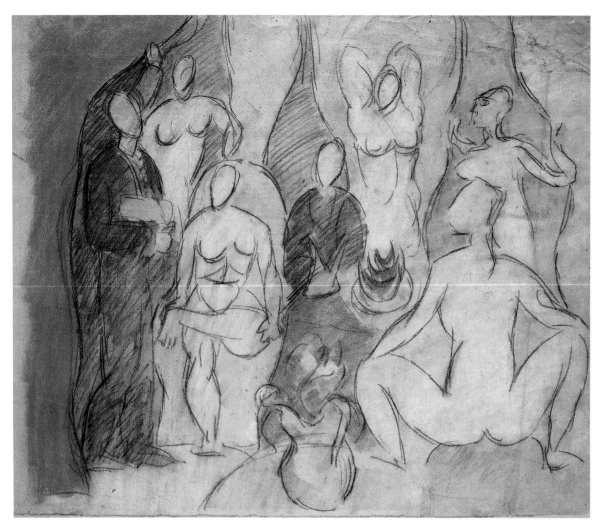

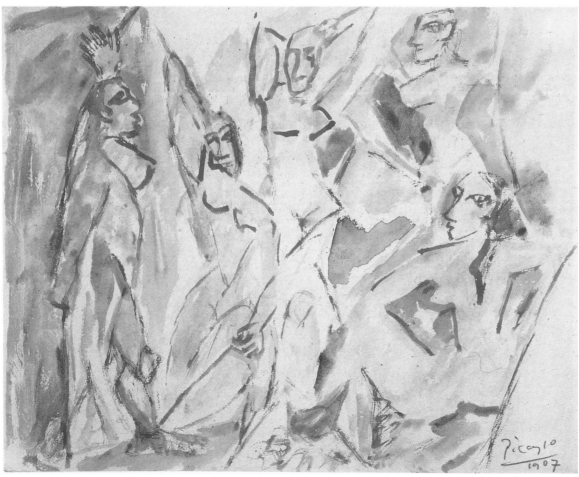

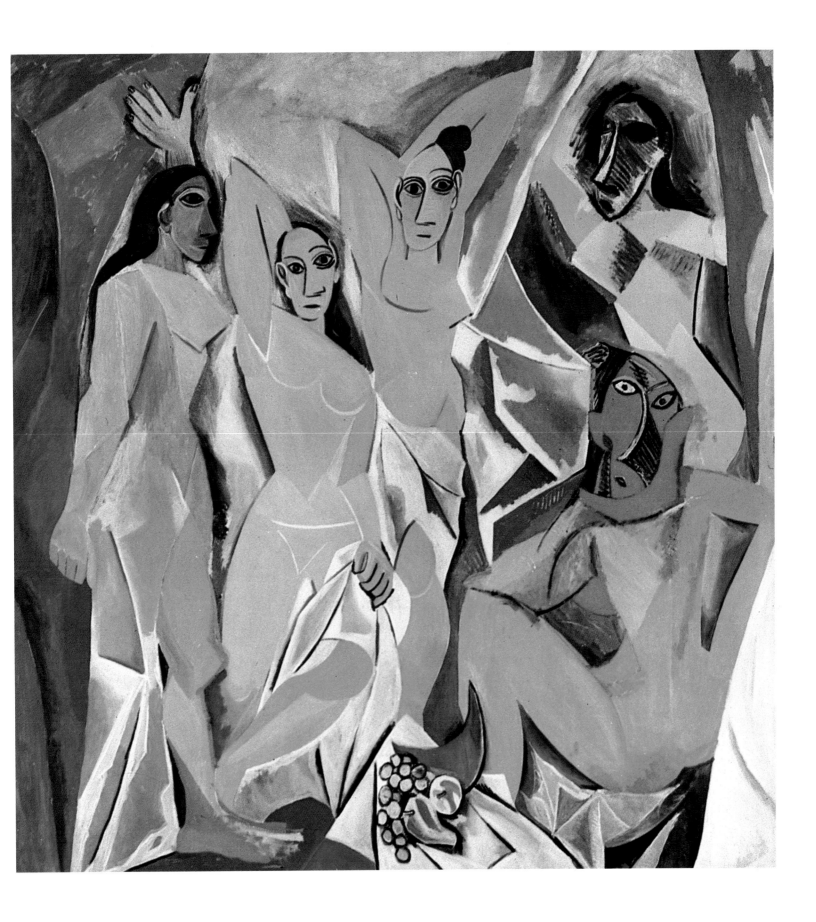

PAGE 66 TOP:
Study for "Les Demoiselles d'Avignon", 1907
Etude pour "Les Demoiselles d'Avignon"
Pencil and paste! on paper, 47.7 x 63.5 cm
(sheet size)
Basel, Öffentliche Kunstsammlung Basel,
Kupferstichkabinett

PAGE 66 BOTTOM:
Study for "Les Demoiselles d'Avignon", 1907
Etude pour "Les Demoiselles d'Avignon"
Watercolour on paper, 17.5 x 22.5 cm
Philadelphia (PA), Philadelphia Museum
of Art

Les Demoiselles d'Avignon, 1907
Oil on canvas, 243.9 x 233.7 cm
New York, The Museum of Modern Art

foot of the canvas: the table, seen as a triangular shape pointing upwards, coincides precisely with the centre axis. Logically, that axis is occupied by the middle one of the five women.

We also need to register the different ways of presentation within individual figures and objects. The bodies are seen at once from the front and the side, in a way not naturally possible. Lines, hatchings and blocks of colour are used to make random changes and de-formations in parts of the women's bodies, and Picasso's over-layering makes for entire areas of abstraction. Even so, Picasso has not completely abandoned mimetic representation. The lines and colours still plainly show naked women in various positions. It is because this is still apparent that the deviations from a conventional aes-

Three Women, 1907/08
Trois Femmes
Oil on canvas, 200 x 178 cm
St. Petersburg, Hermitage

thetic shock us. And the shock was only heightened, for Picasso's contemporaries, by the ostentatious and provocative nakedness of the women.

Les Demoiselles d'Avignon is a meticulously considered, scrupulously calculated visual experience without equal. The formal idiom and utterly new style were by no means a mere relinquishing of prevailing norms in the visual arts but rather a subtly elaborated marriage of relinquishing and preservation. The same is true of the subject matter. The first complete compositional plan, done in March 1907 (p. 66), showed a brothel in Barcelona's Carrer

Woman with Pears (Fernande), 1909
Femme aux poires (Fernande)
Oil on canvas, 92 x 73 cm
New York, Private collection

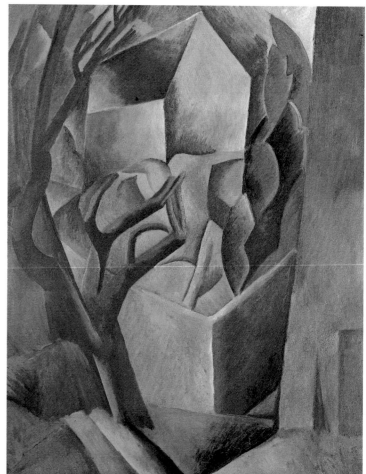
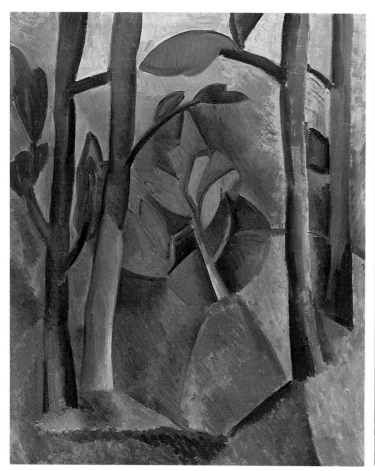
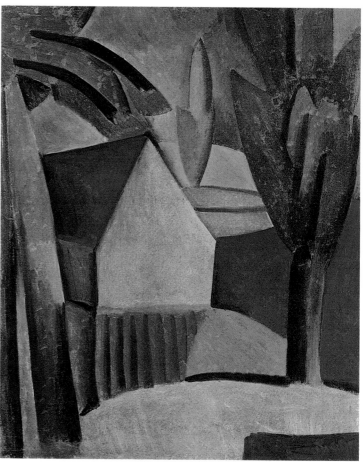

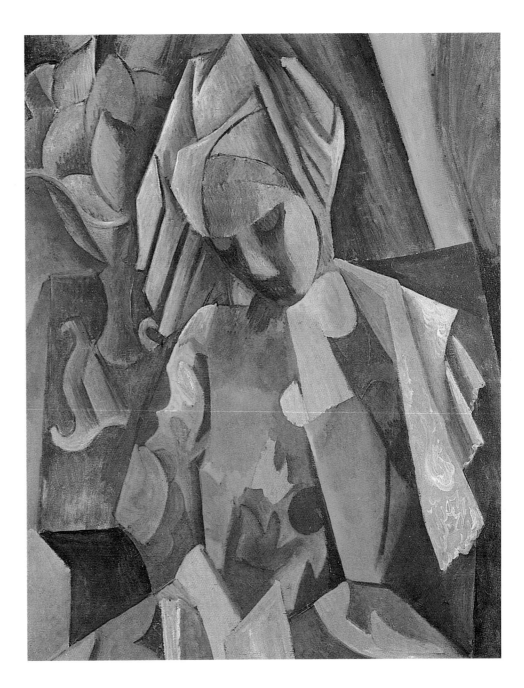

d'Avinyó, according to Picasso himself: in other words, it had nothing in particular to do with the French town of Avignon. It was not till 1916 that the writer André Salmon put about the innocuous and simply wrong title by which the picture is now known. After he did the Basle drawing he changed the composition fundamentally, dropping everything that could unambiguously suggest a brothel interior. What is more, by citing the Venus de Milo in the two frontal figures, he also parodied the aesthetic canon of many eras. Picasso re-conceived the entirety of the European art tradition from the roots up, and used its constituents to create a new visual language. This painting, more than any other work of European Modernism, is a wholly achieved analysis of the art of painting and of the nature of beauty in art.

Picasso marked the end of a historical process that had begun in the mid-18th century. The absolute aesthetic impact of painting and the autonomous status of draughtsmanship and colour were established. This was a fundamental change. Where once content and form, message and image had needed to harmonize, now form became dominant, and indeed became the content. If ways of seeing, conceptualization, and cognition were to be con-

Study for "Carnival at the Bistro", 1908/09
Etude pour "Carnaval au bistrot"
Gouache on paper, 32 x 49.5 cm
Estate of the artist

Study for "Carnival at the Bistro", 1908/09
Etude pour "Carnaval au bistrot"
Pencil on paper, 31.3 x 23.8 cm
Paris, Musée Picasso

Study for "Carnival at the Bistro", 1908/09
Etude pour "Carnaval au bistrot"
Watercolour and pencil on paper,
24.2 x 27.5 cm
Estate of the artist

Loaves and Bowl of Fruit on a Table,
1908/09
Pains et compotier aux fruits sur une table
Oil on canvas, 164 x 132.5 cm
Basel, Öffentliche Kunstsammlung Basel,
Kunstmuseum

sidered inseparable, then the cognitive content of painting must logically enough be purely a matter of how the observer looked at it. Inevitably, once this view gained ground, painting would tend to lose its mimetic character and become detached from the things which it claimed to represent. French 19th-century art and the art of post-Romantic northern Europe underwent a parallel move towards greater abstraction, and greater autonomy of image. That evolution peaked in Picasso's *Demoiselles d'Avignon*.

And this marked the arrival of Cubism, slowly but surely: the first major peak that it reached is generally known as Analytical Cubism. Picasso's famous portrait of art dealer Ambroise Vollard is an arresting example (p. 77). It fulfils the main requirements of a portrait: it represents the outer appearance of a certain individual in a recognisable way. But the artist is also displaying his skill at playing with the natural image. The lines are continued at random, no longer restricted to defining an available form. They have a life of their own. So do the colours: lighter and darker shades, with little regard for the subject, obey the curious rules of the composition instead. The subject is dissected, as it were, or analyzed. And hence this kind of Cubism has become known as Analytical Cubism.

Though the laws of the random afford common ground, the portrait of Vollard remains a distinctly different work from *Les Demoiselles d'Avignon*. In the 1907 painting the aim was closed form; in the 1910 work it is open figuration. The dissolution of the subject establishes a kind of grid in which overlaps and correspondences can constantly be read anew. The essential characteristics of the subject are preserved purely because Picasso is out to demonstrate that the autonomy of line and colour is on a par with straightforward representation, and just as convincing aesthetically. His new approach put an end to the traditional scheme of foreground, middleground and background, and the demarcation of subject and setting, which were still present in the *Demoiselles*. Between the two extremes lay a three-year transitional period. It began in 1908 and can be seen as the phase in which Cubism was established.

In midsummer 1908 Picasso made a breakthrough with his landscapes. *House in a Garden (House and Trees)* and the simply-titled *Landscape*

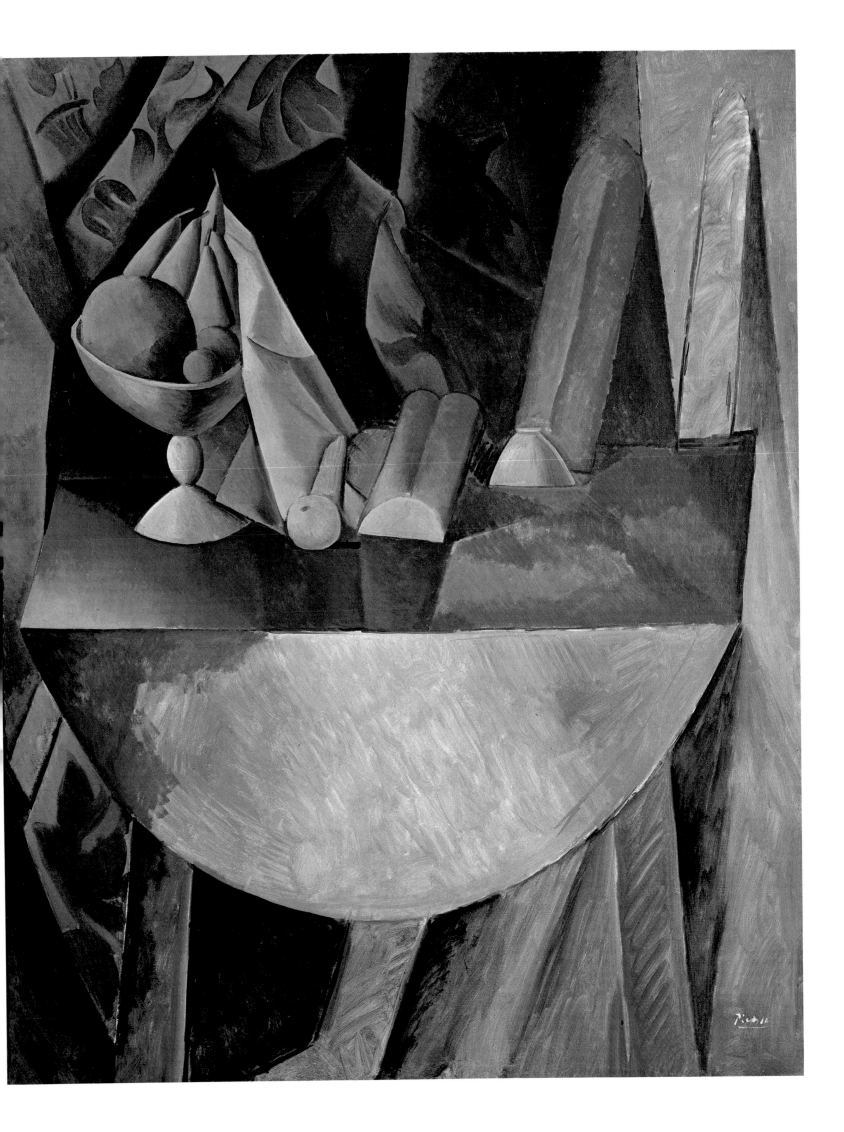

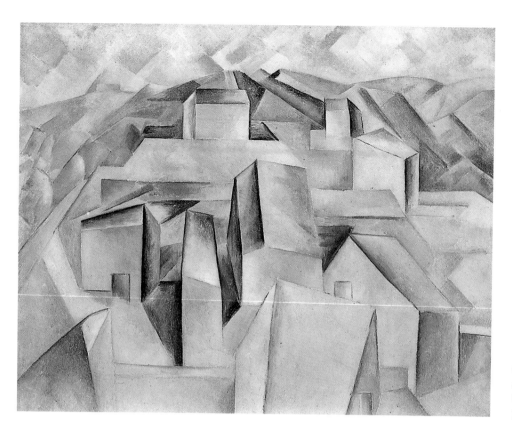

Houses on the Hill (Horta de Ebro), 1909
Maisons sur la colline
Oil on canvas, 65 x 81 cm
New York, The Museum of Modern Art

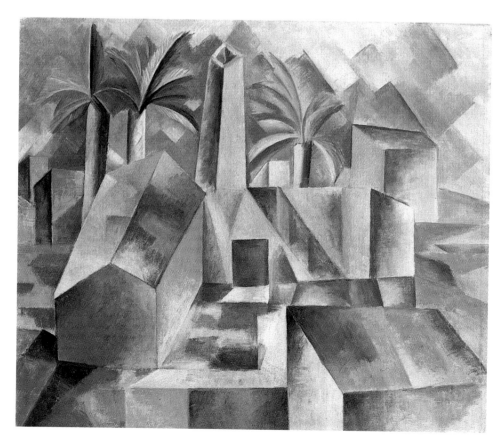

Brick Factory in Tortosa (Factory at Horta de Ebro), 1909
Briqueterie à Tortosa (L'Usine)
Oil on canvas, 50.7 x 60.2 cm
St. Petersburg, Hermitage

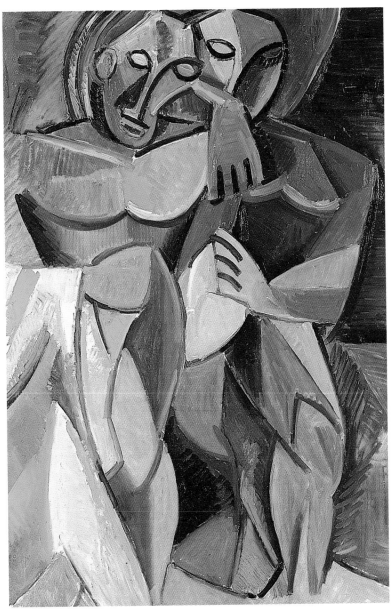

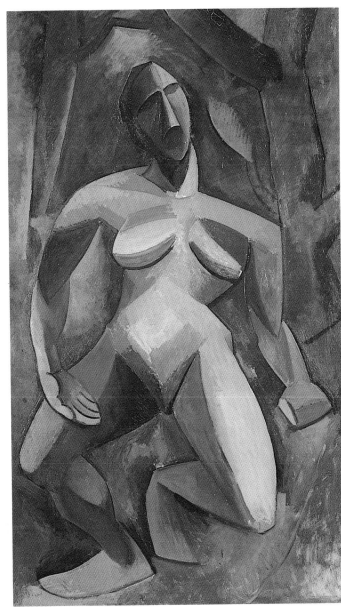

Friendship, 1907/08
L'Amitié
Oil on canvas, 152 x 101 cm
St. Petersburg, Hermitage

The Dryad (Nude in a Forest), 1908
La Dryade (Nu dans une forêt)
Oil on canvas, 185 x 108 cm
St. Petersburg, Hermitage

(p. 70) take the principle of autonomous spatial values and evolve forms that make a stereometrically stylized impression. At the same time, the young French painter Georges Braque had arrived at a similar position in paintings of the landscape near L'Estaque. At first glance, the motifs look like cubes – which is why the term Cubism was coined in the first place. In autumn 1908, Braque unsuccessfully submitted his new work for the Paris autumn Salon. Henri Matisse, who was a member of the jury, observed to the critic Louis Vauxcelles that the pictures consisted of lots of little cubes. Vauxcelles adopted the phrase in a review he wrote in the magazine *Gil Blas* when Braque showed the paintings at the Kahnweiler gallery in November. And thus (as is so often the case) a misunderstanding produced a label; and by 1911 everyone was using the term Cubism.

In the winter of 1908, following Braque's exhibition, Picasso and Braque developed a give-and-take that often verged on collaboration. Both artists – and this is unique in the history of art – were developing a new style together. It was emphatically a mutual process: both artists have the same standing in the history of Cubism. The painstaking Braque, a slow worker, painted extraordinarily subtle works incomparable in their aesthetic effect.

By contrast, Picasso was more restless and abrupt, jumping to and fro amongst various formal options. Both were experimenting in their own way, and both, independently, hit upon significant innovations. For Picasso, drawing and the investigation of form were always the focus of his interest.

One of the finest and most instructive of his games played with form is the still life *Loaves and Bowl of Fruit on a Table* (p.73), painted in winter 1908/09, showing a drop-leaf table with loaves of bread, a cloth, a bowl of fruit and a lemon on it. The informing principle is not one of Cubist transformation, though, so much as a genuine metamorphosis – for the picture began by showing not objects in a still life but carnival merry-makers in a bistro! Picasso pursued his idea through a number of studies (p.72).

It is characteristic of Picasso (and a contrast to Braque) that he never saw Cubism purely in terms of painting. He tackled spatial values and planes in various media, using various motifs. As in 1906, he explored questions of volume in sculpture, to see if they too had autonomous values. In preparing the near-lifesize *Head of a Woman (Fernande)*, a portrait of Fernande Olivier (p.61), Picasso made his experiment using plaster; a small edition was later cast in bronze for Vollard. In this sculpture, three-dimensional volume appears to be made of particles roughly equal in size. The ruling structural principle is an equilibrium of volume and emptiness. The most important points – the eye sockets, nose, lips – are done in accordance with their natural appearance. But in the forehead, cheeks and neck the natural lie of the features has been inverted – most noticeably in the neck and nape – so that a new rhythmic sense arises that introduces dynamics to the work. In the paintings, this analytic deconstruction of form inevitably led to the presence of non-representational elements.

In 1910, Picasso and Braque took their strategy to the borders of pure abstraction, producing paintings of great artistic charm which clearly demonstrate that beauty in art need not be pinned down to illusionist representation. Cubism now entered a somewhat different phase, one that was heralded in 1911 and led the following year to new visual forms different in structure and principle. Braque, who had already used single letters of the alphabet in Cubist paintings of 1909, now took to using entire words.

Another innovation also originated with Braque. As a youngster he had been an apprentice house painter, and was familiar with a number of trade techniques, such as the "comb" – a template for mechanically establishing a whole area of parallel lines. Braque used it to imitate the graining of wood, and achieved a higher level of illusionism, conveying not only the appearance but also the material consistency of an object – a technical trick dazzlingly and absurdly used. Picasso borrowed the method for a number of still lifes, sometimes in combination with letters. Cubism had changed considerably. A "simple" deconstruction of the mimetic, representational function of a picture had become an art which used the picture, itself a system of signs, to prove the random contingency of signs.

To understand how radical an innovation Synthetic Cubism in fact was, we need only consider the work of other artists at the time. In 1911 and 1912, there were two major exhibitions by a group of artists who called themselves Cubists. This group was led by Albert Gleizes and Jean Metzinger and among the most important members were Fernand Léger and Robert Delaunay. The pictures they exhibited, however, were merely pleasing variants of Braque's idiom of 1908; and their true point of reference was Cézanne, not the revolutionary work of Picasso and Braque. Though they

***Man with a Moustache and a Clarinet**, 1911*
Homme moustachu à la clarinette
Ink, India ink and black chalk, 30.8 x 19.5 cm
Paris, Musée Picasso

***Portrait of Ambroise Vollard**, 1910*
Portrait d'Ambroise Vollard
Oil on canvas, 93 x 66 cm
Moscow, Pushkin Museum

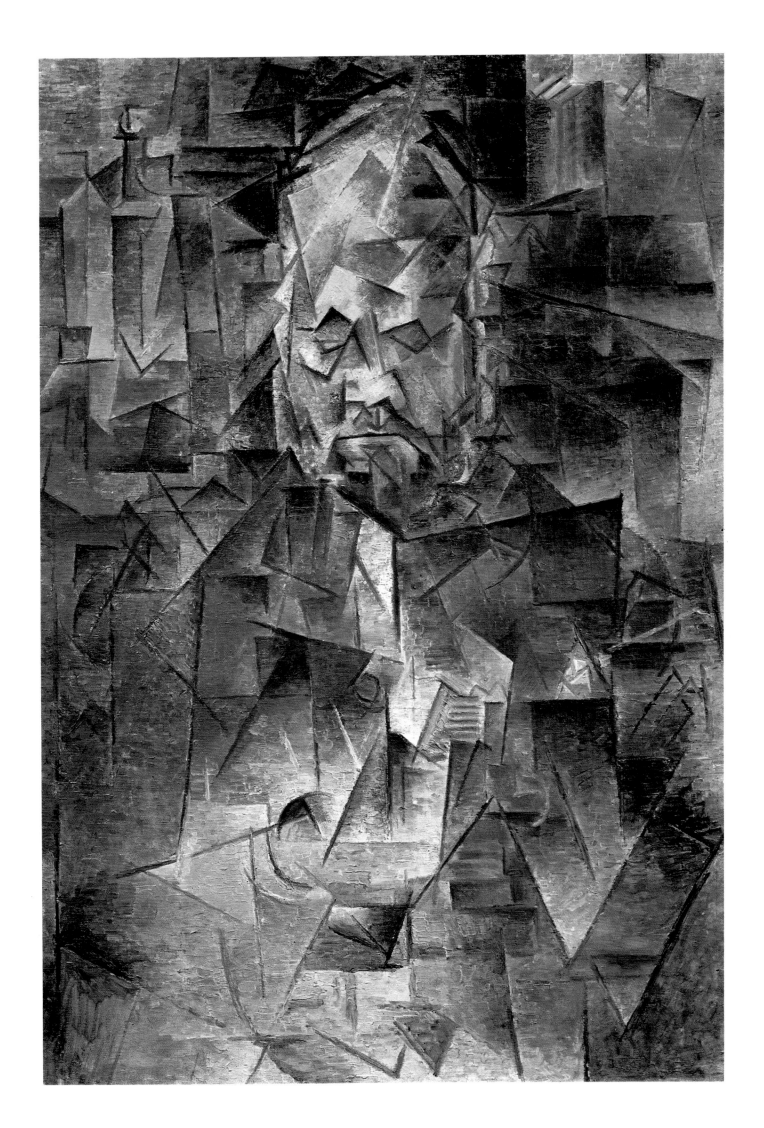

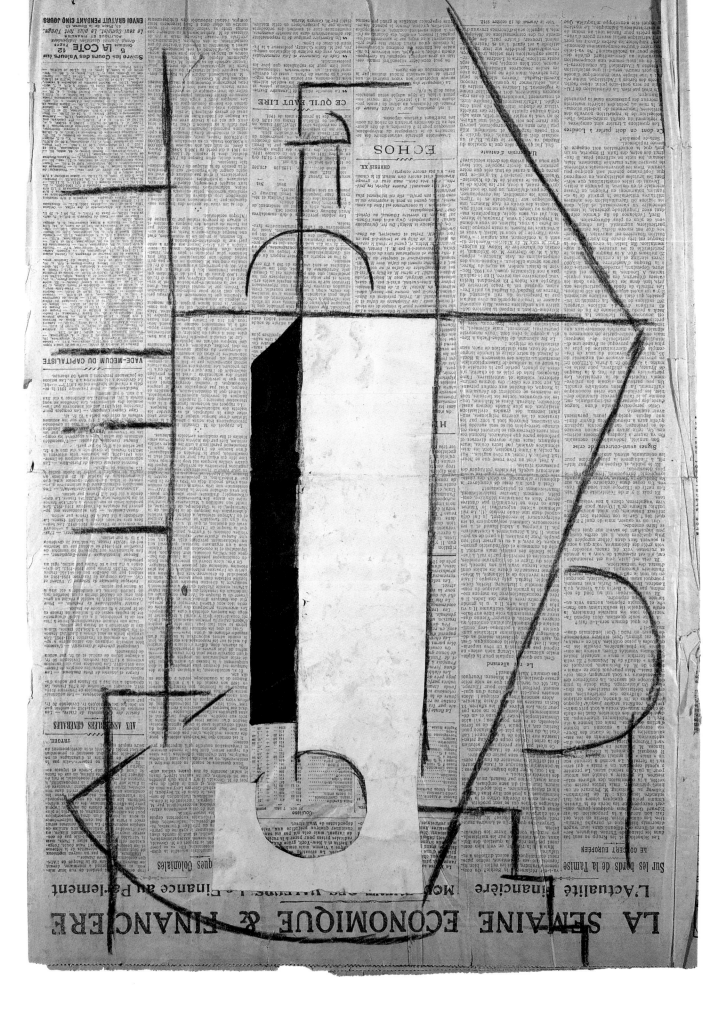

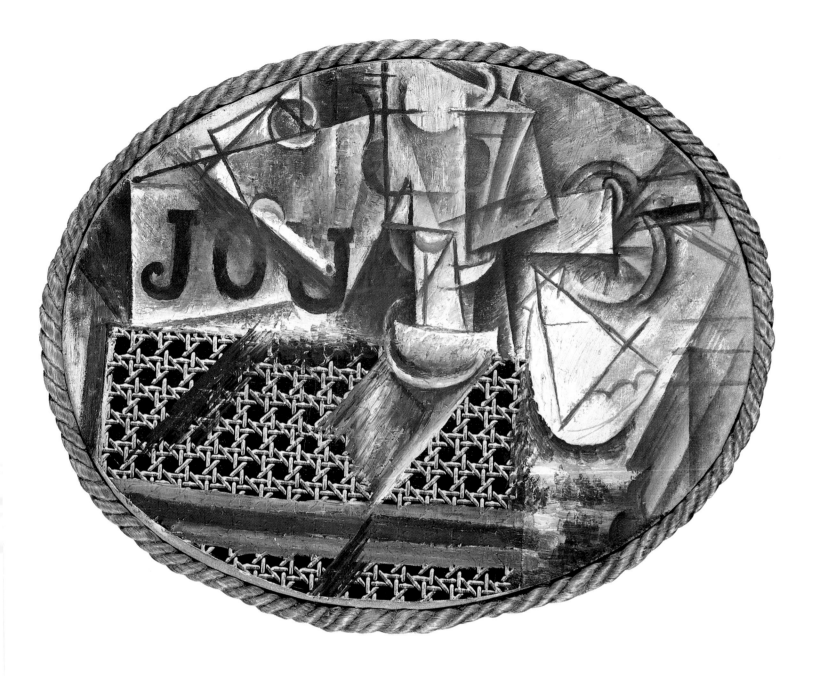

The official Cubist shows of 1911, at which Picasso and Braque were not represented, inevitably changed things. The public debate forced their work into the open and made it imperative to establish their significance in the evolution of Cubism. In 1912 Metzinger and Gleizes published *Du cubisme*, a theoretical, popularizing view of Cubism that took Cézanne as the great exemplar. But numerous writers in Picasso's circle published other views. That same year, André Salmon published two books which are seen to this day as vital sources in the history of Modernist art: his *Histoire anecdotique du cubisme*, and *La jeune peinture française*. He was the first to stress Picasso's key position and the seminal importance of *Les Demoiselles d'Avignon* in the founding of Cubism. Then in 1913 Apollinaire's book *Les peintres cubistes* appeared, and made an attempt to distinguish and characterize groupings within the movement. Braque and Picasso were labelled "scientific" Cubists.

All of this produced a fundamental revaluation of Cubism and the individual painters. Now Picasso stood centre-stage, vilified and acclaimed as the innovator par excellence. Though it does not fit the facts, Braque has been viewed ever since as Picasso's junior partner. This too can be accounted for

Still Life with Chair Caning, 1912
Nature morte à la chaise cannée
Oil on oilcloth on canvas framed with cord, 29 x 37 cm
Paris, Musée Picasso

Bottle on a Table, 1912
Bouteille sur une table
Papiers collés and charcoal on newspaper, 62 x 44 cm
Paris, Musée Picasso

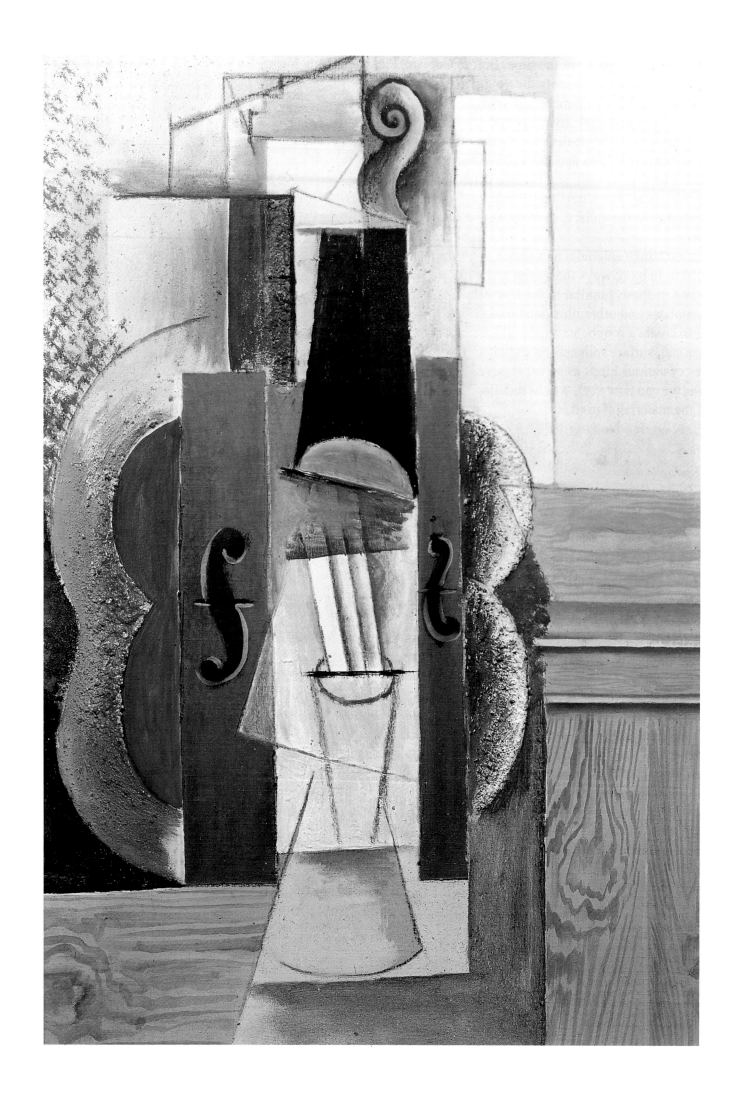

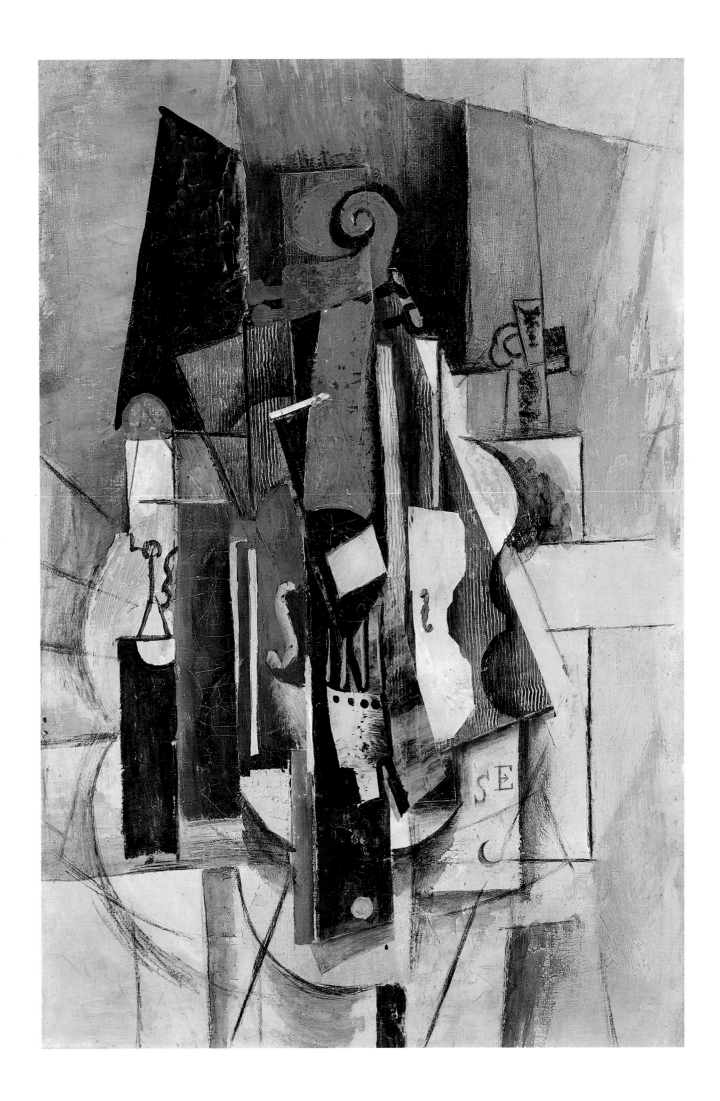

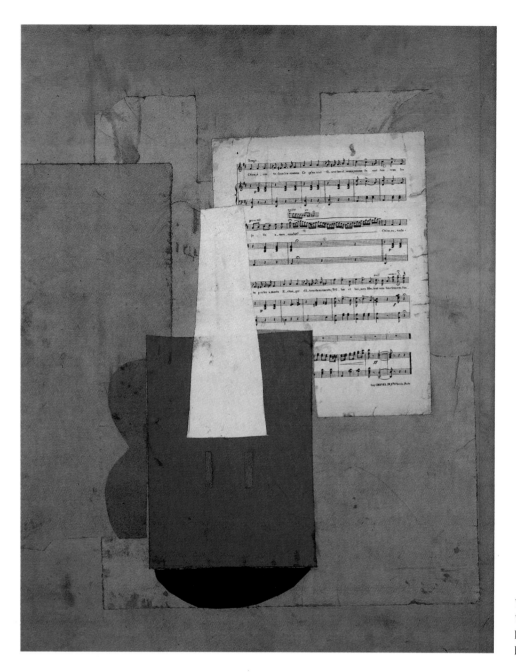

Violin and Sheet Music, 1912
Violon et feuille de musique
Papiers collés on cardboard, 78 x 65 cm
Paris, Musée Picasso

The form and content of the picture are at variance, but they are necessarily combined; and thus a subtle tension of great aesthetic and intellectual presence is created. This defamiliarization still works entirely within the parameters of mimetic iconography. Picasso went about his work quite differently in the collage technique he devised at the time. In collage – unlike papier collé - an object is introduced into a context in such a way as to alter not only the medium but also the style and meaning of the motif. *Still Life with Chair Caning* (p.81), done in May 1912, is the cornerstone work of this new method. A composition in the manner of Analytical Cubism has been joined to a slant rectangular area showing the weave of a cane chair. This naturalistic component is at odds with the style of the rest. In fact it is not a representational piece of work by the artist, but a printed scrap of oilcloth. The semblance of reality is deployed as an illusion, identified as such, and exploited iconographically. During this phase of Cubism, using new materials and techniques, Picasso was exploring the problem of spatial values in the illusion established by pictures. Many of his works therefore started from three-dimensional work.

Violin, 1913/14
Violon
Papiers collées and charcoal on paper,
62 x 47 cm
Paris, Musée National d'art Moderne,
Centre Georges Pompidou

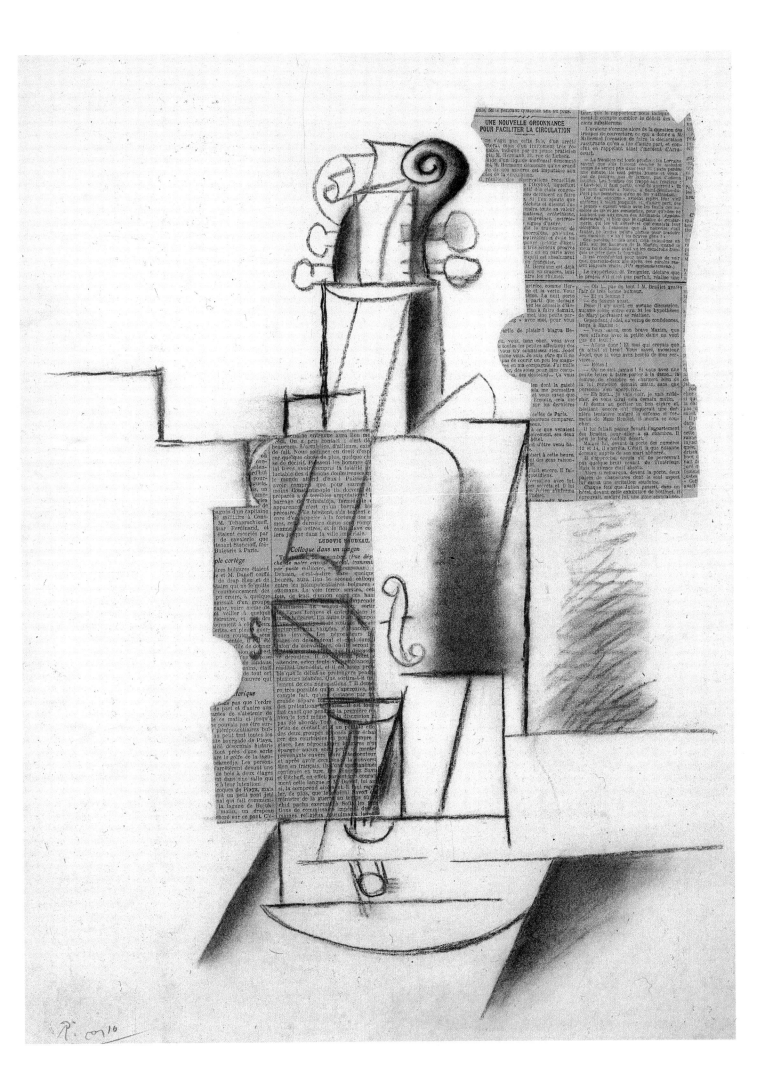

Guitar, 1912
Guitare
Cardboard, paper, canvas, string and
pencil, 22.8 x 14.5 x 7 cm
Paris, Musée Picasso

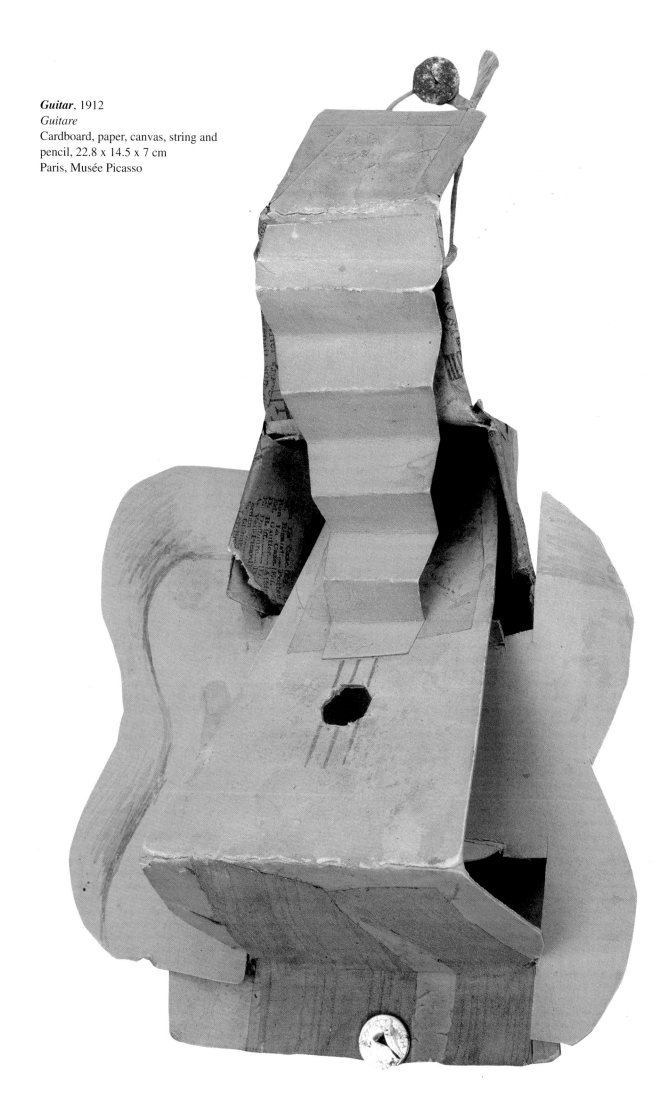

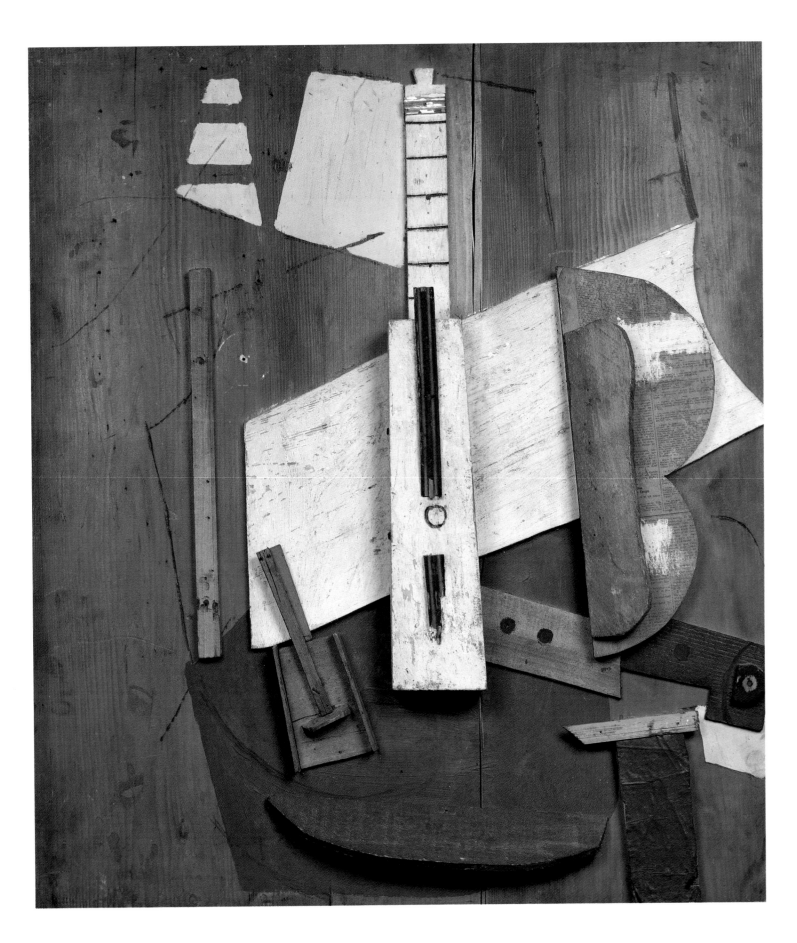

Guitar and Bottle of Bass, 1913
Guitare et bouteille de Bass
Pieces of wood, paper, charcoal and nails
on wooden board, 89.5 x 80 x 14 cm
Paris, Musée Picasso

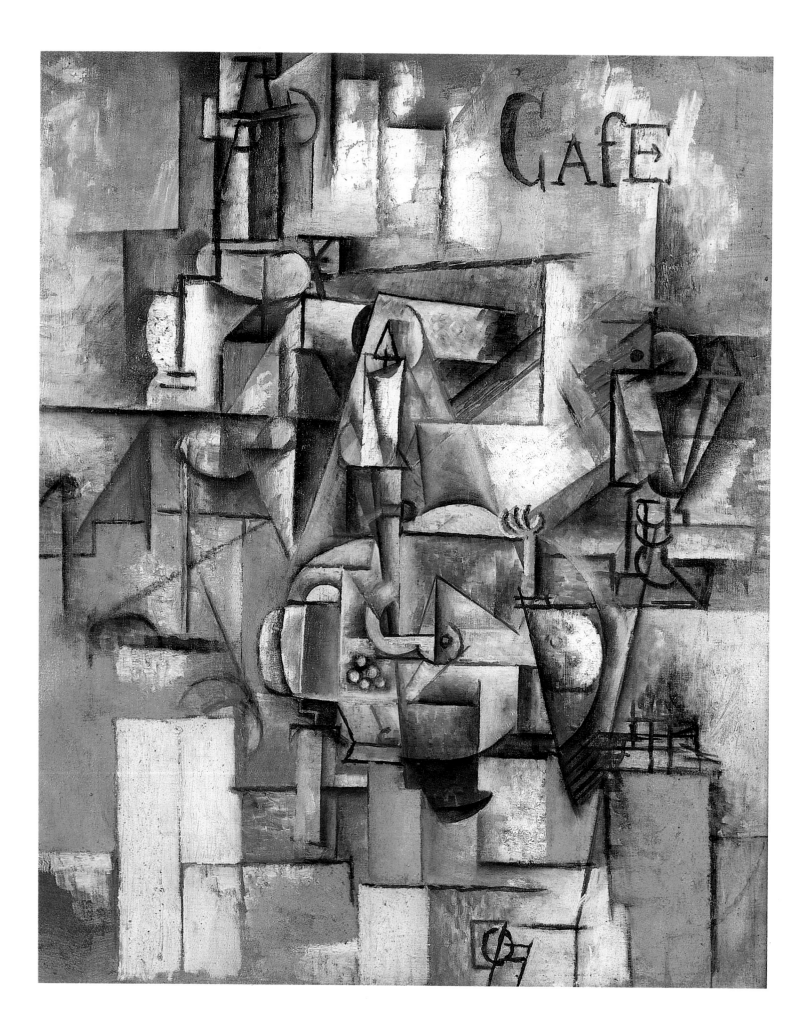

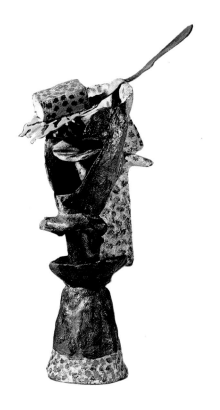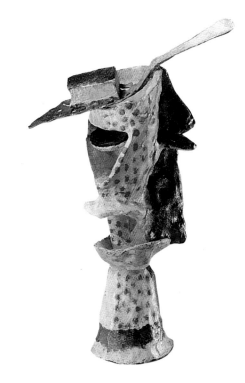

Alongside the papiers collés he began to make guitars out of cardboard (cf. p. 88). The instrument is crudely but recognisably made: the brown colours of the cardboard, reminiscent of the wood of guitars, doubtless help us in the recognition. But inappropriate materials are used too, and spatial values subverted. The lid, bottom and side walls of the cardboard boxes are flattened to equal status. The basic Cubist rule of combining the representational and the random applies to these works too. But in contrast to Analytical Cubism, which dissected objects, here they are re-assembled. And for this reason a different term is used: Synthetic Cubism.

Following this line, Picasso devised another new form, the assemblage. Basically it transposed the methods and effects of collage into three dimensions. As well as wood, Picasso used metal here; but it was painted over, and its original textural properties were no longer recognisable. Picasso also combined multi-level semantic defamiliarizations with tandem aesthetic and intellectual appeals in his only regular sculpture from this period, a famous serial work of which six copies were made: *The Glass of Absinthe* (p. 91). He made a wax and plasticine mould and variously painted the bronze casts. Absinthe (a vermouth brandy now banned because it is a health risk) was drunk from a glass goblet of the kind the sculpture shows. Picasso dissolved its transparent volume, with various highlights occasioned by the light, into isolated zones which he then juxtaposed, adding a genuine little spoon with a wax model of a sugar lump. The distinction between reality and simple representation inevitably vanished, because the spoon too now became only a representation of itself; but what matters, in terms of the principles of Synthetic Cubism, is the contrast between conventionally faithful representation (the spoon and sugar) and Cubist methods. In all six copies this contrast is observed. The various painting merely served purposes of accentuation.

Thus the processes of deception underlying the art of illusion are excellently displayed in the assemblages and sculptures of Synthetic Cubism. Picasso arguably took this line of thinking to the logical extreme in his metal *Violin* (p. 82), done in 1915 and a full metre high. It is made of cut sheet

The Glass of Absinthe, 1914
Le Verre d'absinthe
Painted bronze after a wax maquette with silver absinthe spoon, 21.5 x 16.5 x 8.5 cm
New York, The Museum of Modern Art

The Glass of Absinthe, 1914
Le Verre d'absinthe
Painted bronze after a wax maquette with silver absinthe spoon, 21.5 x 16.5 x 8.5 cm
Private collection

The Glass of Absinthe, 1914
Le Verre d'absinthe
Painted bronze after a wax maquette with silver absinthe spoon, 21.5 x 16.5 x 8.5 cm
Philadelphia (PA), Philadelphia Museum of Art, A. E. Gallatin Collection

Dove with Green Peas, 1912
Le Pigeon aux petits pois
Oil on canvas, 65 x 54 cm
Paris, Musée d'Art Moderne de la Ville de Paris

metal, but the parts are wired in and colourfully overpainted so that the nature of the material is once again not immediately apparent. The volume of the metal components and the spatial values implied by the painting are at variance. The impact is further blurred because Picasso has interchanged spatial values. Parts that should occupy a foreground position in the object supposedly represented, and others that would be further from us in a conventional three-dimensional treatment, have exchanged places. The two holes in the soundboard are not depressions or holes in the metal but added components. Reversing their state in the real world, they have here become small rectangular boxes lying on the board. Then there are the colours, white, black and blue areas alongside the brown ones suggesting the actual colour of a violin. Black areas seem suggestive of shadow, just as white ones imply bright light; yet this contrasts with the way things appear in reality. Graphic and spatial approaches, and the art of the painter, have all been combined in a sophisticated synthesis in this sculptural construction.

This playful approach to form can hardly be taken any further without exceeding the bounds of meaning – and evolving an altogether new artistic idiom. Constructions such as these thus took Cubism to the furthest limit of its options. And ever since, from Dada to the present day, artists of every stylistic persuasion have used and developed the methods evolved by Cubism. Small wonder, then, that as Cubism gained ground it also founded international recognition of Picasso's special status in 20th-century art. In the second decade of the century he was already being seen as the artist who initiated the great Modernist breakthrough. Whenever new movements were started, it was Picasso and his work that served as a rallying cry. In a word: he became the hero of 20th-century art.

Harlequin, 1915
Arlequin
Oil on canvas, 183.5 x 105.1 cm
New York, The Museum of Modern Art

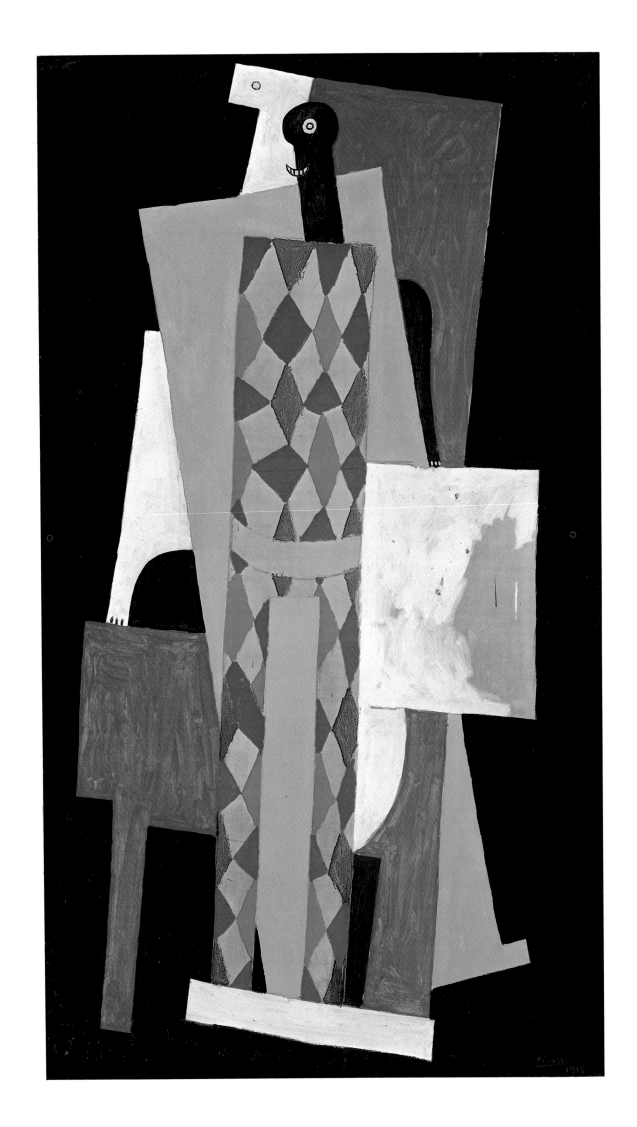

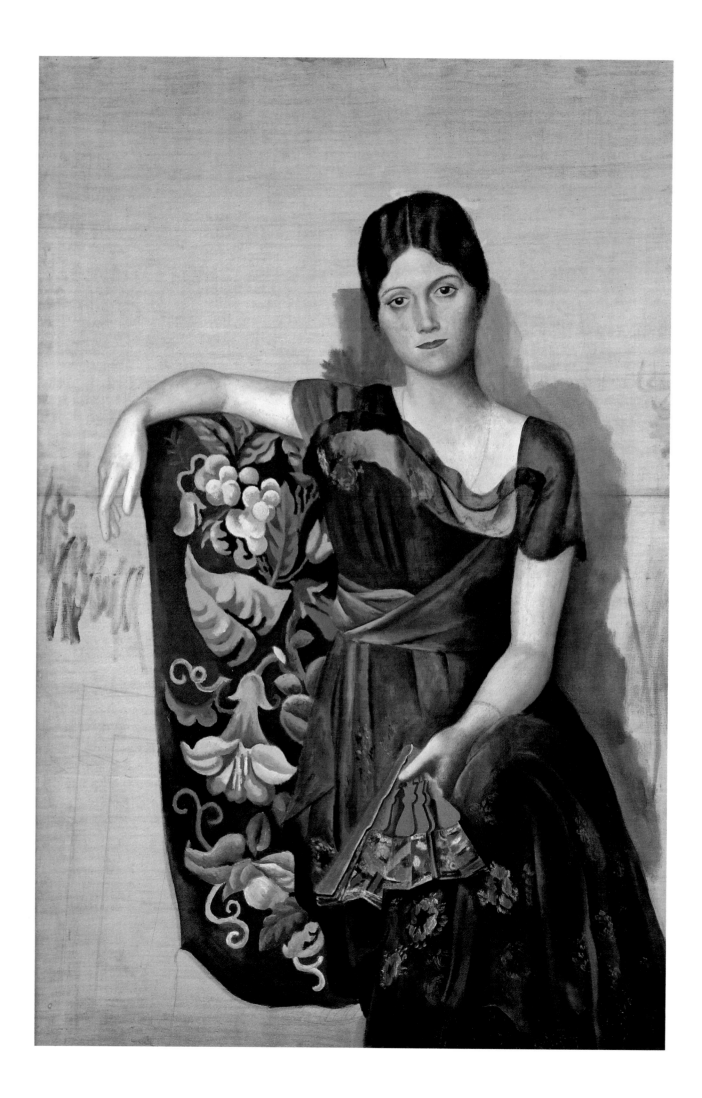

5 Classicism and Surrealism
1916–1936

The work Picasso did from 1916 to 1924 was among the most baffling in his entire output. The public, his critics, and fellow artists were now familiar with him as the founder of Cubism and indeed of modern art. But now the great iconoclast bewildered the experts and general public alike by returning to a representational art of a monumental, statuesque kind, painting classicist nudes, portraits, scenes, and works in the spirit of Synthetic Cubism – at first sight quite incompatible – all in the same period. And yet Picasso's work matched the mood of the age, and pursued his own intentions as an artist.

Now an established artist, Picasso moved in theatre and ballet circles, and thus had an entrée into high society. He saw Naples and Pompeii; he saw the originals of the most important works of classical art; and changes in the art world accompanied those in his personal life. France saw itself as the direct descendant of antiquity, the guardian of human values; and a return to the values of the ancient world was common in all the Mediterranean countries. It is certain that these years of Modernism were by no means of a piece, though. There was a strong tendency to render the formal features of avant-garde art purely decorative.

Remarkably enough, Picasso was very interested in the applied arts at that time, primarily in art design for the theatre. From 1916 to 1924 he was involved in no fewer than eight ballet or drama productions. The first of these – designs for the curtain (pp. 98/99), set and costumes of the ballet *Parade* – was also the most important. Together with Jean Cocteau, Eric Satie and choreographer Léonide Massine he evolved an overall concept that adapted Cocteau's original idea somewhat, marrying Cubist style and figural representation in a novel way. This is particularly striking in the figures of the French and American managers (p.97). Both figures are about three metres high, formed from various surfaces of painted papier maché, wood, cloth and even metal, slotted and notched into each other. The motifs – skyscrapers, Parisian boulevard trees – suggest the countries the managers come from, and underpin the Futurist principle of simultaneity. The managers are the formal idiom of Cubism in motion as they stomp their robotic way across the stage, personifying the mechanization and inhumanity of modern life.

In the eyes of fellow artists, Picasso's *Parade* provided exemplary solutions to questions that were then interesting many artists throughout Europe, questions of how to create a new unity out of performance, choreography, music, set design and costumes. But it would be wrong to see his interest in the applied arts and the influence of a classicizing mood in the arts in France as the main cause of Picasso's own classicism. The inadequacy of any one-

Olga Picasso in the Studio
Photograph, c. 1917

Portrait of Olga in an Armchair, 1917
(after the photograph above)
Portrait d'Olga dans un fauteuil
Oil on canvas, 130 x 88.8 cm
Paris, Musée Picasso

sided view can be readily seen if we grasp the irreconcilability of his own works with the European classical ideal in art. The human image is central to his work as it is to classicism, and the tendency to monumentalize it unmistakable. But in contrast to classical tradition his treatment ignores principles of balance and goes for monstrous and disproportioned physical mass. Picasso was exchanging the two poles of formal visual definition, the mimetic and the Cubist. This exchange was a return to first principles. A return seems logical since Cubism could go no further. To attempt to go on would have meant adopting total abstraction – a step that other artists did take at the time.

A new visual medium prompted Picasso's return: photography. Hitherto, this is a consideration that has been too little taken into account by Picasso's critics. Yet Picasso was an enthusiastic photographer as far back as Cubist days, and Picasso will inevitably have noticed the distinctive features of the photographic image. The unfinished *Portrait of Olga in an Armchair* (p. 94) painted in 1917, the 1923 *Paul, the Artist's Son, on a Donkey* (p. 110), his studies of dancers (Olga among them) and of Sergei Diaghilev and Alfred Seligsberg or Igor Stravinsky (p. 100), were all painted or drawn from photographs. Nor must we forget his many copies and variations of works of art

"Parade": Costume of the French Manager, 1917
"Parade": Costume de manager français
Cardboard and cloth, painted,
approx. 200 x 100 x 80 cm
Original destroyed (photo dated 1917)

"Parade": Costume of the American Manager, 1917
"Parade": Costume de manager américain
Cardboard and cloth, painted,
approx. 200 x 100 x 80 cm
Original destroyed (photo dated 1917)

The Peasants' Repast (after Le Nain), 1917
Le Retour du baptême (d'après Le Nain)
Oil on canvas, 162 x 118 cm
Paris, Musée Picasso

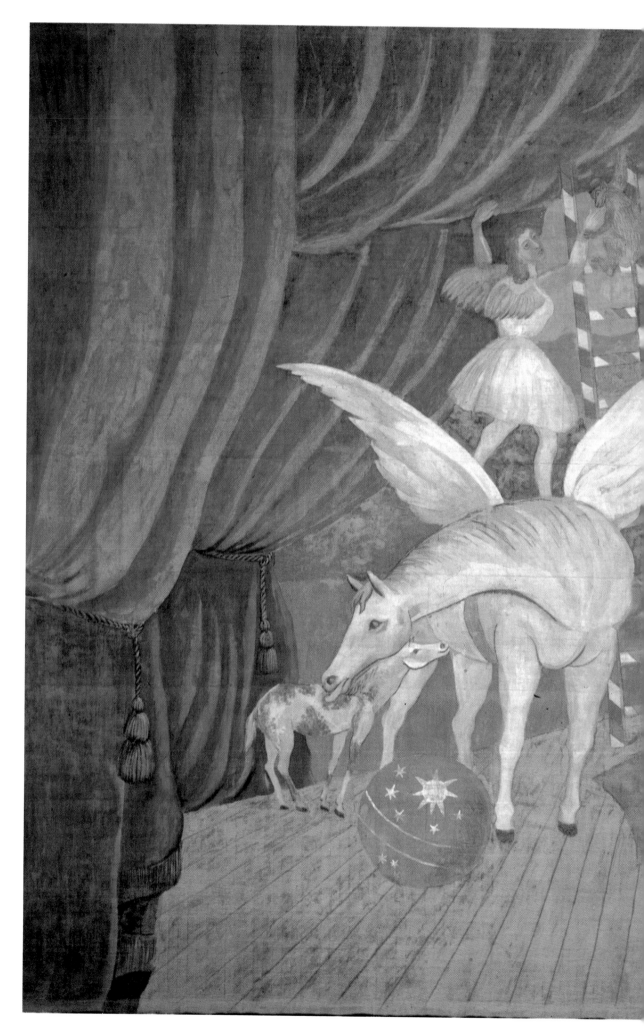

Curtain for "Parade",
1917
Le Rideau de "Parade"
Tempera on cloth,
10.6 x 17.25 m
Paris, Musée National
d'Art Moderne, Centre
Georges Pompidou

98

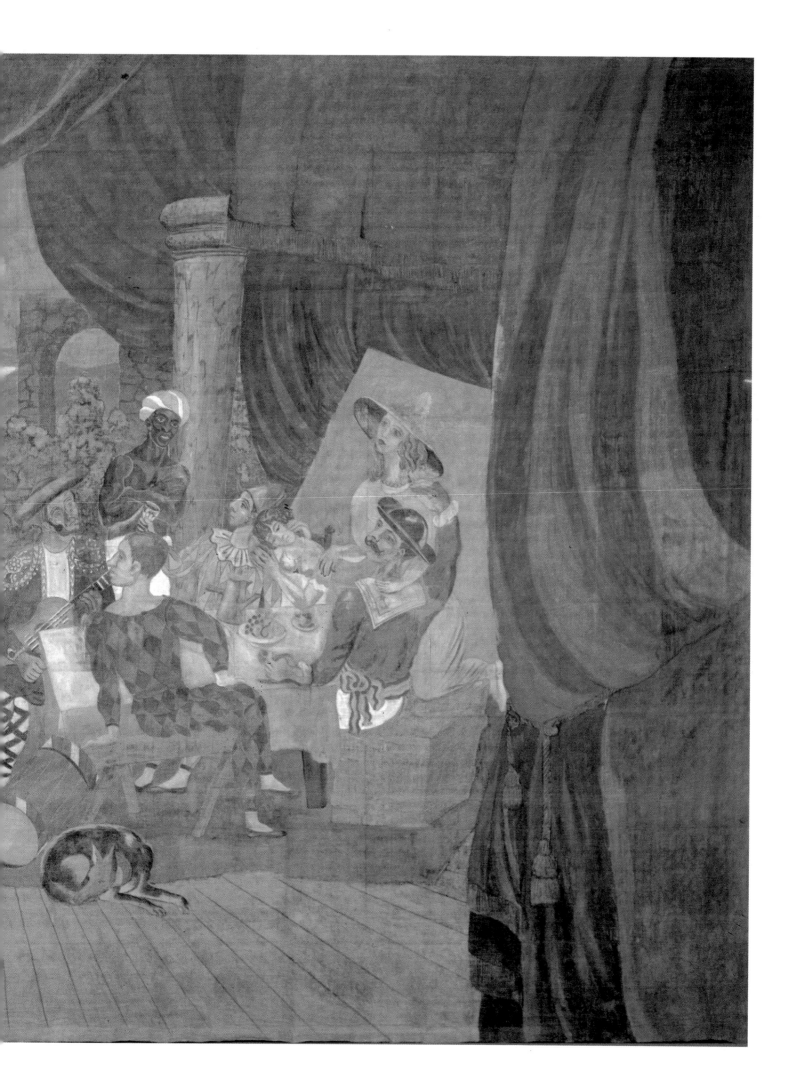

Sisley and His Wife, 1919
(after a painting by Renoir)
Le Ménage Sisley
Pencil on paper, 31 x 23.8 cm
Paris, Musée Picasso

seen in photographic reproduction. Line studies predominate among these works, reduced to essentials and almost completely disregarding shades of colours or indications of volume.

Linear austerity, a predilection for a purely linear style, was a feature of late 18th-century classicist art. People therefore assumed a link between that period and Picasso. But the similarity is only superficial. Rather, Picasso was trying to apply the stylistic resources of photography to painting and drawing. Black and white photography translates natural colours into a tonal scale from white through grey to black, and renders subjects in varying degrees of clarity or unclarity according to the depth of field. An impression of documentary precision is conveyed; in reality, the recorded scene is defamiliarized. Photography either radically polarizes available contrasts or blurs them if the focus or light are not right. The distance from the photographed subject can reinforce or distort the sense of perspective. At all events, the picture that results has a character all its own. It may be more precise than hand-drawn likenesses, but it is not faithful. And it was these peculiar features of photography that attracted Picasso to the medium.

The nature of his concerns can readily be deduced from the study after a photo of Diaghilev and Seligsberg (p. 100), drawn in outline, with only occasional charcoal accentuation to suggest volume. Picasso has accentuated the very features a photograph highlights: eyes, nose, mouth, folds in clothing. The seated man seems rather too bulky below the waist compared with his build above it, an impression caused by the slightly distorted perspective of the angle from which the original picture was taken.

PAGE 100 TOP LEFT:
Portrait of Sergei Diaghilev and Alfred Seligsberg, 1919
(after a photograph)
Portrait de Serge Diaghilev et d'Alfred Seligsberg
Charcoal and pencil on paper, 63.5 x 49.6 cm
Paris, Musée Picasso

PAGE 100 TOP RIGHT:
Portrait of Igor Stravinsky, 1920
(after a photograph)
Portrait d'Igor Stravinsky
Pencil on paper, 61.5 x 48.5 cm
Paris, Musée Picasso

Landscape near Juan-les-Pins, 1920
Paysage de Juan-les-Pins
Oil on canvas, 48 x 68 cm
Paris, Musée Picasso

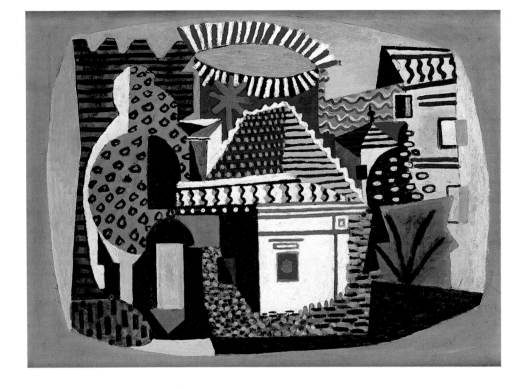

Studies, 1920
Etudes
Oil on canvas, 100 x 81 cm
Paris, Musée Picasso

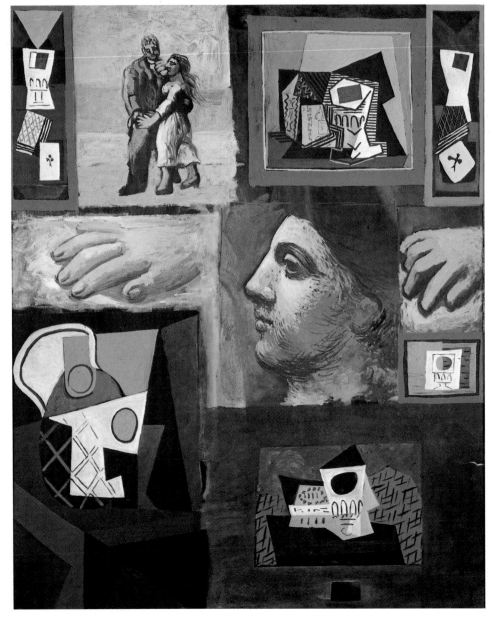

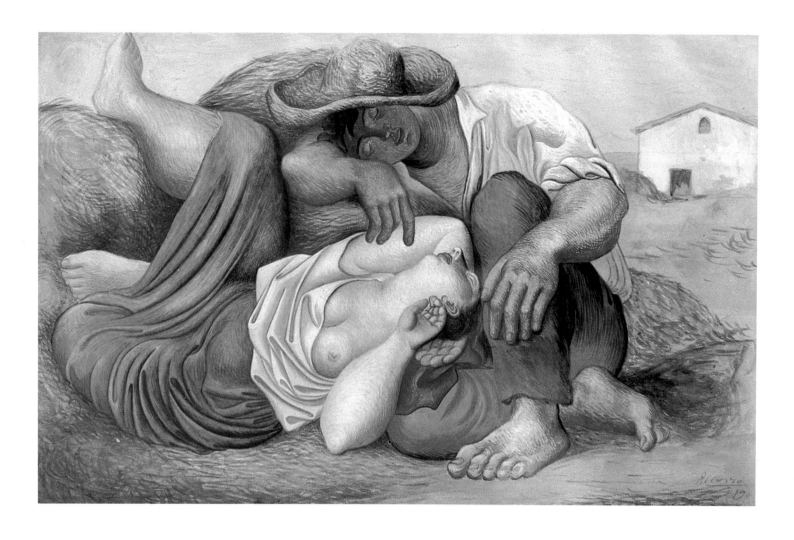

La Sieste
Tempera, watercolour and pencil,
31.1 x 48.9 cm
New York, The Museum of Modern Art,
Abby Aldrich Rockefeller Bequest

The Bathers, 1918
Les Baigneuses
Oil on canvas, 26.3 x 21.7 cm
Paris, Musée Picasso

Picasso approached the unfinished portrait of his wife Olga (p. 94) in similar fashion. The figure is cropped at the knee and placed vertically in the right-hand two-thirds of the composition. In her left hand, resting lightly on her crossed left leg, she is holding a half-open fan. Her right arm, crooked at the elbow, is out-stretched across the back of the armchair. Her wide-open eyes are gazing dreamily into nowhere, or within her own inner depths. The lustreless dark brown dress contrasts with her light flesh, the colour of which is also the colour of the canvas ground. The armchair is covered in a striking fabric of red and yellow flowers, purple grapes and green leaves – a floral pattern which makes the loudest visual impact but is somewhat muted by the patterning of the dress and fan. These agitated areas of the picture do not distract from the true subject, the portrait, but in fact lend emphasis to it. This highlighting is further assisted by Picasso's indifference to the textural, material qualities of the fabrics: Olga's face, by contrast, is painted with great sensitivity. And that was what Picasso was out to do in this painting. The canvas, however, was not yet filled.

Picasso clearly intended to finish the picture. But doing so posed a problem: he would have had to complete the composition – and the photo afforded him no help in his quest for the right counterbalance in what remained to be painted. Everything in the photo was of roughly equal clarity, and thus of roughly equal status. A photograph is like a sampler of forms, all of equal value; it is only the response in the beholder's eye that introduces differentiation. A painting, however, unlike a photo, is built on a hierarchical sense of forms – otherwise it cannot easily be grasped. The camera is impartial towards its subjects and therefore able to open up surprising perspectives

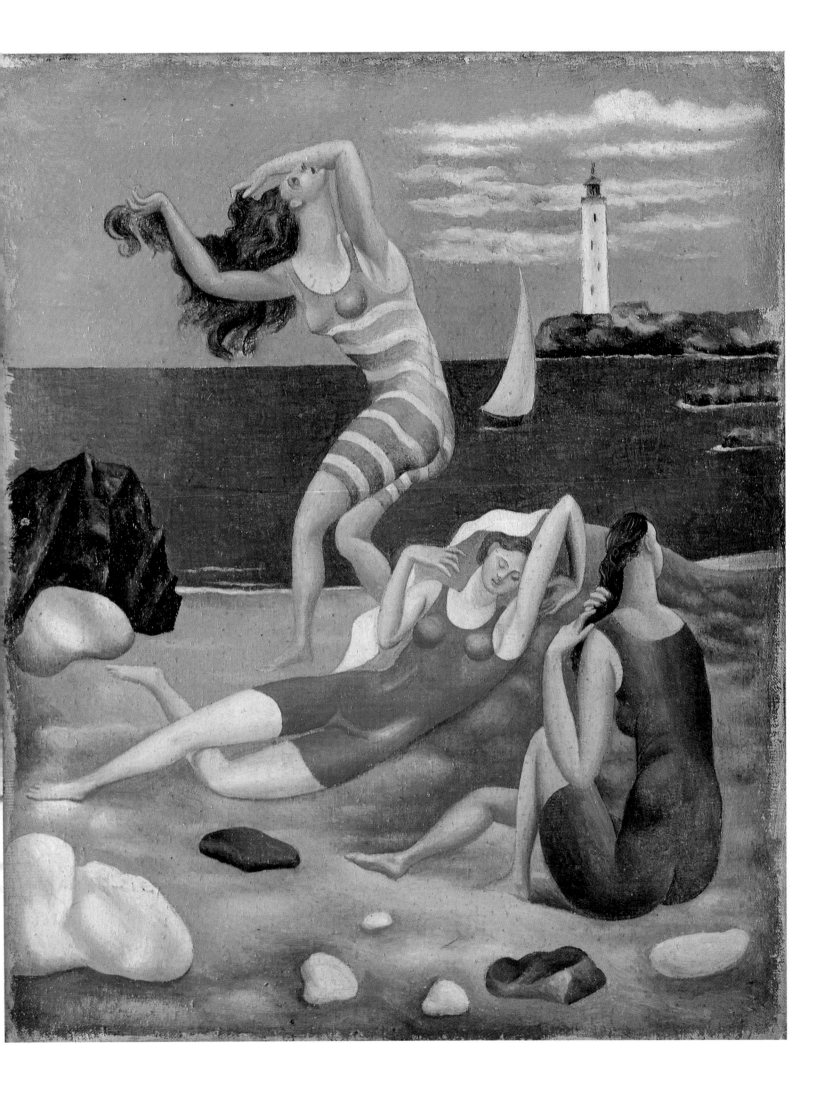

Family on the Seashore, 1922
Famille au bord de la mer
Oil on panel, 17.6 x 20.2 cm
Paris, Musée Picasso

Woman and Child on the Seashore, 1921
Femme et enfant au bord de la mer
Oil on canvas, 143 x 162 cm
Chicago (IL), The Art Institute of Chicago

Seated Nude Drying Her Foot, 1921
Femme nue assise s'essuyant le pied
Pastel on paper, 66 x 50.8 cm
Private collection

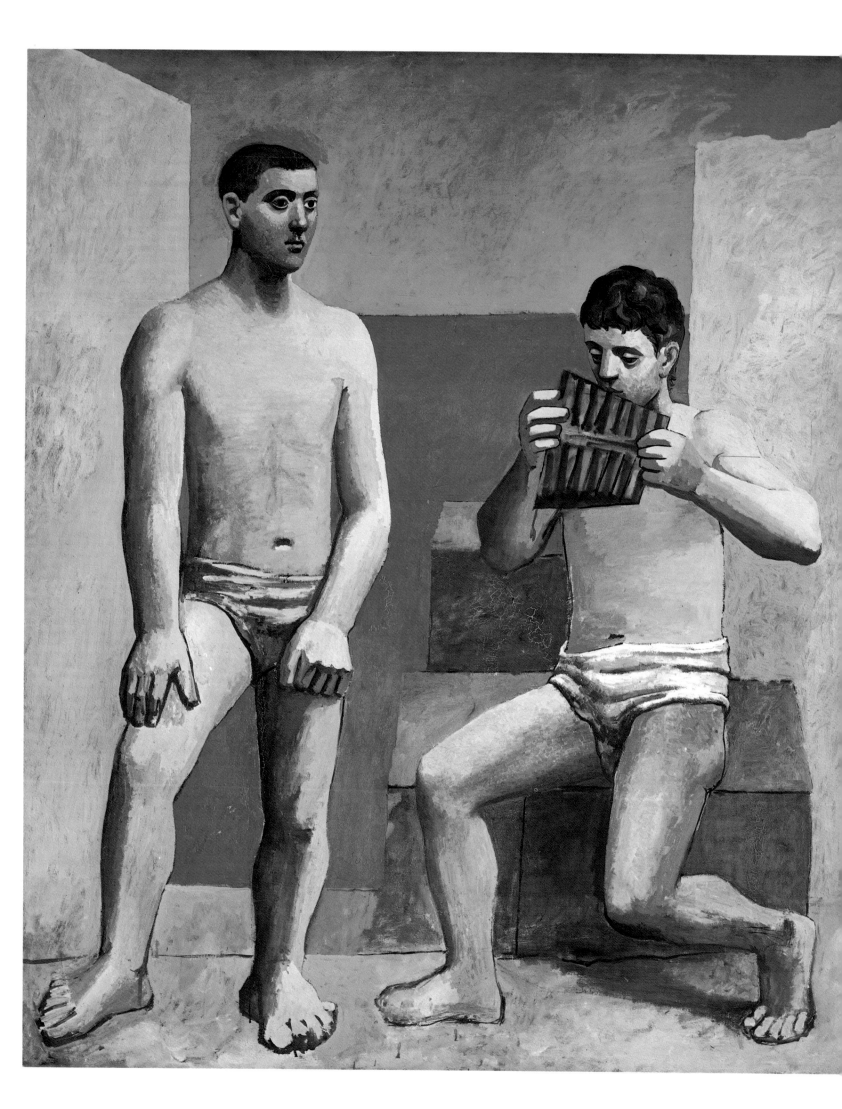

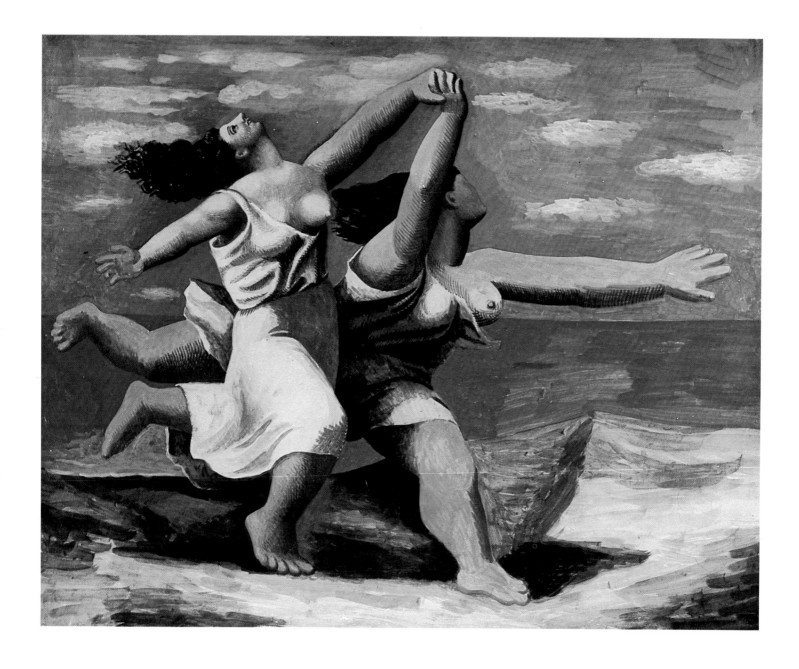

or even, in extreme cases, convey almost Cubist visual experiences using purely representational means. So Picasso abandoned work on the painting at this point. It is all the more attractive for being unfinished; the neutral canvas counteracts the tension between the woman's figure and the colourful, rather loud pattern of the armchair. Had he continued painting, Picasso would probably have become entangled in a formal jungle.

Picasso viewed the photograph as a thoroughly artificial original, the formal principle of which resided in a curiously dialectical relationship of polarities to levelled-out uniformities. Every recognisable detail was distinct from every other; yet the sheer number of details defied the eye. Polarity and uniformity were inseparable. Thus, the formal constituents of the image – line, surface, depth modelling – were themselves distinct. And what was true of photographs in general was also true of reproductions of artworks, images constituting a twofold defamiliarization, as it were. When Picasso, working with photography, returned to the mimetic image, it was by no means a step back. His work from 1916 to 1924 was every bit as avantgarde as his Cubist work. He was altogether progressive in his approach. He was simply trying something different.

Women Running on the Beach, 1922
(Curtain for the ballet *Le Train bleu*, 1924)
*Deux Femmes courant sur la plage
(La Course)*
Gouache on plywood, 32.5 x 42.1 cm
Paris, Musée Picasso

The Pipes of Pan, 1923
La Flûte de Pan
Oil on canvas, 205 x 174.5 cm
Paris, Musée Picasso

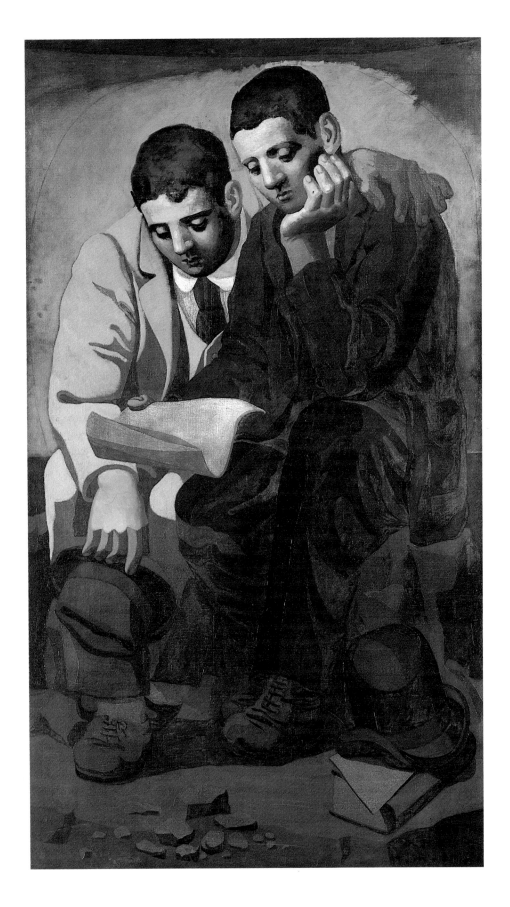

The Reading of the Letter, 1921
La Lecture de la lettre
Oil on canvas, 184 x 105 cm
Paris, Musée Picasso

The Lovers, 1923
Les Amoureux
Oil on canvas, 130.2 x 97.2 cm
Washington (DC), National Gallery of Art,
Chester Dale Collection

Woman with Blue Veil, 1923
La Femme au voile bleu
Oil on canvas, 100.3 x 81.3 cm
Los Angeles (CA), Los Angeles County
Museum of Art

Portrait of Olga (Olga in Pensive Mood),
1923
Portrait d'Olga (Olga pensive)
Pastel and pencil on paper, 104 x 71 cm
Paris, Musée Picasso

Portrait of Olga, 1923
Portrait d'Olga
Pastel and pencil on paper, 100 x 81 cm
Washington (DC), National Gallery of Art,
Chester Dale Collection

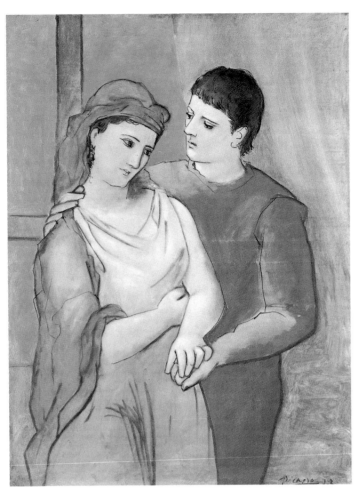

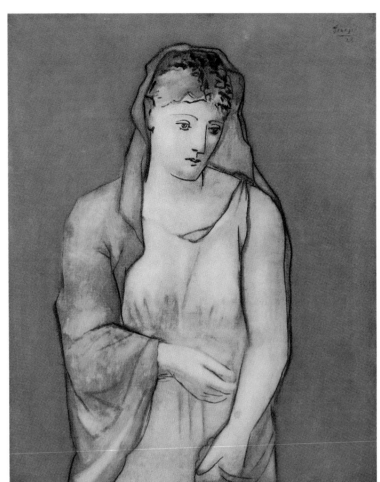

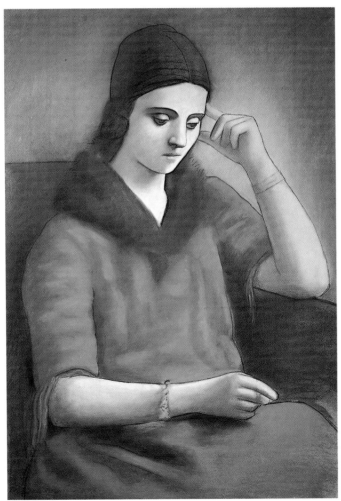

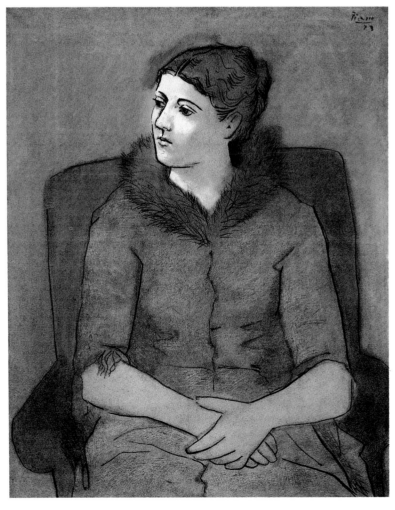

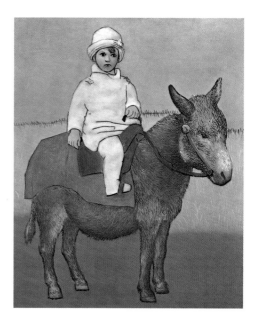

Paul, the Artist's Son, on a Donkey, 1923
Paul, fils de l'artiste, à deux ans
Oil on canvas, 100 x 81 cm
Paris, Bernard Ruiz-Picasso Collection

Paul Drawing, 1923
Paul dessinant
Oil on canvas, 130 x 97.5 cm
Paris, Musée Picasso

PAGE 112:
Paul as Harlequin, 1924
Paul en arlequin
Oil on canvas, 130 x 97.5 cm
Paris, Musée Picasso

PAGE 113:
Seated Harlequin (The Painter Jacinto Salvado), 1923
Arlequin assis (Le Peintre Jacinto Salvado)
Oil on canvas, 130 x 97 cm
Paris, Musée National d'Art Moderne,
Centre Georges Pompidou

At that time, a great deal of thought was going into the nature and potential of photography, and it had achieved recognition as an art from which other visual artists could in fact learn. From about 1920 on, Dadaists, Surrealists, Soviet Constructivists and artists at the Bauhaus were all trying to bring new ideas to visual art with the help of experimental photography.

And Picasso was trying to do the same. All of his figure drawings after 1916 were constructed according to the basic principles of photography – and for that reason they lack something we usually find in an art drawing: variability of line. Lines can be thick or thin, deep black or pale grey, and the gradations chosen can make the visual rhythm of a picture by emphasizing certain portions and not others. Not so in Picasso. From his portraits of composers Satie and Stravinsky (p. 100) to his copy of Renoir's portrait of *Sisley and His Wife* (p. 100), the lines are almost mechanically even. It is an astonishing effect, at once cold and utterly stylized.

Picasso was not only adopting the photographic contour. His paintings and drawings also borrowed the characteristic overemphasis of light-dark contrasts in defining volume, the juxtaposition of the linear and the spatial, even the distortions of perspective. He still used the visual artist's conventional methods, thus often mixing forms. In the Stravinsky portrait, for example, the composer's limbs are outsize, combining photographic distortion with the cartoonist's technique. In such works as *The Reading of the Letter* (p. 108) or the great nudes of 1921–22, photographic harshness in the contrast of light and shadow is combined with a sculpturally modelled three-dimensionality, adding a slight distortion of perspective. These massive figures with dark eye sockets and seemingly machine-made bodies are the result.

Other pictures present linear figures seen against neutral, non-representational areas of colour. In these, Picasso blended the techniques of Synthetic Cubism with the kind of mimesis he was borrowing from photography. He was using motifs drawn from his stock repertoire: harlequins, mothers with children, nudes, still lifes, studies of bullfights, portraits. New motifs were the beach scenes and bathers. These gave Picasso the chance to test his nudes in contexts of action. And he was also looking back to art history. His arresting motion study, *Women Running on the Beach* (p. 107), uses motif details from Raphael's Vatican frescoes and from an ancient Medean sarcophagus in the National Museum in Rome, both works Picasso saw in 1917. The range of different techniques Picasso was using all shared a concern with identity of craftsmanship and form. As well as painting in oil on canvas, he painted on wooden panels as in centuries gone by. He even transferred pastel to canvas and combined it with oils: *The Reading of the Letter* (p. 108) is a fine example. The textural effect of pastel chalk on a rough canvas ground curiously reinforces tonal contrasts.

As in earlier periods, the experiments were all subsumed into one major work recapitulating his experience throughout this period: *The Pipes of Pan* of the year 1923 (p. 106). Over fifty studies in sketchbooks and on single sheets have survived, but the number of preliminary studies for the painting must have been far greater, for Picasso also used his 1920–1921 pencil and pastel drawings of bathers on the beach for his new purpose. He settled on the idea of tightly ordered groups of standing and seated figures. He returned to this idea in 1923, linking it to bacchanalian motifs from antiquity. The result was the final big painting completed in summer 1923.

Rough brown, beige and sandy areas provide a backdrop to the youths, foregrounding them through the contrast, accentuating the spatiality, and rounding out the centripetal composition. The two figures illustrate Picasso's methods of three-dimensional modelling: darker and lighter shades, variously contrasting, to indicate a range of volume qualities from flat to round, together with the natural proportions of the bodies, heighten the picture's evocativeness. Like Picasso's entire output from 1916 to 1924, this picture was a variation on others, uniting in one place subject-matter with shades of antiquity, classical models, a classicist mode of composition, and a style derived from photography and blended with Synthetic Cubism.

In the year 1928, in the Paris studio of the Spanish sculptor Julio Gonzáles, Picasso made four constructions using iron wire and sheet metal, three of which have survived (p.118). They are fairly small, from 38 to 60 centimetres high, and economical in their use of iron wire of various thicknesses.

Three Musicians, 1921
Musiciens aux masques
Oil on canvas, 203 x 188 cm
New York, The Museum of Modern Art,
Mrs. Simon Guggenheim Fund

The Dance, 1925
La Danse
Oil on canvas, 215 x 142 cm
London, Tate Gallery

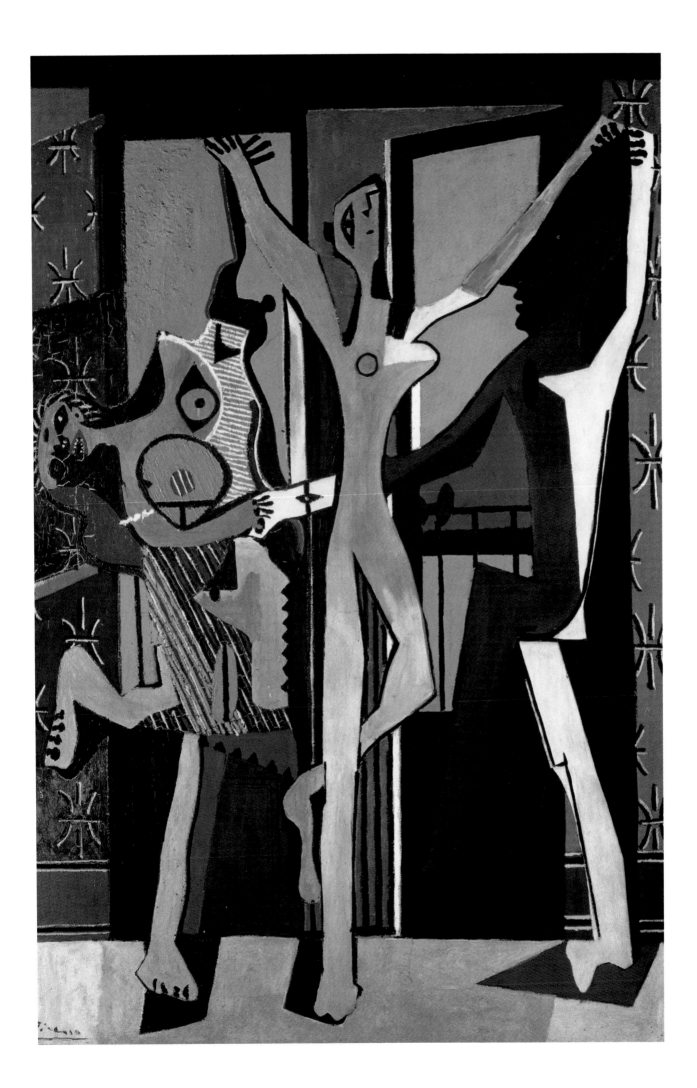

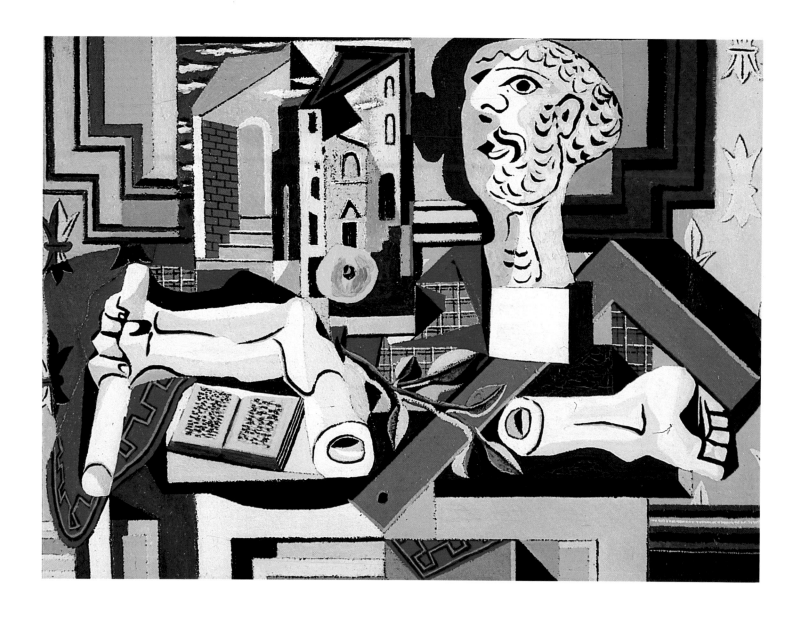

Studio with Plaster Head, 1925
Tête et bras de plâtre
Oil on canvas, 98.1 x 131.2 cm
New York, The Museum of Modern Art

The Sculptor, 1931
Le Sculpteur
Oil on plywood, 128.5 x 96 cm
Paris, Musée Picasso

At first glance these constructions look complicated and confusing. But on closer inspection we see two fundamental features. On the one hand, they present a juxtaposition of geometrical shapes, rectangles, triangles and ellipses grouped spatially into irregular stereometric configurations – extended pyramids, squashed cubes. On the other hand, at points there are details – small spheres, discs, irregular tricorn ends – recalling, however remotely, the human figure. This encourages us to read the works entirely differently: what looked totally abstract at first now seems to be a stylized representational figure.

The works are like picture puzzles. Picasso's remarkable and noteworthy handling of the fundamentals of sculpture is striking. The use of wire translates form into an issue of linear definition. This is a principle of the draughtsman, not the sculptor. Strictly speaking, these works are three-dimensional transfers of two-dimensional graphics. They were given the label "spatial drawings" by Kahnweiler. The ambiguity of formal meaning, the open expressive significance of an art object, the fundamental doubts concerning images conveyed by draughtsmanship – all these basic issues entered into Picasso's picture puzzles, on page and plinth alike. In 1932, this process culminated in the oil *Bather with Beach Ball* (p. 126). The visual opulence of this work at once proves it a peak achievement, a final point along a development, the sum of a long series of studies, experiments and insights.

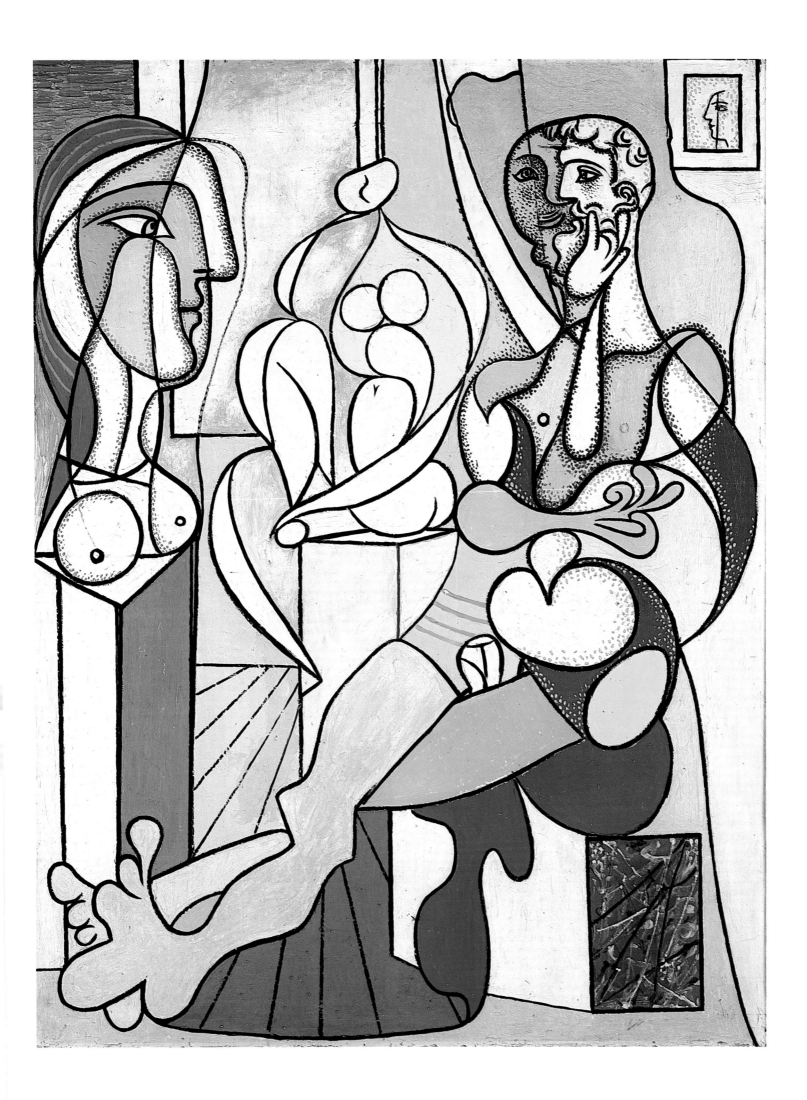

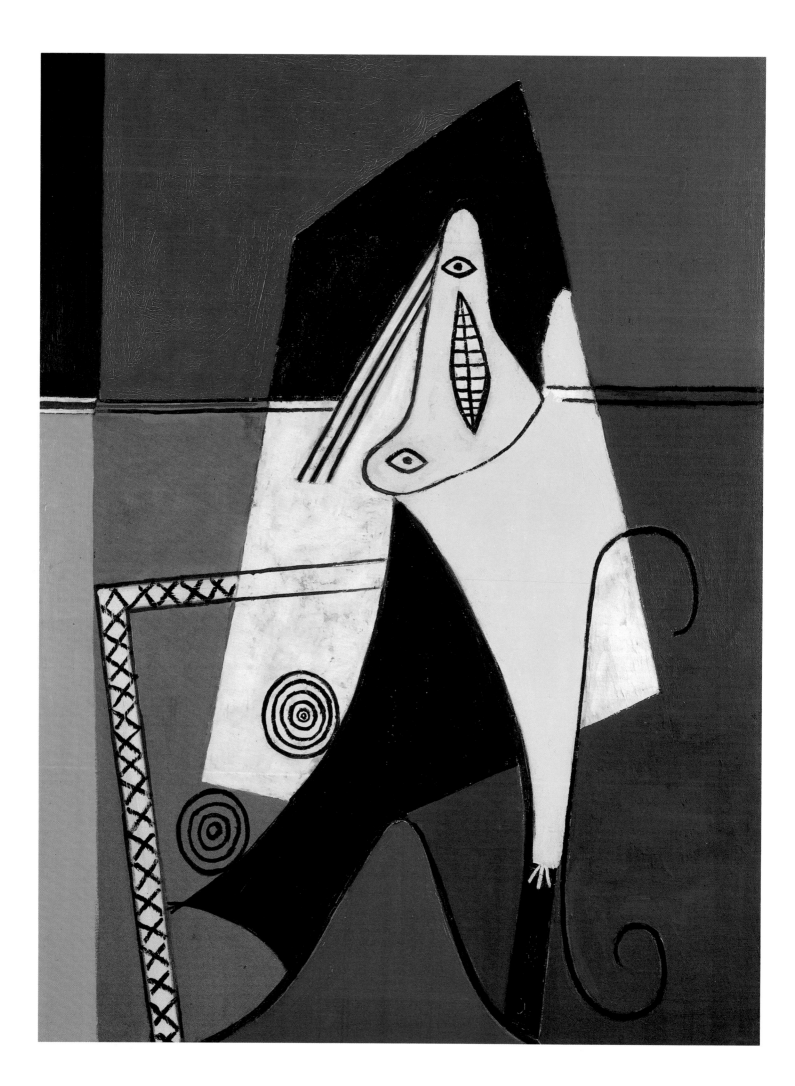

The Studio, 1927/28
L'Atelier
Oil on canvas, 149.9 x 231.2 cm
New York, The Museum of Moderrn Art

The composition, seemingly simple and yet subtle, is typical of Picasso in its use of correspondences and contrasts. Angular forms are juxtaposed with rounded ones; naturalistic features appear alongside abstract. Spheres and shapes like clubs, thick, sweeping, dense, form a figure that has a distantly human appearance. Legs apart, arms crossed as she leaps, the bather has just caught a ball that makes a distinctly tiny impression beside her bulky body. The figure almost completely fills the canvas, this, with Picasso's use of a vertical diagonal, making the sense of movement all the more dynamic. Taken with the clumsiness of this body, the crass pattern of the bathing suit, the beach cabin and the blue sea, Picasso's view of life at the seaside is distinctly humorous. But for Picasso form in itself was devoid of content; so he considered himself at liberty to interchange forms and substitute other contents. His juggling with form found support at that period in another new movement that had emerged from Dada: Surrealism.

In the summer of 1923 Picasso met the leader of the movement, the writer André Breton, and did an etching of him. In 1924 Breton published the first Surrealist Manifesto. In it he proposed that the subconscious was a more valid mode of perceiving reality than rational thought and sense. He advocated dreams and the visions of madness as an alternative to reason. He was inspired by Sigmund Freud's psychoanalytic writings, and by the poetry of Arthur Rimbaud, Stéphane Mallarmé, Comte de Lautréamont and Apollinaire, from whose work the label of the new movement was indirectly derived. Surrealism's aim was to reveal the subconscious realm of dreams by exploring avenues opened up by psychoanalysis. It disregarded the causal order of the perceptible world and set out to counter it with an unlimited use of the irrational. In this way, individual life would undergo a revolutionary transformation: feeling and expressive potential would be infinitely enhanced and extended.

The Surrealists were opposed to all artistic procedures based on conscious reason. In its place they put chance, trivia, and a revaluation of plain everyday sensation. Originally a literary movement, it quickly embraced the visual arts too, and a number of new techniques were developed. The most important of them were frottage, which (like brass rubbing) calls for the

Figure, 1927
Figure
Oil on canvas, 128 x 98 cm
Estate of Jacqueline Picasso

PAGE 122:
The Kiss, 1925
Le Baiser
Oil on canvas, 130.5 x 97,7 cm
Paris, Musée Picasso

PAGE 123:
Large Nude in a Red Armchair, 1929
Grand nu au fauteuil rouge
Oil on canvas, 195 x 129 cm
Paris, Musée Picasso

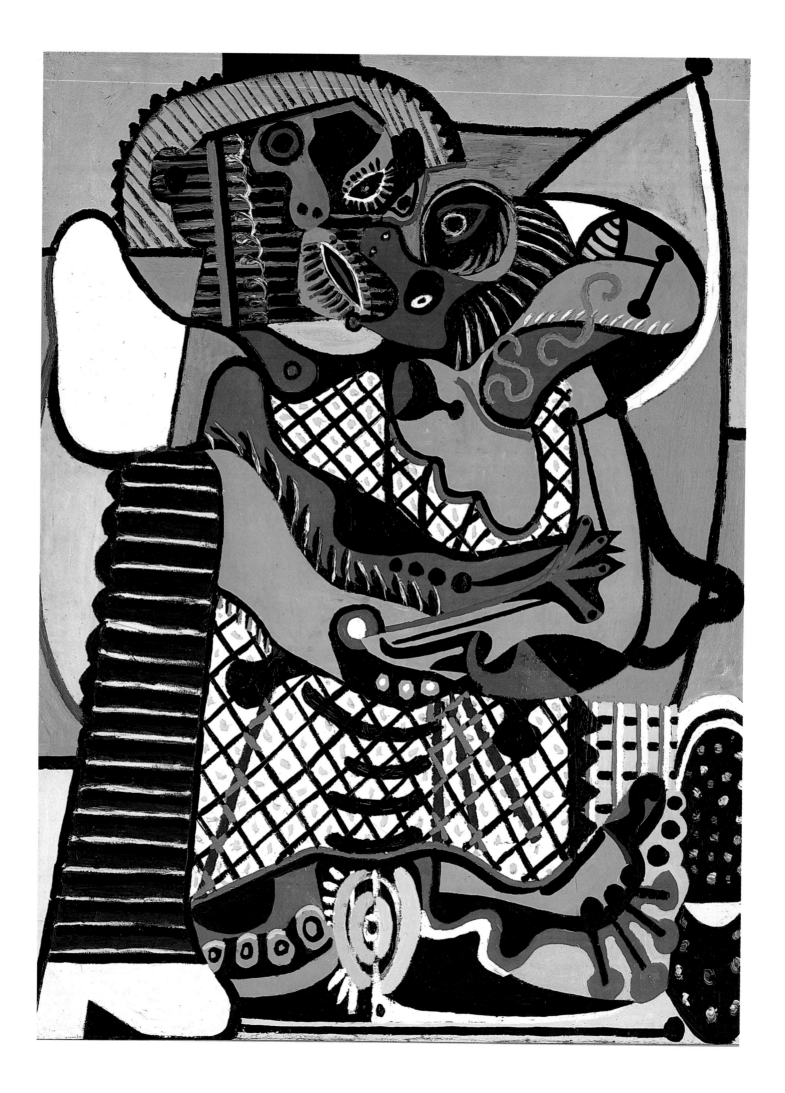

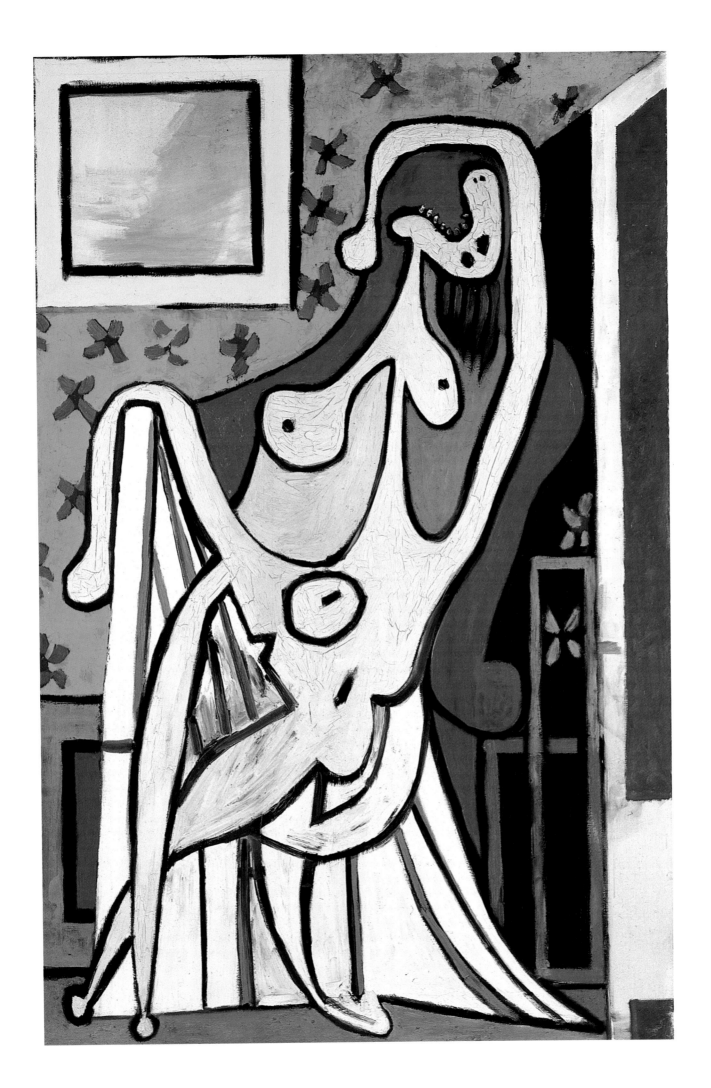

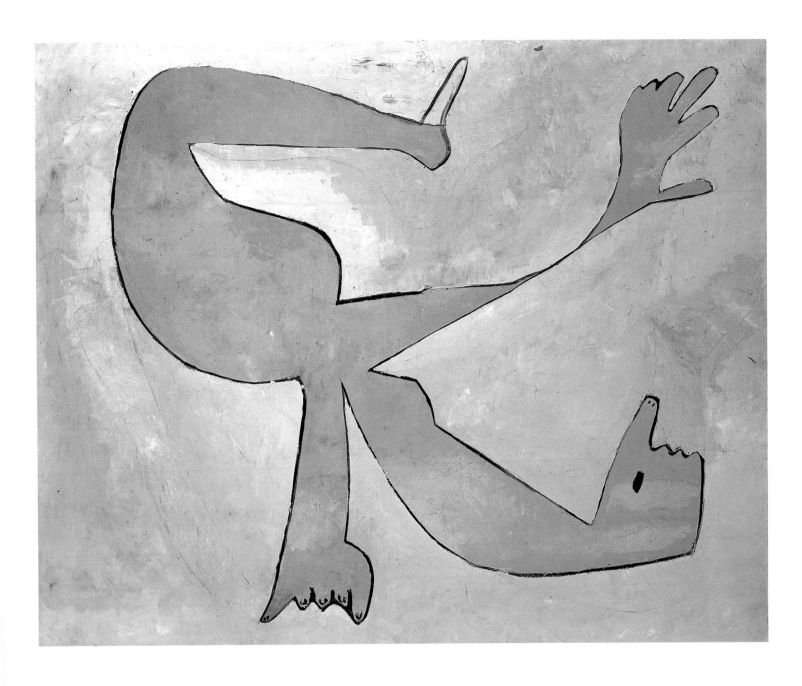

The Swimmer, 1929
La Nageuse
Oil on canvas, 130 x 162 cm
Paris, Musée Picasso

production of visual, textural effects by rubbing, and grattage, a kind of reverse frottage, in which paint is thickly applied and then scraped off revealing the layer underneath. Nor should we forget "Ecriture automatique", the Surrealists' rediscovery of automatic writing and equivalent procedures in painting and drawing whereby what mattered was to suspend rational control and allow the subconscious to express itself directly via the text or image produced.

In 1925 Picasso exhibited at the first joint Surrealist show in the Galerie Pierre in Paris. He did portraits of Surrealist writers for their books, and in 1933 one of his collages was taken for the title page of the new magazine, *Minotaure* (p.139). Like the Surrealists, Picasso too explored the visual potential of tactile qualities. There are a number of affinities in technical methods, the use of montage, and the further development of collage and assemblage.

Yet still the tensions that existed between Picasso and the Surrealists were the product of deep-seated differences. It is no exaggeration to say that their respective aims and intentions were in fact diametrically opposed. For that very reason there were superficial overlaps in the approach to artistic experi-

The Blue Acrobat, 1929
L'Acrobate bleu
Charcoal and oil on canvas,
162 x 130 cm
Paris, Musée Picasso

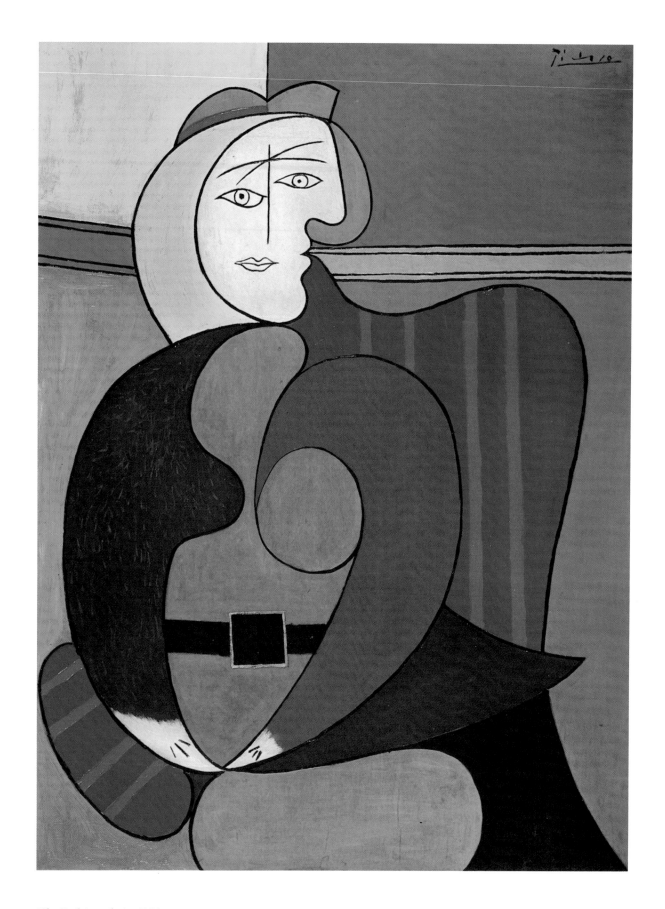

The Red Armchair, 1931
Femme assise dans un fauteuil rouge
Oil and enamel paint on plywood, 130.8 x 99 cm
Chicago (IL), The Art Institute of Chicago

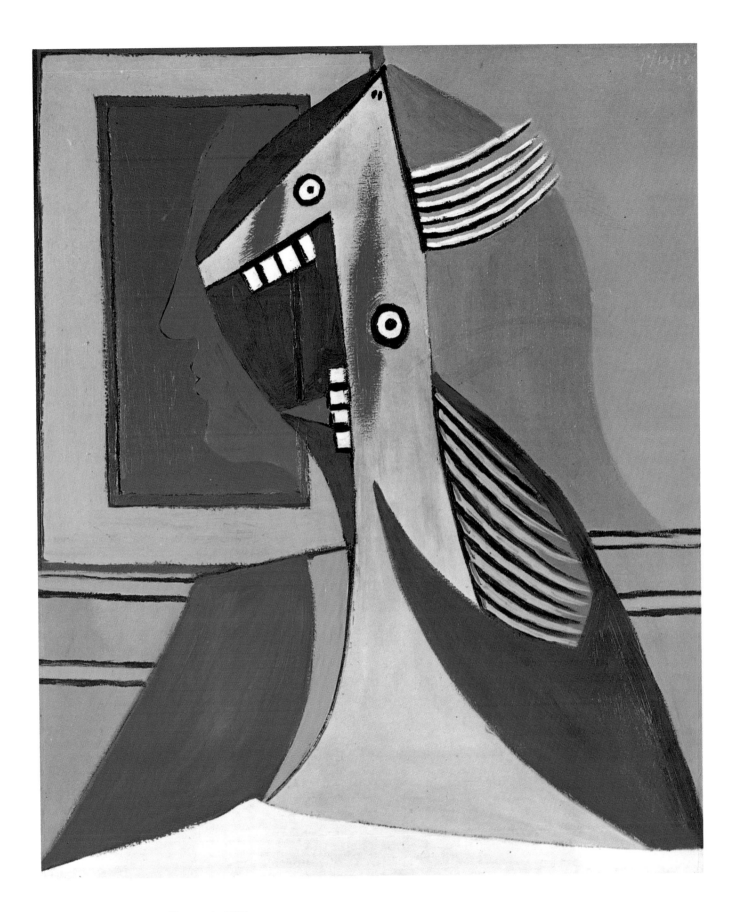

Bust of a Woman with Self-portrait, 1929
Buste de femme et autoportrait
Oil on canvas, 71 x 60.5 cm
Private collection

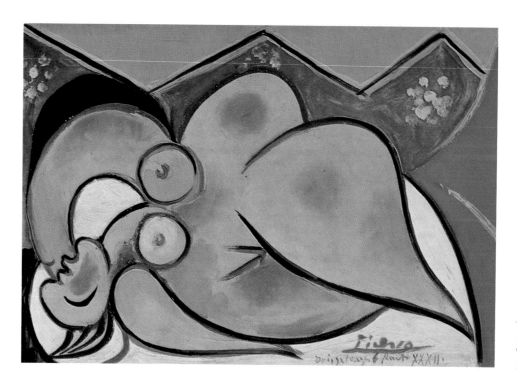

Reclining Nude, 1932
Femme nue couchée
Oil on canvas, 24 x 35 cm
Rome, Private collection

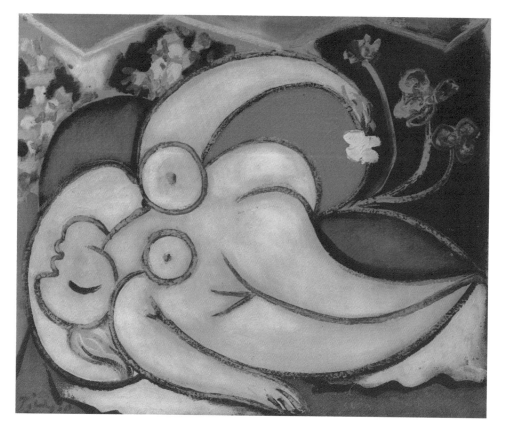

Reclining Nude, 1932
Femme nue couchée
Oil on canvas, 38 x 46 cm
Paris, Musée National d'Art Moderne,
Centre Georges Pompidou

Woman with a Flower, 1932
Femme à la fleur
Oil on canvas, 162 x 130 cm
New York, Mr. and Mrs. Nathan Cummings
Collection

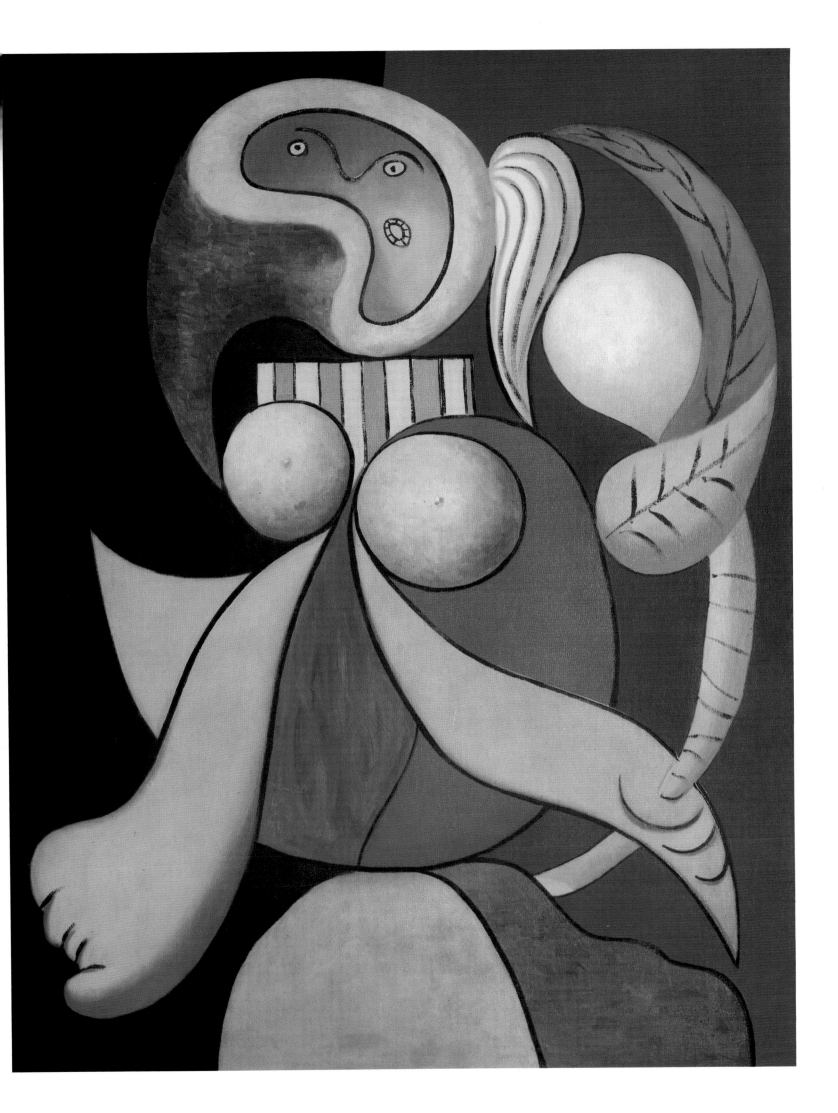

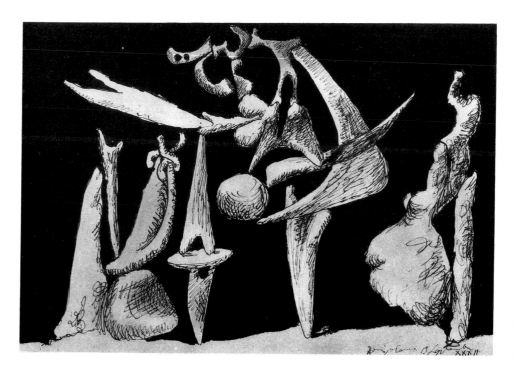

The Crucifixion (after Grünewald), 1932
La Crucifixion (d'après Grünewald)
Ink and India ink on paper, 34.5 x 51.5 cm
Paris, Musée Picasso

The Crucifixion, 1930
La Crucifixion
Oil on plywood, 51.5 x 66.5 cm
Paris, Musée Picasso

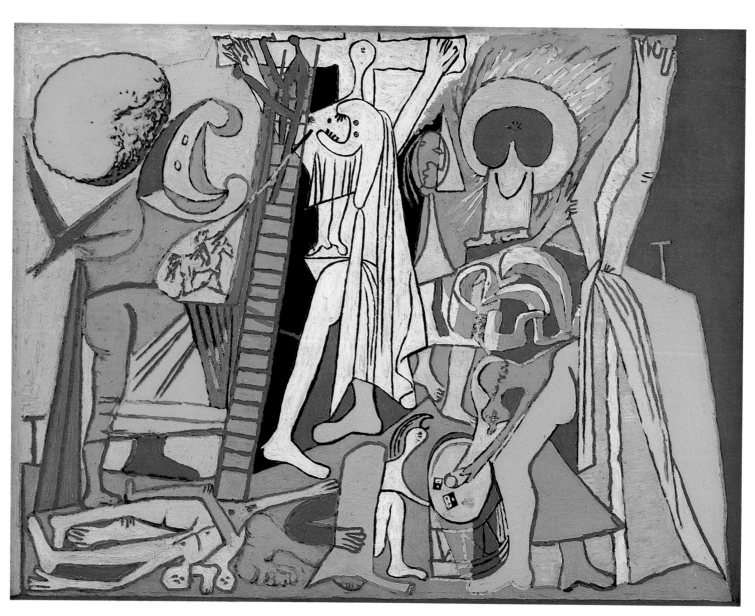

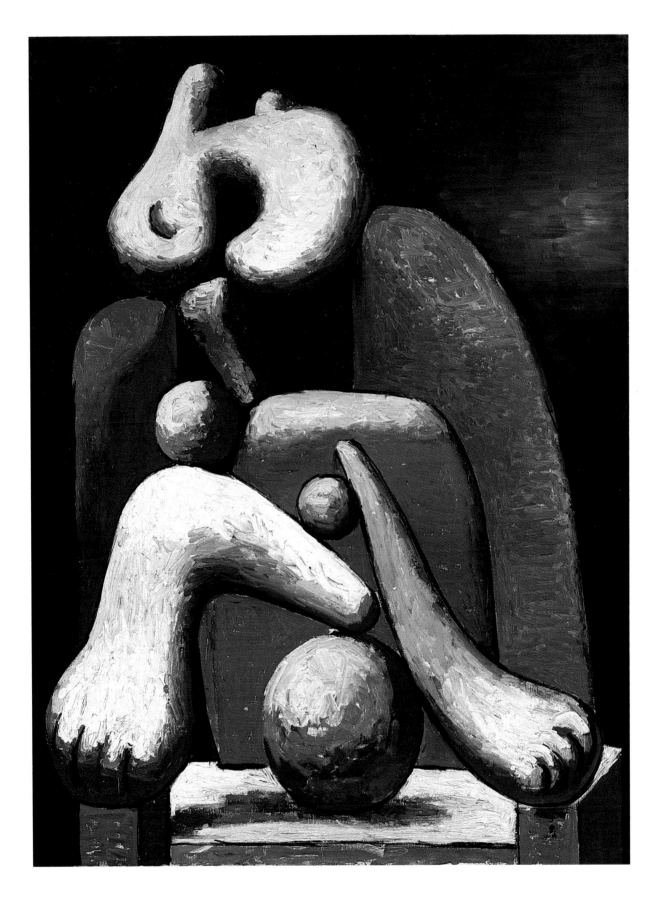

Woman in a Red Armchair, 1932
Femme au fauteuil rouge
Oil on canvas, 130.2 x 97 cm
Paris, Musée Picasso

Interior with a Girl Drawing, 1935
Deux Femmes
Oil on canvas, 130 x 195 cm
New York, The Museum of Modern Art,
Nelson A. Rockefeller Bequest

A large number of Picasso's etchings are responses to Rembrandt. Picasso was placing himself on a par with Rembrandt – a high ambition indeed, for Rembrandt is widely seen as the master of etching, and in Picasso's time was considered the greatest artist of all time. Picasso was asserting that he himself was Rembrandt's legitimate successor, that he himself was the most important 20th-century artist.

In 1925, Picasso created a masterpiece of formal metamorphosis, *The Kiss* (p. 122), a truly awful picture – but wonderful too! A manifesto of new ways of expression, it presents the aggressive, violent and primitive aspects of the act of love with a brutality scarcely ever attempted before. It makes demands on us. We have to disentangle what we see, gradually discovering at the top, amidst the seeming chaos of loud colours and contrasts, mouths locked in a devouring kiss; a figure at left, holding another in an embrace; an exploded backbone atop straddled legs. But what looks like a mouth or eye, soulfully intimate, is in fact a vagina about to be "eaten", and at the bottom of the picture we are provocatively confronted with an anus – balancing the composition in ribald parody of classical laws of composition. Not until late work done in the 1960s did Picasso again treat sexuality thus.

A picture as aggressive as *The Kiss* was of course not merely the articulation of an artistic programme. It came out of personal experience. Picasso's marriage to Olga was not a happy one. They shared few interests, neither communicating nor enriching each other's lives. Art here mirrors reality, expresses it vividly. In other works of the period, distress and violent feeling

Woman Reading, 1935
Femme lisant
Oil on canvas, 161.5 x 129.5 cm
Paris, Musée Picasso

are apparent in the visible tension. From 1930 on, we frequently find the Christian motif of the crucifixion (p. 132). Above all, he dealt with relations between the sexes, in numerous variations on his artist-and-model subject but also in a new version of his bullfight pictures: the motif of the Minotaur.

The various states of the *Minotauromachy* etching, and the India-ink and gouache studies of 1936 (p. 137), allude both to the ancient tradition and to the modern. The Minotaur invades the sculptor's studio. He is also seen dragging the dead mare, a symbol of female sexuality, from his lair. He is plagued by demons, and is vanquished by Theseus. But the creature can always be identified with the dual nature of the artist. This owes something to Nietzsche's *The Birth of Tragedy*, in which Nietzsche saw art as essentially a duality, possessing Apollonian and Dionysian features.

Of course we must remember that the violence in many of these works also reflected contemporary politics. France and indeed all of Europe was radically unstable at the time, and Fascism was on the rise. Spain had been in the hands of a military dictatorship since 1923, and it was not till 1931 that an elected government replaced it. Since 1930, the Surrealists had been increasingly committed to the Communist Party, but Picasso refused to be directly involved in politics. This does not mean that he took no interest in political events or was ignorant of social conditions.

The key picture in political terms is the composition showing the Minotaur in the clutches of a gryphon figure (p. 137 top), Picasso's variation on a famous ancient model, the Hellenistic Pasquino group, showing the dead Patroclus in the arms of Menelaus. It was done as a study for the curtain for Romain Rolland's play *14 juillet*, performed in Paris in summer 1936 in honour of the election victory of the French People's Front. Like the bullfight, the use of the Minotaur motif shows the subject's symbolic value in Picasso's eyes, as an expression of social concern.

Girl Before a Mirror, 1932
Jeune Fille devant un miroir
Oil on canvas, 162.3 x 130.2 cm
New York, The Museum of Modern Art,
Gift of Mrs. Simon Guggenheim

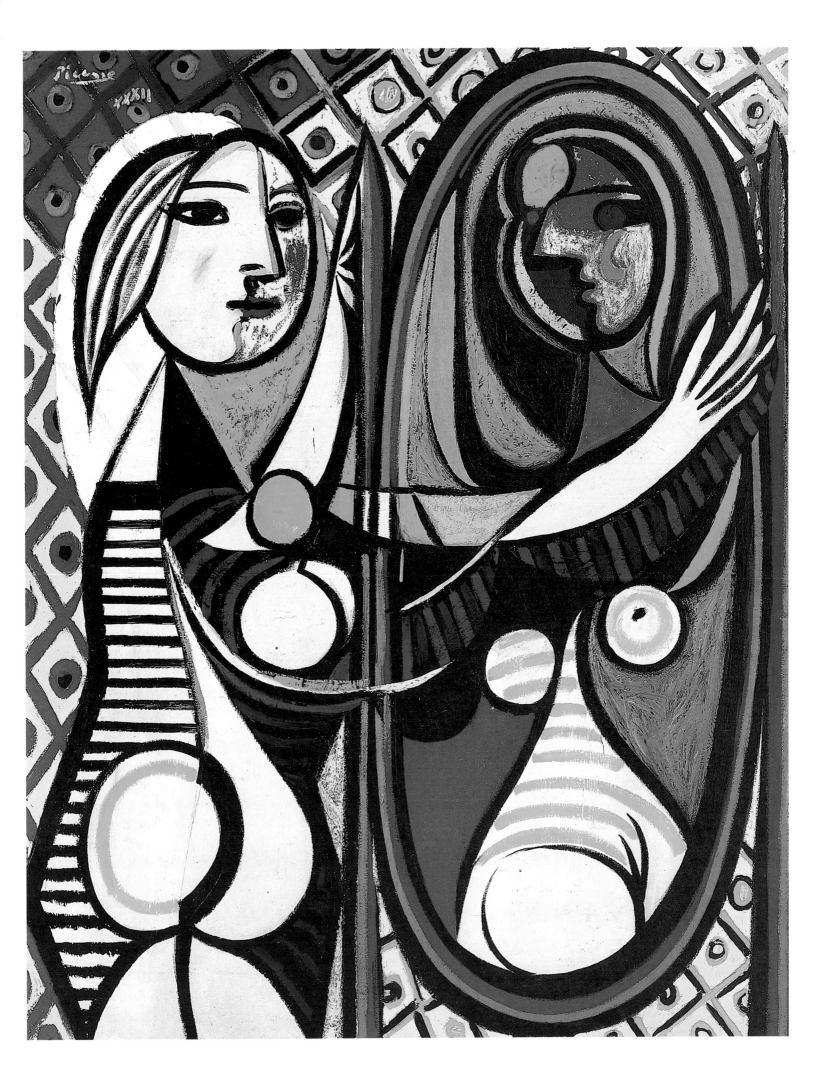

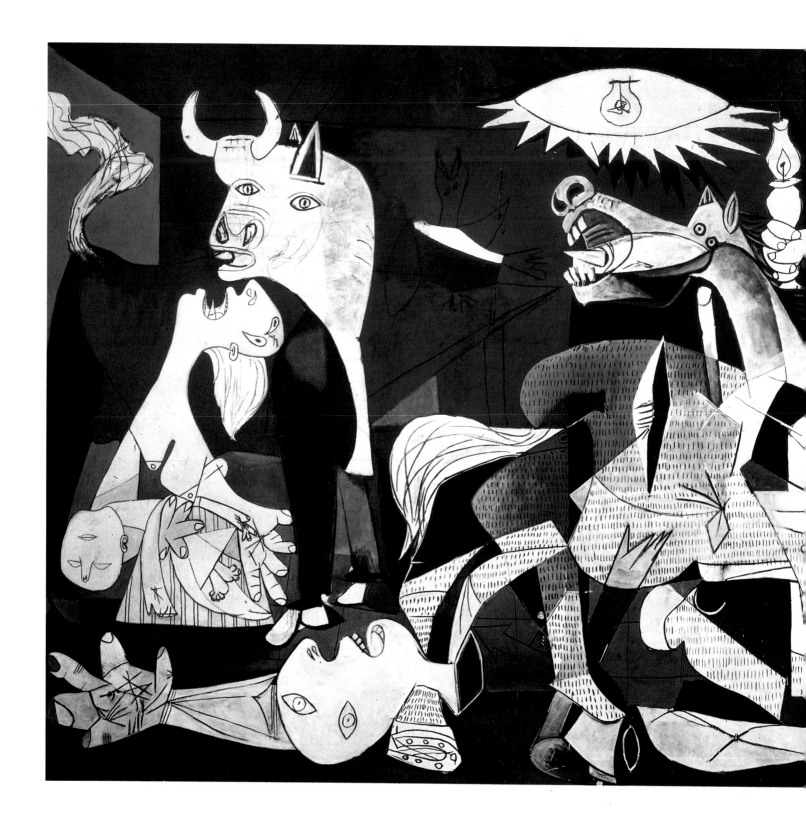

In fact Guernica, the great symbol of the terror of war, had prompted an allegorical composition. The painting is monumental in effect but not oppressive. The horizontal-format composition uses seven figures, or figure groups; it is clearly yet subtly divided up. Two presentations occupy the left and right sides, with a flat triangle between. In the middle, unnaturally posed, stands a wounded horse, its neck wrenched to the left, its mouth wide open in pain. To the right, from a square space, are a stylized human head in profile and an arm holding a lighted oil lamp over the scene. Above the horse's head is an ambivalent motif: a large eye of God, surrounded by a circlet of irregular jags, with a lightbulb for a pupil – standing for sunlight as well as electric light. To the right of the horse a woman is hurrying, her pose

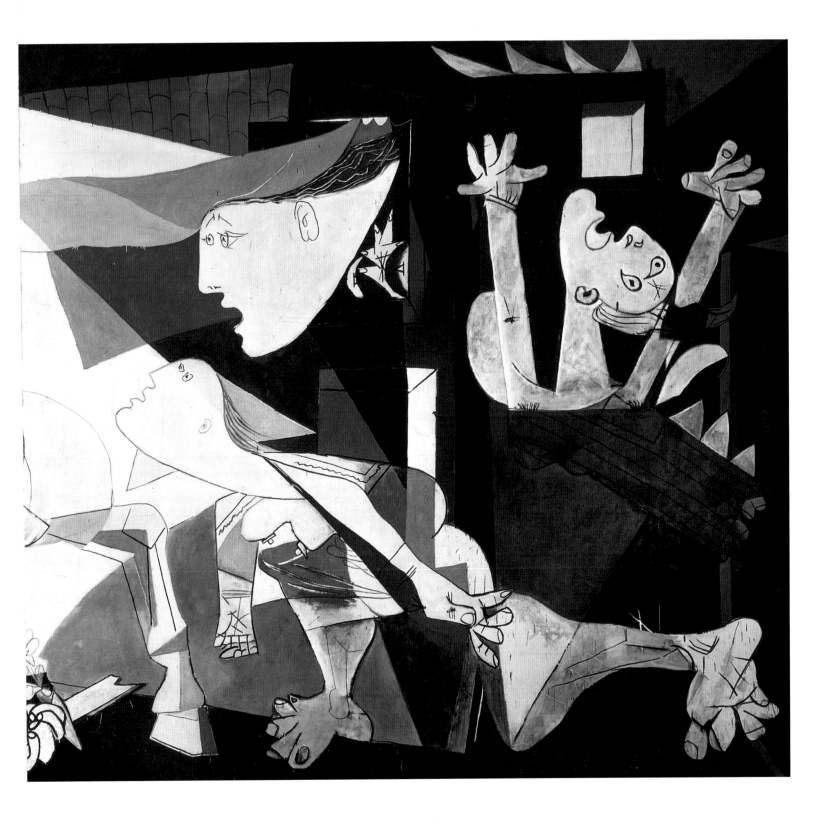

plainly conceived to fit the falling diagonal: this is where the central group is completed, in compositional terms. A counterpart to this figure is a warrior statue on the ground to the left below the horse, its arms outstretched, a broken sword in one hand. The statue has been smashed into hollow pieces.

Picasso avoids the involuntary rigidity of precision composition. The sun and lamp are to the left, the equally striking white house wall to the right of the painting's central vertical axis. Above the smashed statue stands a unified group. A mother is kneeling before a bull, screaming, holding her dead child in her arms. A corresponding figure at the right edge of the canvas has its head flung back, mouth open to cry out, and arms stretched heavenwards in a gesture of profound emotion.

Guernica, 1937
Oil on canvas, 349.3 x 776.6 cm
Madrid, Museo Nacional Centro de Arte
Reina Sofía

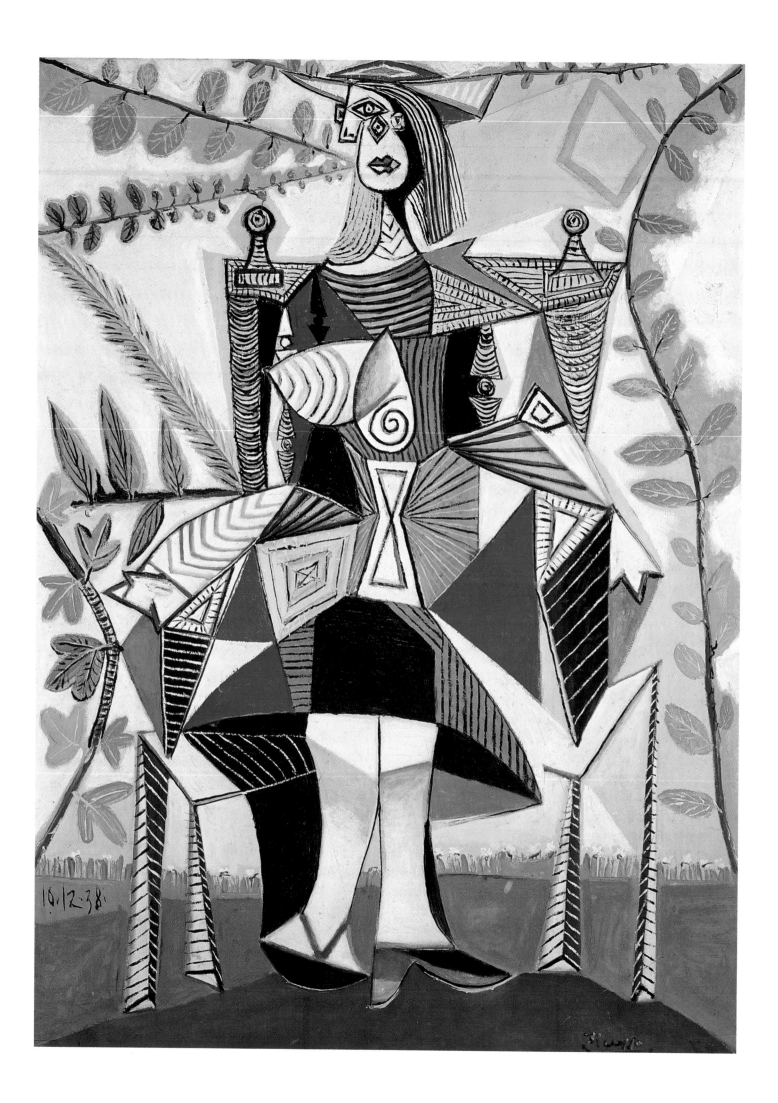

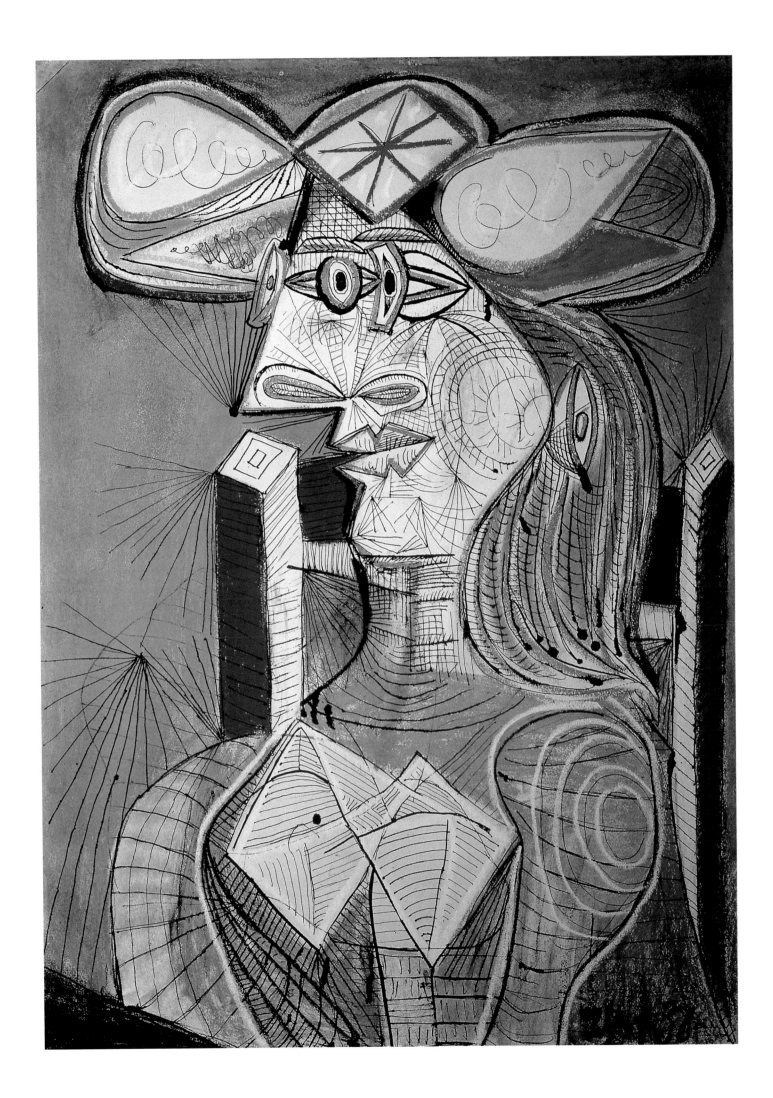

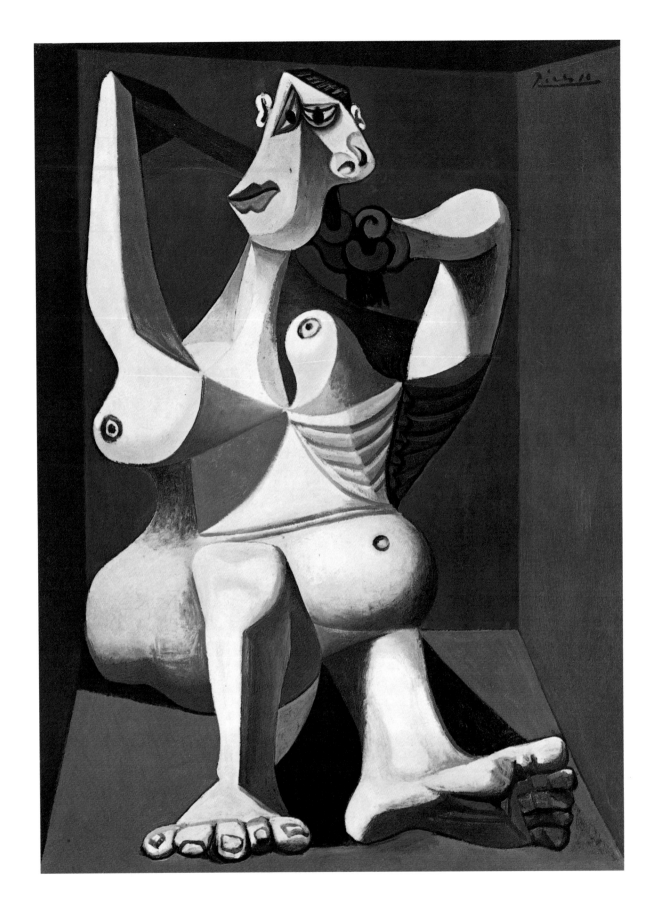

Nude Dressing Her Hair, 1940
Femme se coiffant
Oil on canvas, 130 x 97 cm
New York, Mrs. Bertram Smith Collection

156

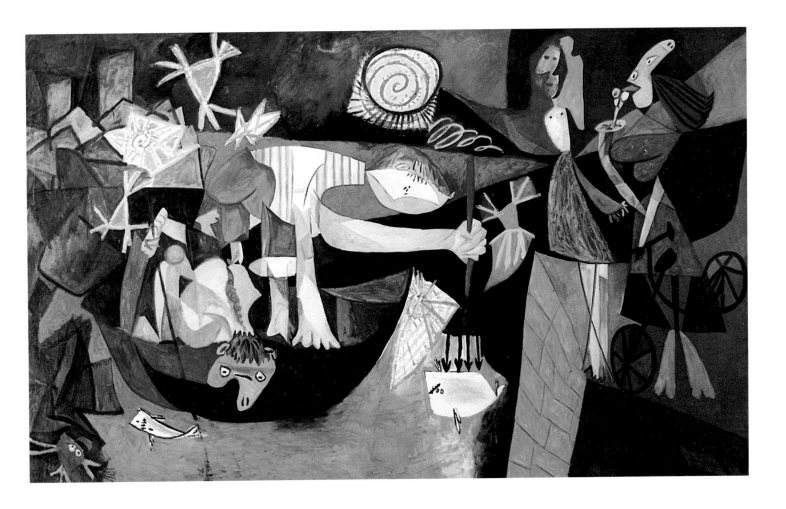

Once again, Picasso's stylistic quest had been catalysed by examination of source material. In this case, the key is the fourth sketch of 1 May, the first detail study for *Guernica* (preceded by three compositional drafts). The study shows a horse (p. 146, No. 4). It is drawn as a child would draw a horse, its physical proportions purely symbolic, all four legs and both eyes equally visible. In the third sheet (p. 146, No. 3) there are seemingly infantile uses of line as well. These, however, are a response to surrealist figural work. Both strands – children's drawings and Surrealism – were interwoven and important influences. In *Guernica* Picasso combined his linear style, widely termed classical, with surreal recordings of the subconscious; and the foundation on which the combination was established was the basic idiom of children's drawings. Children's principles determined his contouring, the use of detail motifs, and the perspective.

For Picasso, the idiom of children's drawings was evidently a completely new discovery. His early professional training had given him no opportunity to draw in a childlike way himself, nor had his own children prompted in him an awareness of the child's way of seeing the world. This is all the more remarkable when one considers that Picasso had actually portrayed his little son Paul drawing and painting (p. 111). It was not till the Thirties that Picasso, under the influence of Surrealism, occasionally admitted the child's manner to his work, as he did in *The Crucifixion* (1930; p. 132). Taking a detour through another style in art, Picasso came to value the expressive power of children's art. The Surrealists, looking for modes of expression that were untainted by existing mental and cultural pressures, had discovered children's creative powers for themselves. And that discovery in turn helped Picasso.

Night Fishing at Antibes, 1939
Pêche de nuit à Antibes
Oil on canvas, 205.7 x 345.4 cm
New York, The Museum of Modern Art,
Mrs. Simon Guggenheim Fund

PAGE 158:
Maya with a Boat, 1938
Maya au bateau
Oil on canvas, 61 x 46 cm
Luzern, Private collection

PAGE 159:
Portrait of Maya with Her Doll, 1938
Portrait de Maya avec sa poupée
Oil on canvas, 73.5 x 60 cm
Paris, Musée Picasso

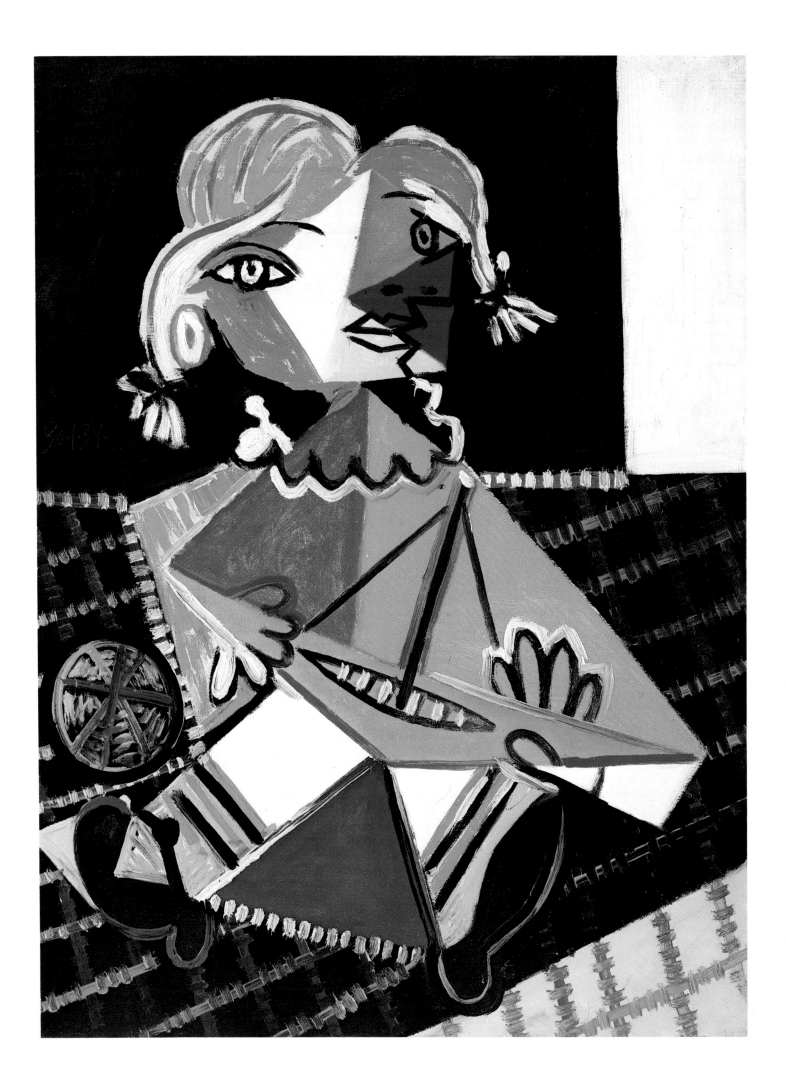

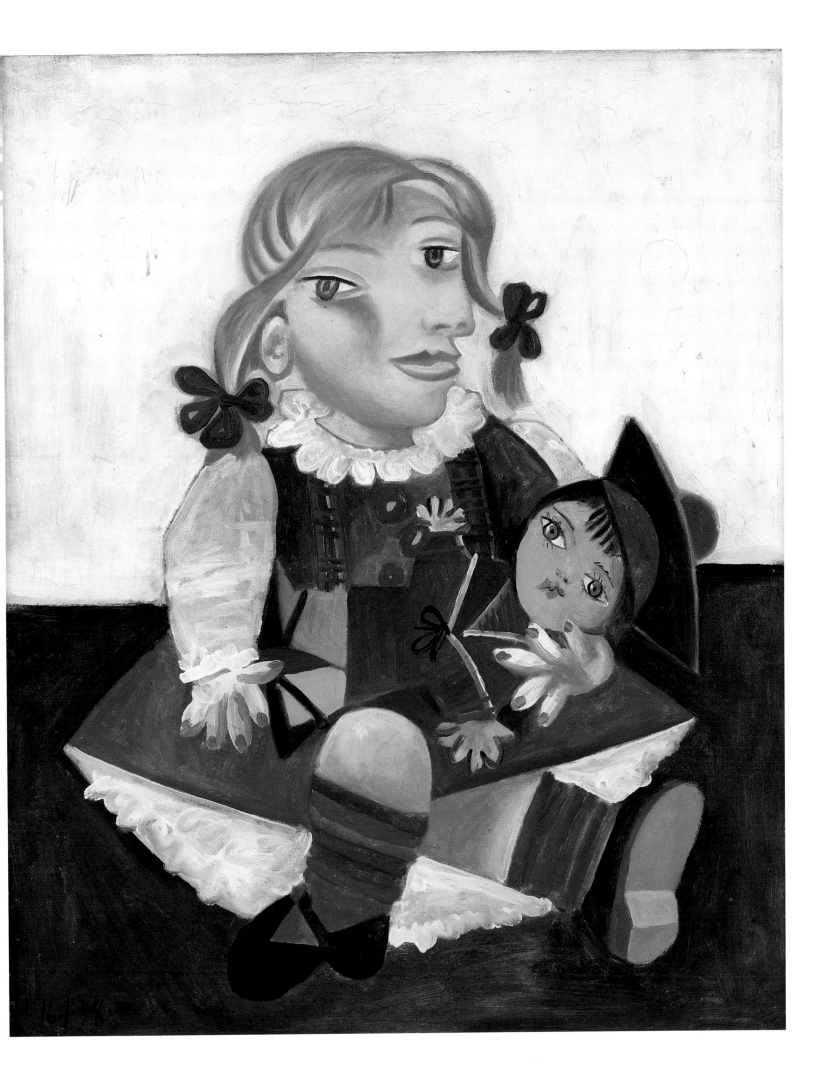

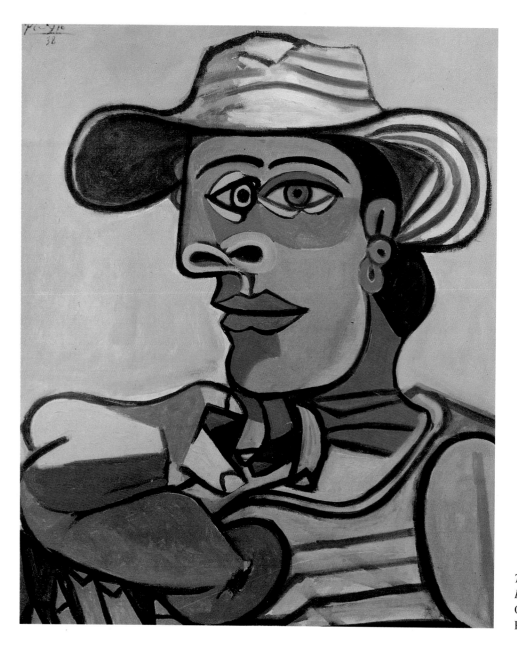

The Sailor, 1938
Le Marin
Oil on canvas, 58.5 x 48 cm
Private collection

Thus *Guernica*, for Picasso, became a great synthesis of the very various artistic approaches he had been taking since his period of so-called classicism. In *Guernica* he had arrived at the formal idiom with which we automatically associate his name. Since the great experiment of *Les Demoiselles d'Avignon*, the subsequent further development of Cubism, and the years of so-called classicism, two mutually contradictory principles of depiction had coexisted in Picasso's art. They may be labelled dissociation and figuration. Figuration is mimetic, representational art, handed down by tradition; dissociation is autonomous art, non-representationally departing from its subjects in the given world. In Picasso's work they alternate and exert a mutual influence.

Within the overall system of depiction, figuration and dissociation represent polar opposites. The former reproduces the subjective viewpoint, shows the subject as the beholder sees it. The laws of perspective apply: a subject viewed from the front cannot reveal its rear. That aspect of its appearance is left to the imagination, figuration relying upon the associative cooperation of the beholder. Dissociation, by contrast, includes the whole subject, shows the rear as well as the frontal view if it so wishes. In this respect it is more

The Yellow Sweater (Dora Maar), 1939
Le Chandail jaune (Dora Maar)
Oil on canvas, 81 x 65 cm
London, National Gallery, on loan of
the Heinz Berggruen Collection

160

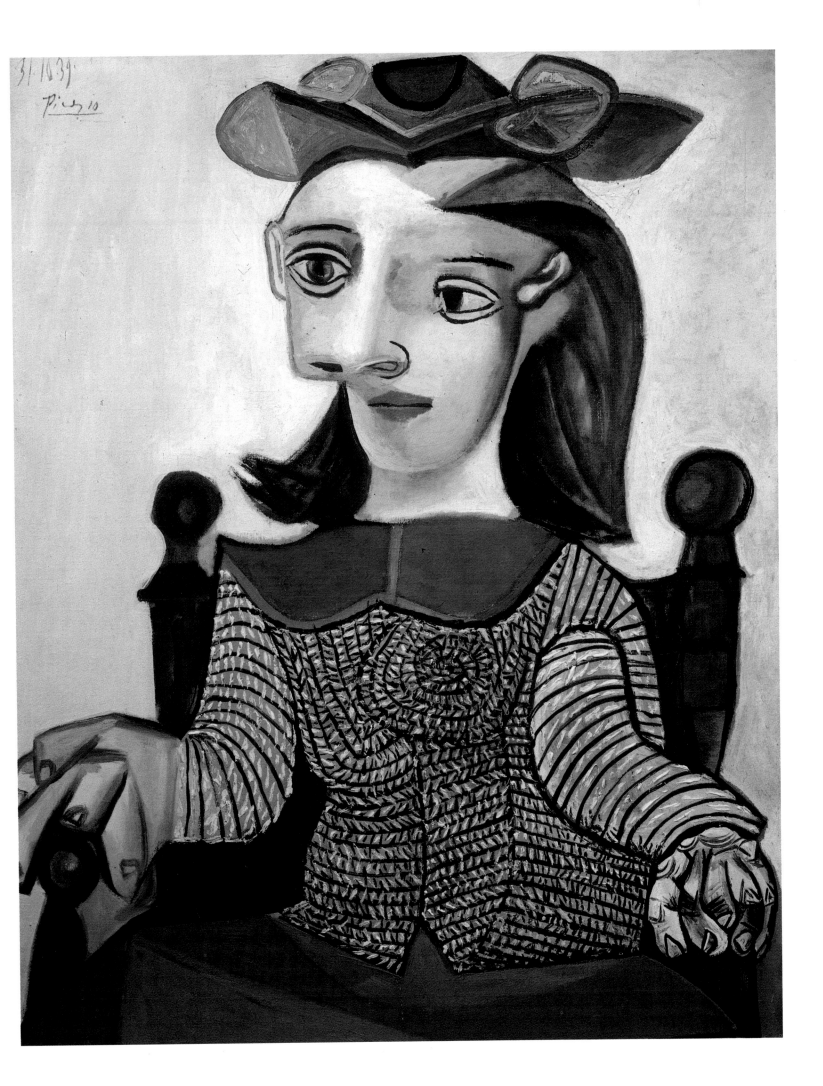

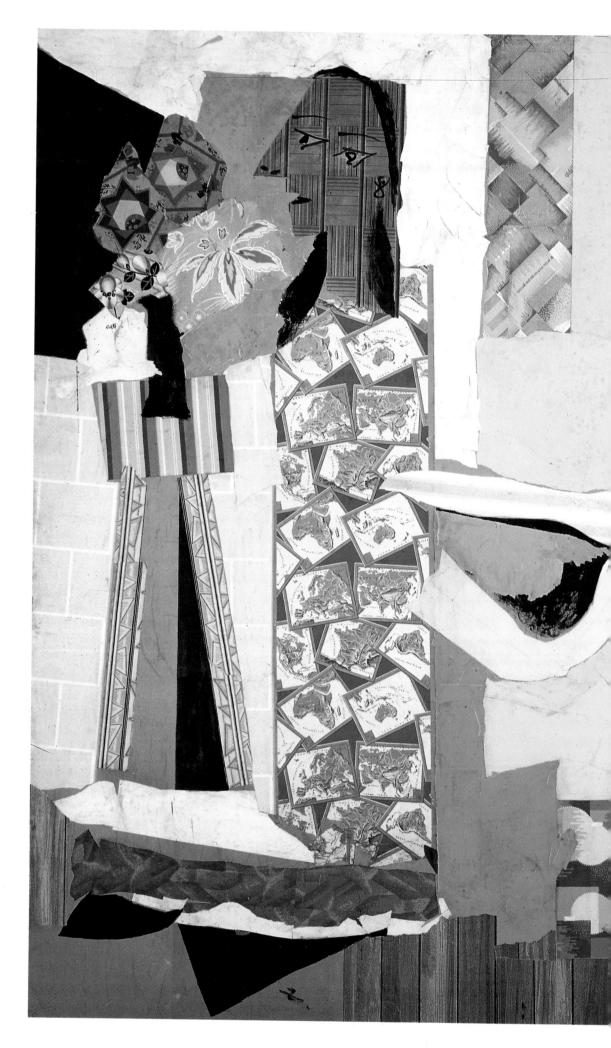

Women at Their Toilette, 1938
(Cartoon for a tapestry)
Femmes à leur toilette
Pasted wallpaper and gouache
on paper, 299 x 448 cm
Paris, Musée Picasso

162

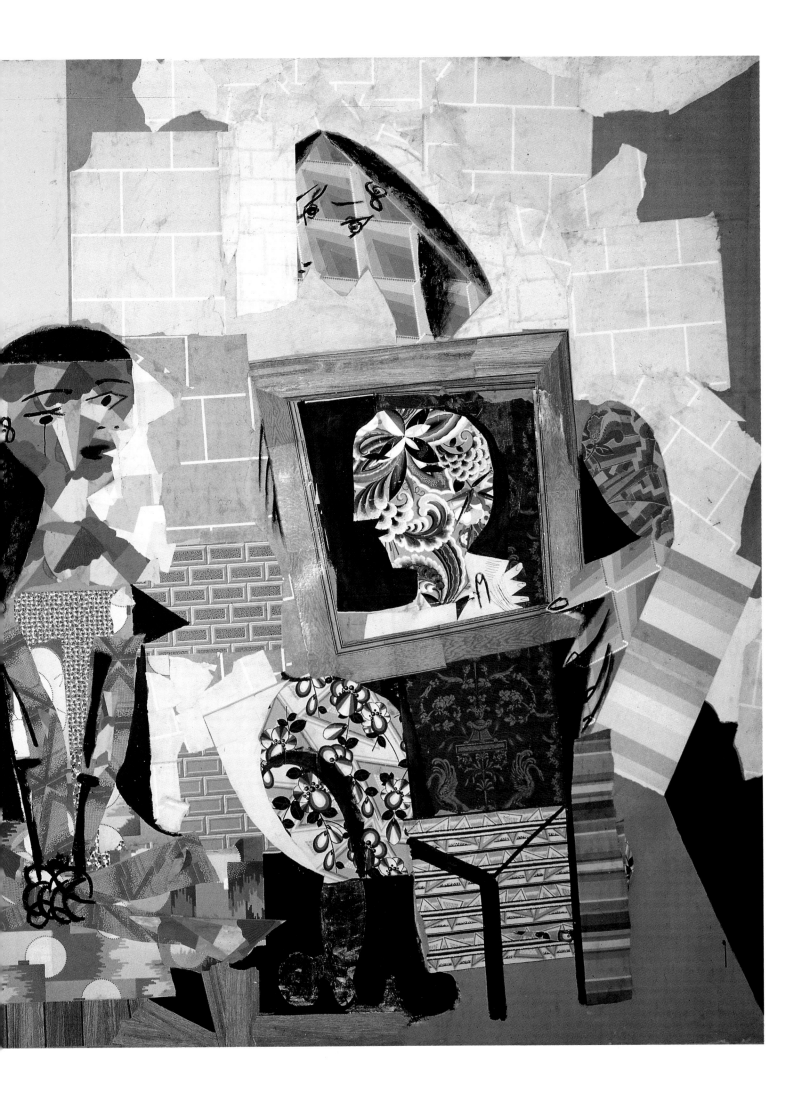

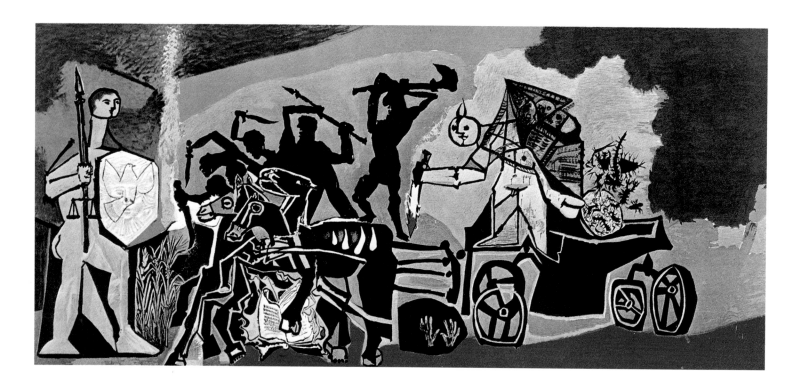

War, 1952
La Guerre
Oil on hardboard, 4.5 x 10.5 m
Vallauris, Temple de la Paix

The Temple of Peace at Vallauris
Photograph, 1952

objective. But the gain in terms of dissociative images is countered by a loss: the various elements can no longer be accommodated within a defined area, and the principle of a containing outline has to be abandoned. That principle belongs to figurative art: it includes everything in unified outlines, ensures that every subject is distinct from every other. The basic task for any depictive art seeking a synthesis of the two approaches is obvious. It has to introduce the gains of dissociative art into the realm of figuration, and vice versa. Picasso's new style did just that, using contoured, linear, figurative outlines without feeling compelled to represent the exact specifics of the given subject; and his options had been extended to include the figurative symbolism characteristic of children's art.

The portrait of his daughter Maya, done on 16 January 1938 (p. 159), clearly reveals how capriciously Picasso handled this new system. The little girl is sitting on the floor, a doll in her arm. Her legs and skirt are rendered as geometrical blocks, unnaturally crossed; the legacy of Cubist dissociation is unmistakable. Her face shows the familiar combination of profile and frontal angles, the two angles not additively juxtaposed in Cubist manner but simultaneously present, as in a superimposed photograph. Picasso more or less retains the natural proportions. There is just one striking exception: the girl's right arm was painted as a child might have painted it, a short stump ending in sketchy shapes that stand for five spread fingers.

Cubist dissociation, figuration and childlike symbolism are the three foundations on which the formal idiom of the "Picasso style" was built. They made possible a vast potential of variation. Every one of these formal systems consists of a number of characteristic features which only define a system once they appear together. But these features can be used separately, or combined with others. This fact is illustrated by a study of a *Seated Woman* done on 27 April 1938 in India ink, gouache and crayon (p. 155). It is a study in both the autonomy and the functionality of the line. The woman's head is done in the familiar combination of frontal and profile; and, in the process, the line as an instrument for conveying form has taken on an independent life of its own. Admittedly an identifiable image of a body has been

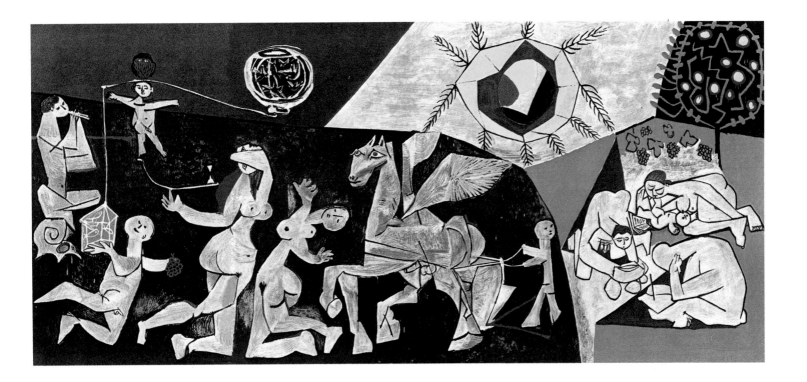

Peace, 1952
La Paix
Oil on hardboard, 4.5 x 10.5 cm
Vallauris, Temple de la Paix

produced, and thus a certain representational value; but the picture is a fabric of webs and meshes. This use of lines totally alters the character of the image. The line is no longer subordinated to representation of the sitter; rather, the seated figure is an excuse to play with lines. Naturally enough, most of the forms are angular. In the December 1938 *Seated Woman in a Garden* (p. 154) Picasso went on to combine autonomy of block with autonomy of line. Since *Guernica*, Picasso had essentially been ringing the same changes on the fundamentals of visual presentation as he had been doing in the Cubist phase.

What did make a considerable difference was the fact that his free variation was now always contained within a defined outline, a figural shape. An important work that used the new method of depiction grew out of the work on *Guernica*. After he had completed that enormous canvas, Picasso did a number of studies on the time-honoured subject of grief, showing a woman weeping into a handkerchief. Using his combined dissociative and figurative method, he dissected the faces into lines and experimented with various colour bases applied in different ways. When he had tried out combinations to his satisfaction, he produced an oil of moderate size which he completed on 26 October 1937 (p. 150). Again the composition combines a frontal and profile view of the face. Furthermore, the face has also been splintered into shards contoured with thick lines, and these shards, painted in shades of varying degrees of aggressiveness, serve to heighten an overall impression of shattered nervousness. The handkerchief, hand and face interconnect (and in this respect extend the method used in *Les Demoiselles d'Avignon*); the treatment defies the natural definition of the individual motifs. This is the most fractured portion of the picture, and the rest of the head, and the background, are juxtaposed in relative tranquillity and clarity of definition. The composition perfectly conveys the act of crying; it catches the expression of profound emotional crisis exactly.

Picasso can well afford to dispense with conventional attention to detail. Only the one or two rounded shapes suggest tears; the anecdotal flavour of big round sobbed tears has been carefully avoided. Here, it is the shattered

Head of a Bull, 1942
Tête de taureau
Bicycle saddle and handlebars,
33.5 x 43.5 x 19 cm
Paris, Musée Picasso

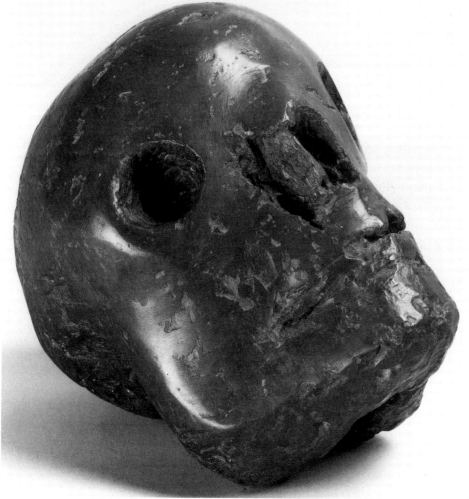

Death's Head, 1943
Tête de mort
Bronze, 25 x 21 x 31 cm
Paris, Musée Picasso

Still Life with Steer's Skull, 1942
Nature morte avec crâne de bœuf
Oil on canvas, 130 x 97 cm
Düsseldorf, Kunstsammlung Nordrhein-
Westfalen

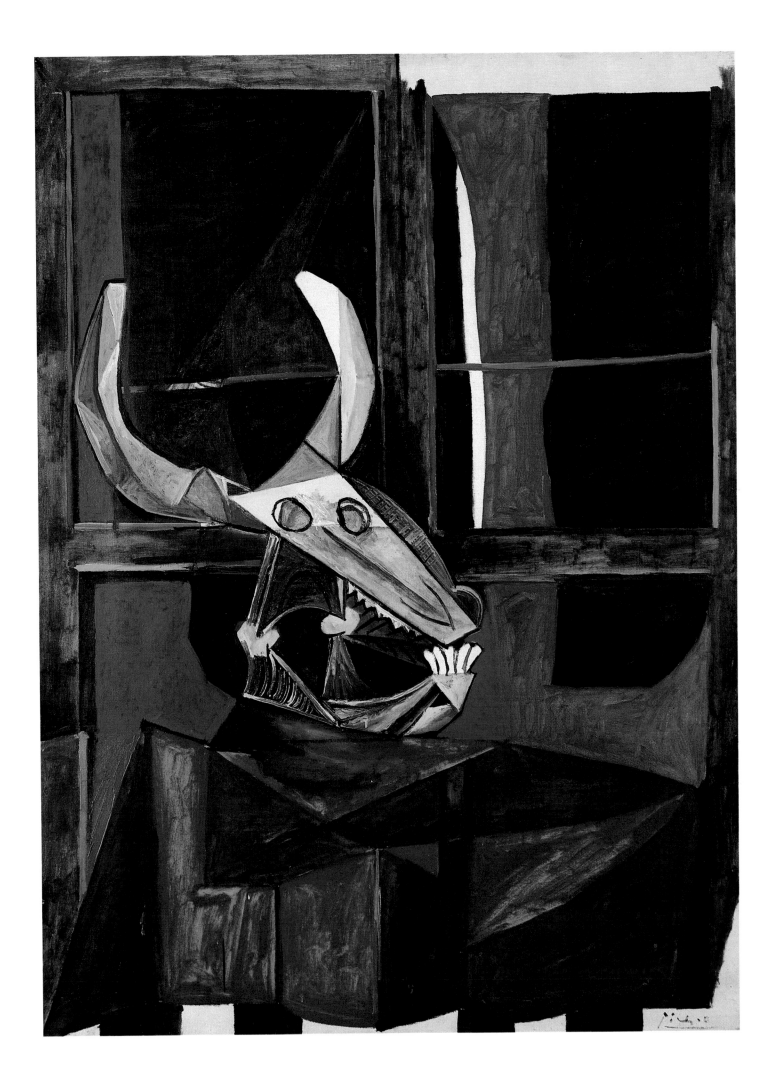

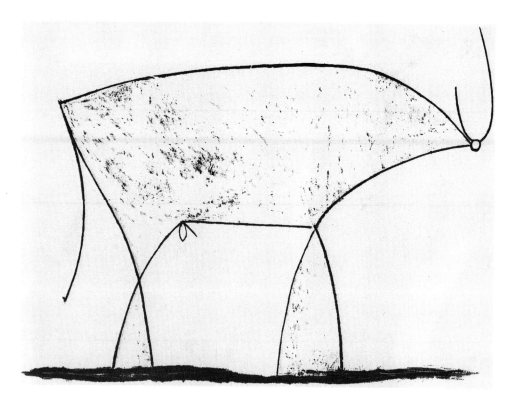

The Bull, 1946
Le Taureau
Lithograph, 28.9 x 41 cm

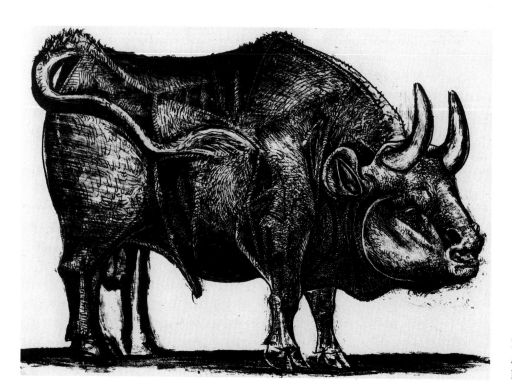

The Bull, 1945
Le Taureau
Lithograph, 28.9 x 41 cm

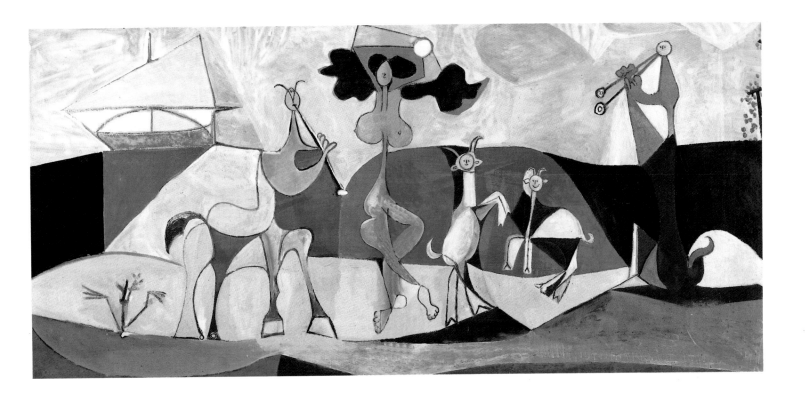

The use of this tight compositional grid introduced a note of disquiet: the figure's attitude calls for elbow room, but space is precisely what this painting, in a direct appeal to our emotions, denies her. Picasso has emphasized this disquiet. The figure's bodily proportions are unnatural. The feet still follow nature, albeit in crudely simplified form; but thighs, knees and calves are harshly juxtaposed, angular areas of light beige and dark brown. The figure is rendered with extreme foreshortening, a capricious use of perspective, and a playful rethinking of the elements of visual presentation. Whole parts of the body (such as the left thigh) are simply left out. The face is no longer an overlapping yoking of frontal and profile views; rather, the silhouette and full-face are crudely juxtaposed at different heights. There is a curious duality in the way the figure has been done. It might be described as mechanization of the organic, and stylizing of the mechanical, both principles so interwoven that it is difficult to make out what is happening in the picture. Though Picasso was plainly performing a variation on stylistic approaches he had already tested, *Nude Dressing Her Hair* was not spontaneously done. In fact a large number of sketches and studies preceded it. In all, Picasso worked on *Nude Dressing Her Hair* for a full six months.

Picasso's serial work had an unmistakable, strongly self-referential component. His fruitful interest in the work of contemporaries had waned. This, however, was less the fault of the artist than of the age: it was, after all, a time of pre-war crises, the Second World War, and the occupation of France by the Germans. The political situation forced Picasso into isolation. First, he was cut off from his homeland by the Spanish Civil War and the victory of Franco's Falangists. And then, after the German invasion of France, the Paris art scene changed in a way that peculiarly affected Picasso, the great practitioner of Modernism. A group that had previously been marginalized, a group whose anti-modern position had rendered it unimportant for the evolution of the arts, was now dominant in the official scene in France. As in Fascist countries, so too in France, political change had brought with it the triumph of reactionaries in the arts. Not that the Modernists did not defend

La Joie de vivre (Pastorale), 1946
Oil on hardboard, 120 x 250 cm
Antibes, Musée Picasso

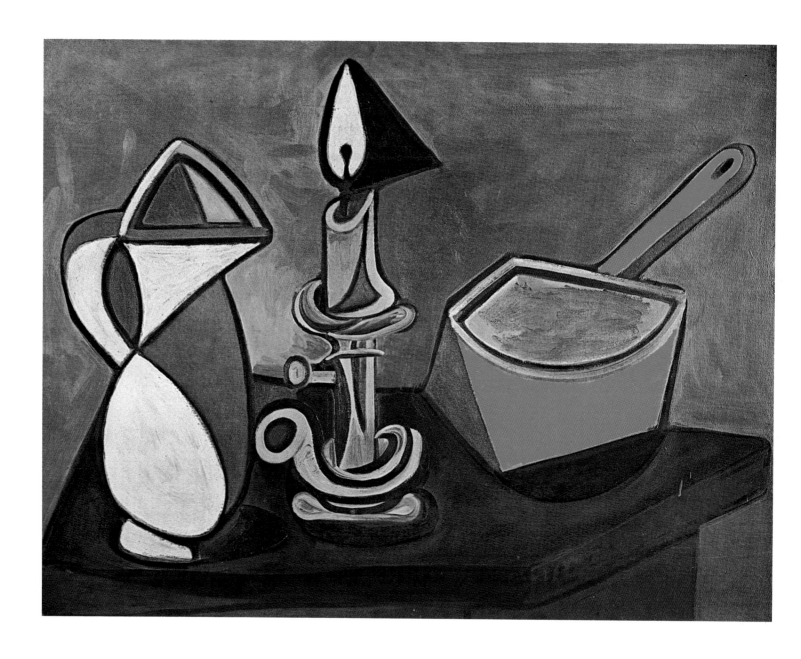

their position vigorously. Indeed, two fronts were defined. On the one side were the reactionary, nationalist advocates of traditional art, and those artists who collaborated with the Nazis. On the other were young French artists, such as Charles Lapicque and Jean Bazaine, who exhibited in a 1941 show of Modernist painting. Like other radical Modernists, such as Alfred Manessier, Nicolas de Staël and Jean Dubuffet, their endeavours all tended to the continuation of pure abstraction.

For Picasso there was no room – as a contemporary artist, that is, rather than a mere cult figure of the Modernist movement. Thus he was doubly isolated during the war. True, his studio was open to German visitors; but when they came he would give them postcard reproductions of *Guernica*, and on one famous occasion, when a German officer asked Picasso, "Did you do that?" the artist replied, "No, you did." Moreover, when he ran out of fuel, he declined to accept special favours as a non-French national, and observed: "A Spaniard is never cold."

Though his personal situation was a melancholy one, Picasso's fame abroad was then growing apace. In America in particular, Picasso came to be recognised as the foremost modern artist in those years. In the year 1937, the newly-founded Museum of Modern Art in New York bought *Les Demoi-*

Pitcher, Candle and Enamel Saucepan, 1945
Pichet, bougeoir et casserole émaillée
Oil on canvas, 82 x 106 cm
Paris, Musée National d'Art Moderne,
Centre Georges Pompidou

Seated Woman in an Armchair, 1948
Femme assise dans un fauteuil
Oil on canvas, 100.5 x 81 cm
Private collection

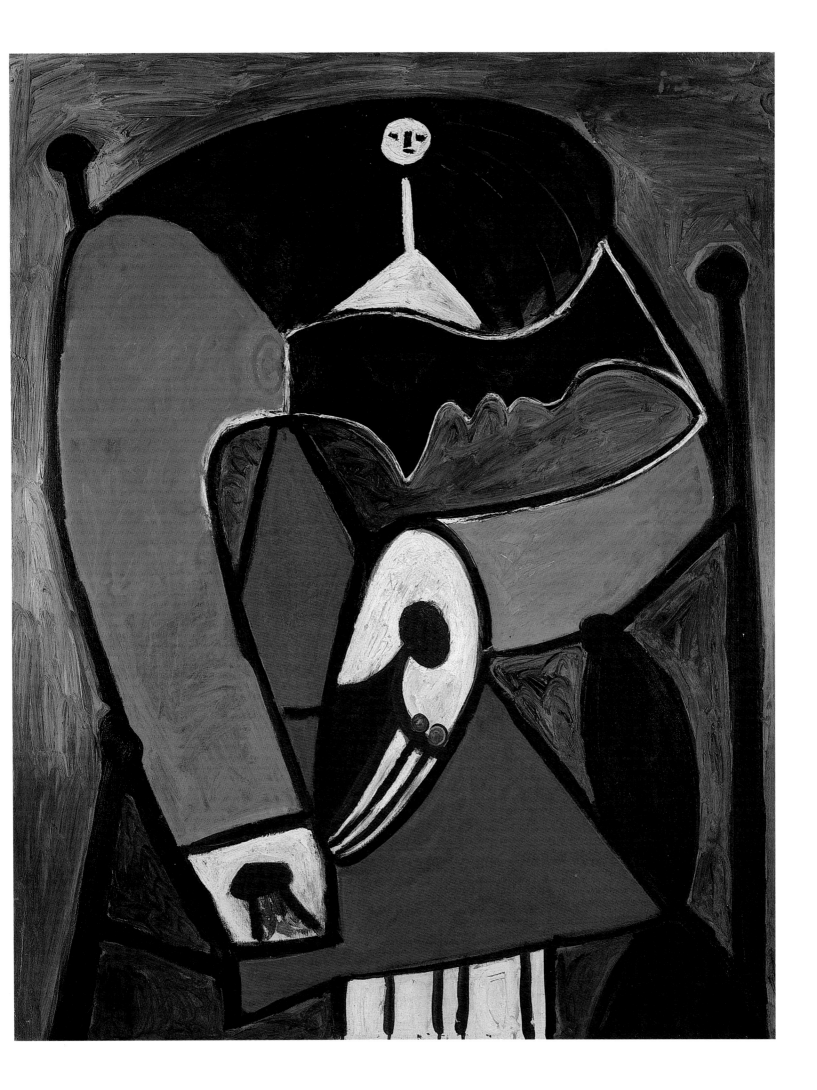

Plate: *Goat's Head in Profile*, 1950
White clay, relief painted with oxidized
paraffin, glazed
Diameter: 25.5 cm
Private collection

Plate: *Goat's Head in Profile*, 1950
White clay, relief painted with oxidized
paraffin, glazed
Diameter: 25.5 cm
Private collection

Vase: *Flute Players and Dancers*, 1950
Red clay, moulded on the wheel, decoration
with carving and engobe
Height: 70 cm
Private collection

selles d'Avignon, and in 1940, together with the Art Institute of Chicago,
mounted the major retrospective "Picasso. 40 Years of his Art", which was
seen in no fewer than ten major American cities. In the eyes of the Ameri-
cans, the tour established Picasso as the most important living artist of the
century.

The Allied landings and the reconquest of France, followed by the end of
the Second World War, marked a turning point in Picasso's life. Suddenly he
became what he had not been (to the same extent) before: a public figure.
Ever since he had been recognised as the founder of modern art, his fame
had spread, albeit within the cultural sector only. He was internationally
known, though purely as an artist. With the entry of the Allies into Paris,
two factors enhanced his status: the growth of his overseas reputation, and
the post-war reinstatement of Modernism at the heart of the arts and political
life. Picasso, more than any other, was the artist whose studio soldiers, gal-
lery owners and reporters wanted to visit. Photographers such as Lee Miller
and Robert Capa documented his life and work in entire series of pictures;
and these photos, widely seen in the mass media, earned Picasso enormous
popularity. As the leading practitioner of an art condemned by the Fascists,
and as a man who had not yielded an inch to them, Picasso became a cult
figure. Anything he said was eagerly noted, printed and parroted.

He was of great importance for the new political and arts scene in lib-
erated France. Just six weeks after the Allies entered Paris, the autumn salon
– the "Salon de la Libération" – opened its doors, on 6 October 1944. It was
the first programmatic expression of Picasso's central importance: he had no
fewer than 74 paintings and five sculptures in the exhibition.

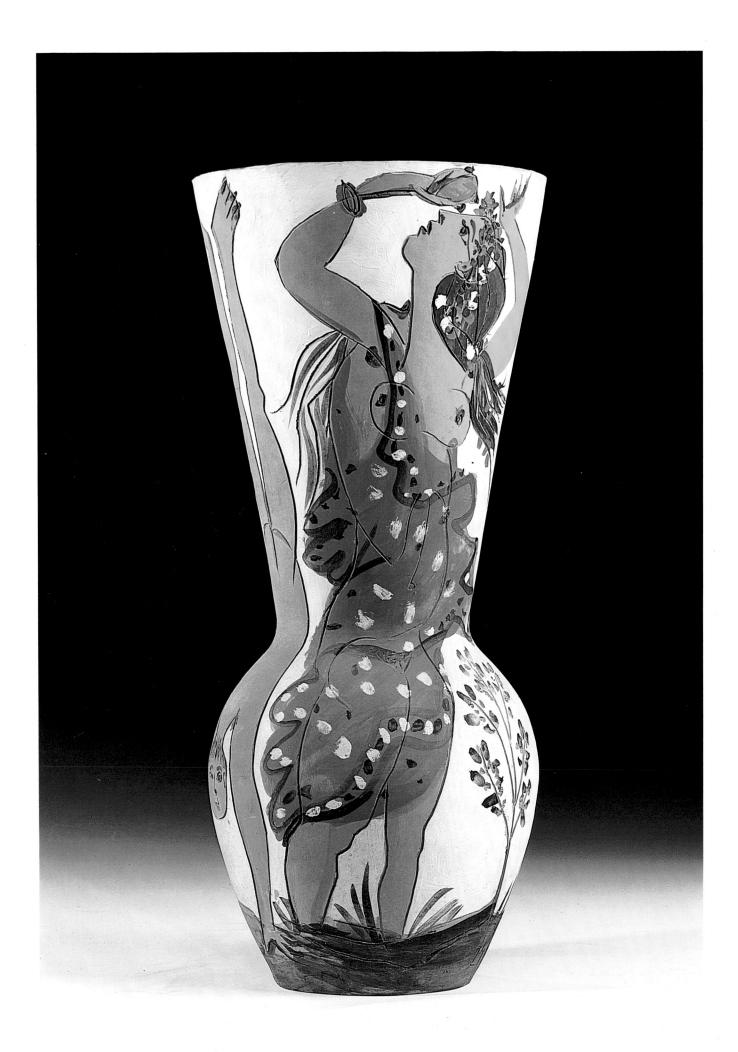

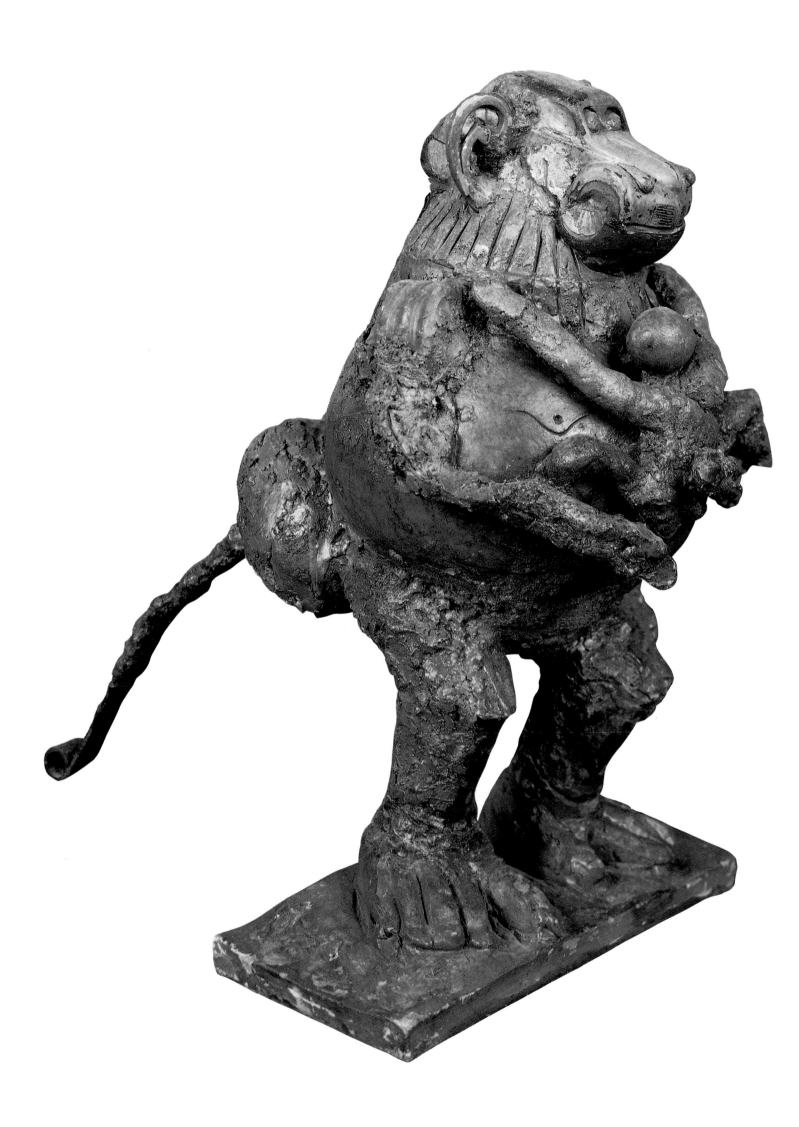

It was in fact the first Salon he had ever shown at; his participation constituted the first official recognition by his French fellows. His political stance and his standing as an artist went hand in hand – and provoked immediate reactions, too. Artistic and political reactionaries, the stragglers of Pétain's regime, attempted to tear down his pictures from the walls, and prompted a scandal. The French society of authors took Picasso's side. The day before the Salon opened, there was news that only served to exacerbate tempers: Picasso had joined the Communist Party of France.

It was a logical consequence of recent history, the expression of his ideals: art, he believed, was not so much something to prettify the home as a weapon in a political struggle. And indeed, many of the works that followed in rapid succession attest to Picasso's involvement in the concerns of the times. Not that those works were an art of direct statement. For instance, in 1945 Picasso painted a number of still lifes that glance at the privations and fears of life during the occupation. Surely the most important of these is *Pitcher, Candle and Enamel Saucepan* (p. 172). The picture shows three objects only. It draws upon crucial formal insights that Picasso had developed in his great *Guernica*. Here too, tried and tested stylistic modes serve to question and undermine what appears unambiguous, but at the same time to render it universally valid. A number of perspective viewpoints – front, side and rear – jointly establish unified, clear outlines that do not correspond with the picture's spatial values. On a brown tabletop we see a pitcher, a burning candle and an enamel saucepan, lined up at only slightly different degrees of visual depth. The bright yellow of the brass candlestick is the strongest colour, strikingly contrasted by the acid blue of the saucepan. Shades of grey, green and brown, and large patches of white, lend stability to this restless colourfulness, so that the overall impression of the canvas is one of subdued colour. The power of the pure colours seems muted, despite the decidedly aggressive use of the yellow and blue. Thus the expressive values of the colours waver between the bright and the subdued. They are unstable. Similarly with the light: the candle's big flame and black shadow convey an appearance of brightness, yet the lit sides of the three objects are on the sides away from the light. It is not light with any real illuminative power; it is symbolic light. The painting's symbolism is simple, using everyday household objects to suggest the difficulty of life under the occupation.

Symbolic form, a compacted artistic treatment of given reality, and translation of the everyday wretchedness of war into an urgent though not superficial visual idiom, are all to be found in a major Picasso done at the very end of the war: his great composition *The Charnel House* (p. 166). It was inspired by a Spanish film about a family killed in their kitchen. When Picasso was working on the painting from February to May 1945, he was influenced by the first photographs of liberated German concentration camps – though this dimension only entered the work at a late stage, as the composition was already fixed in formal terms before any of the photographs were published. This only lends additional weight to the painting's statement, though, taking as it does political terror as its subject.

The picture shows a heap of corpses after an execution. One figure, still tied to a post, is collapsing onto the others. It was only during the course of Picasso's work on the painting that the location became more precisely defined. Greyish blue, white and black areas denote walls, floor and posts, a set of architectonic props that suggest both exterior and interior, as in *Guernica*.

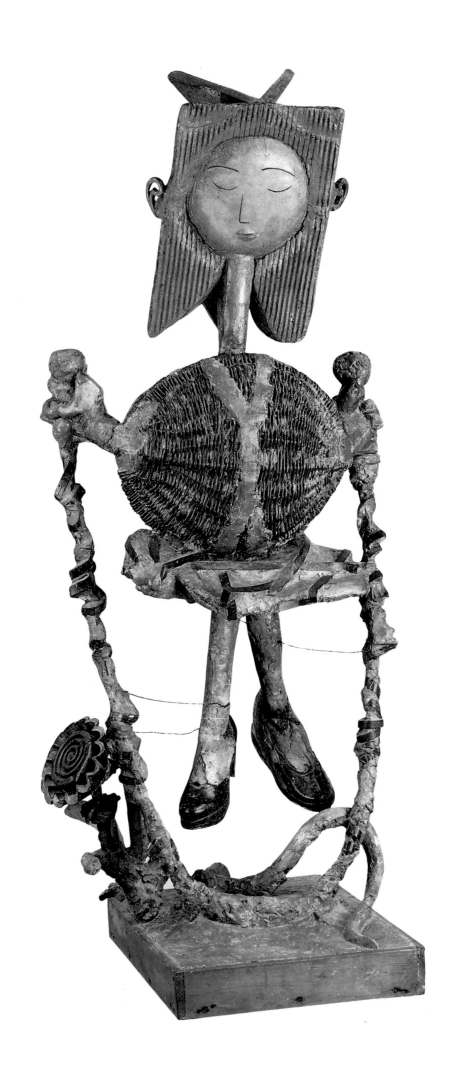

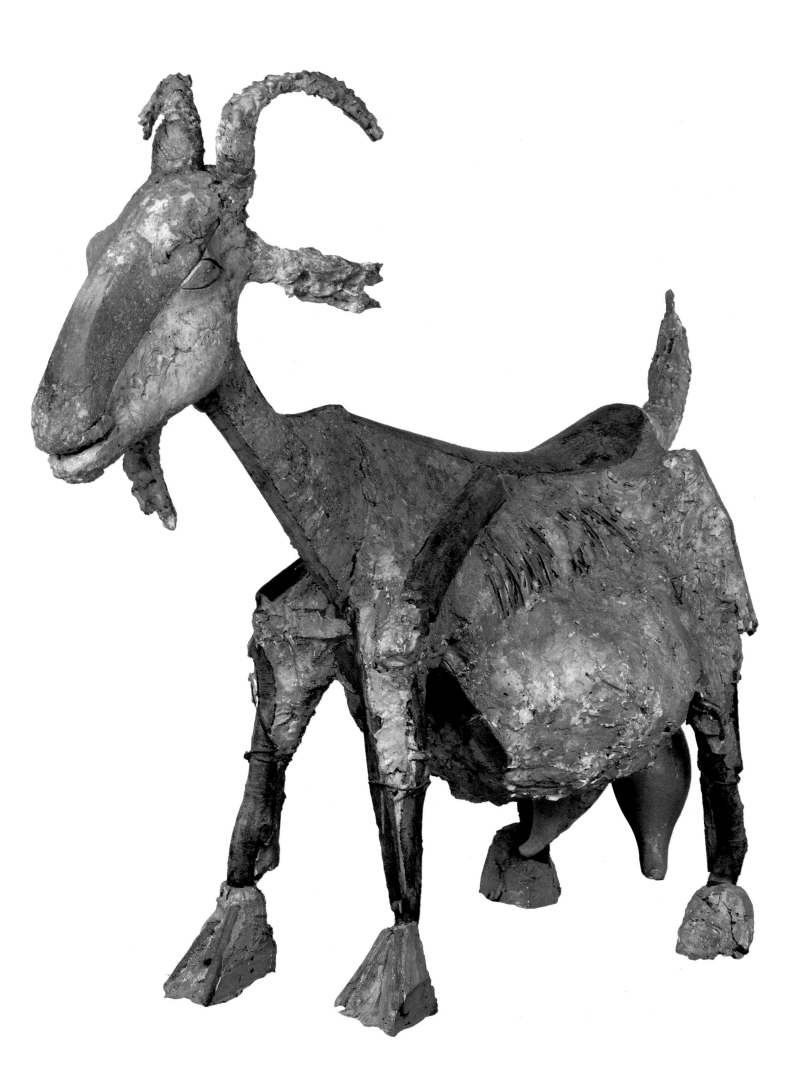

El Greco
Portrait of Jorge Manuel Theotocopulos,
c. 1600–1605
Oil on canvas, 81 x 56 cm
Seville, Museo de Bellas Artes

The still life of kitchen utensils at top left of *Guernica* is not only a glance at the film original; it also underlines the everyday banality and ubiquity of terror. It can hit anyone, anywhere, any time. Even more than in *Guernica* the monochrome scheme, the linearity and the use of areas of unbroken colour serve to make a universal of the statement. First Picasso sketched in the simple outlines of his stylized figures, heaping them so that the lines are interwoven, creating a tangled network that defies distinction of separate forms. Later he filled in some of the segments, so establishing an equilibrium of figural and spatial motifs. (Only the line-drawing still life remains different.) The heap of bodies can be seen as replicating the destruction of individual identity in the world of totalitarian terror. Human beings cannot even preserve their individual physical identities; even their bodies are taken from them.

But six years later things looked somewhat different when he painted *Massacre in Korea* (p. 186/187). The Korean War had begun six months earlier. The painting was Picasso's protest at the American invasion. Shown at the May Salon in Paris, it took sides in a war of ideologies. And its formal idiom was an unambiguous, partisan one, using handed-down simple symbols and only sparingly heightening the figural naturalism with cautious touches of the dissociative. We see the good and evil sides in straightforward confrontation on an extremely broad format. Four naked women, rigid with fear, and their four similarly naked children (the nakedness symbolizing defencelessness), are being aimed at by six soldiers armed to the teeth (symbolizing far superior power). The soldiers' postures seem at once mechanical and archaic; they are ancient warriors transmuted into death-bringing robots. A green, sweeping, simplified landscape featuring only a single ruined house is the backdrop to the composition.

For his work on it, Picasso drew upon a number of cognate works, in particular Edouard Manet's famous painting *The Execution of Emperor Maximilian in Mexico* (1868), Francisco de Goya's *3rd May 1808* (1814), and Jacques-Louis David's *Rape of the Sabine Women* (1799) and *The Oath of the Horatii* (1784). This blatant use of other paintings is in line with the one-dimensionality of the painting's form and content. It is very different from other pictures of similar subject.

Plainly a naturalistic, representational image is in the foreground. What counts for Picasso is the message. Consistently, he has presented the action as a picture within a picture. It is worth examining this defamiliarization. Mimetic representation was far more in line with public expectation than the formal idiom of Modernism, and could therefore count on a more approving response. In this we see the predicament of political, ideological art. Since the early days of Stalin, international Communism had been advocating realism as the only acceptable mode of artistic work. The French Communist Party toed this line too. It was an urgent dilemma for Picasso, as became clear at the 1945 Party congress, which gave him an accolade as man and artist but nonetheless called for realism in art.

Communist ideology saw art as a weapon in a political struggle that embraced every area of human activity. It is true that Picasso saw matters in exactly the same light, and considered himself a Communist artist painting Communist art; but he preserved a distance from art whose form was dictated by the Party, and always insisted on his own independence as an artist. *Massacre in Korea* was a special case, an attempt to reconcile opposite points of view.

Portrait of a Painter (after El Greco), 1950
Portrait d'un peintre (d'après El Greco)
Oil on plywood, 100.5 x 81 cm
Lucerne, Angela Rosengart Collection

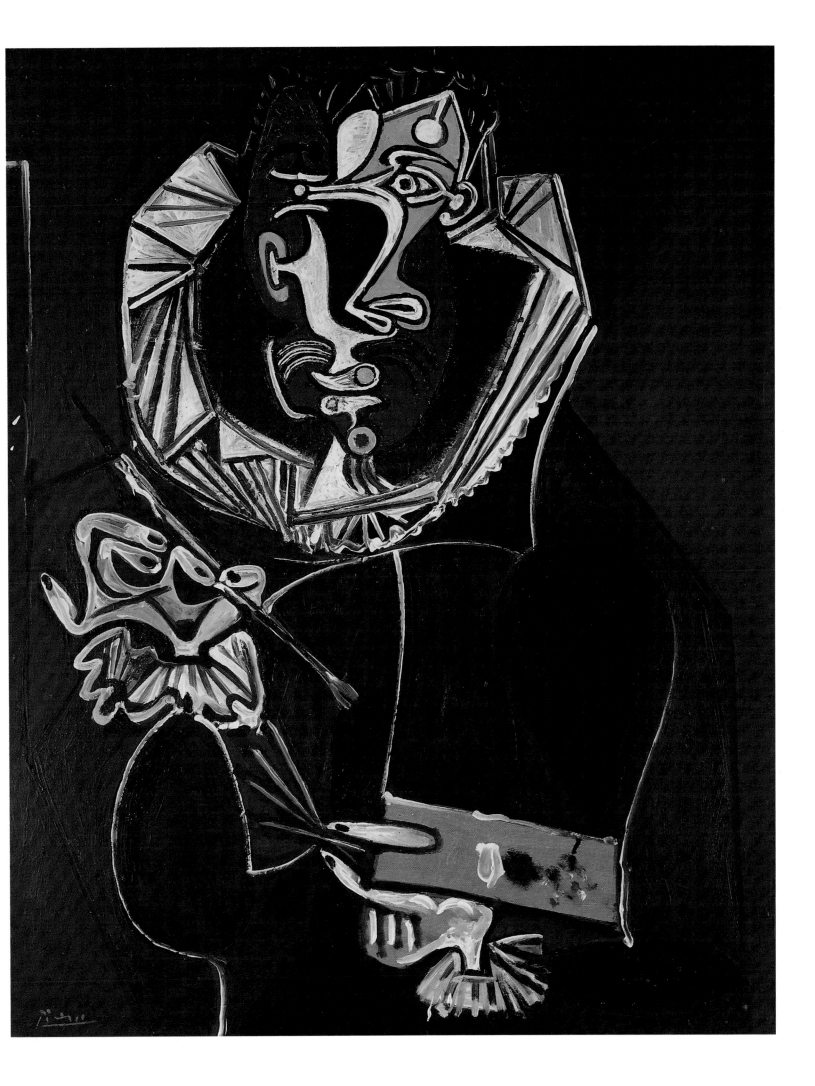

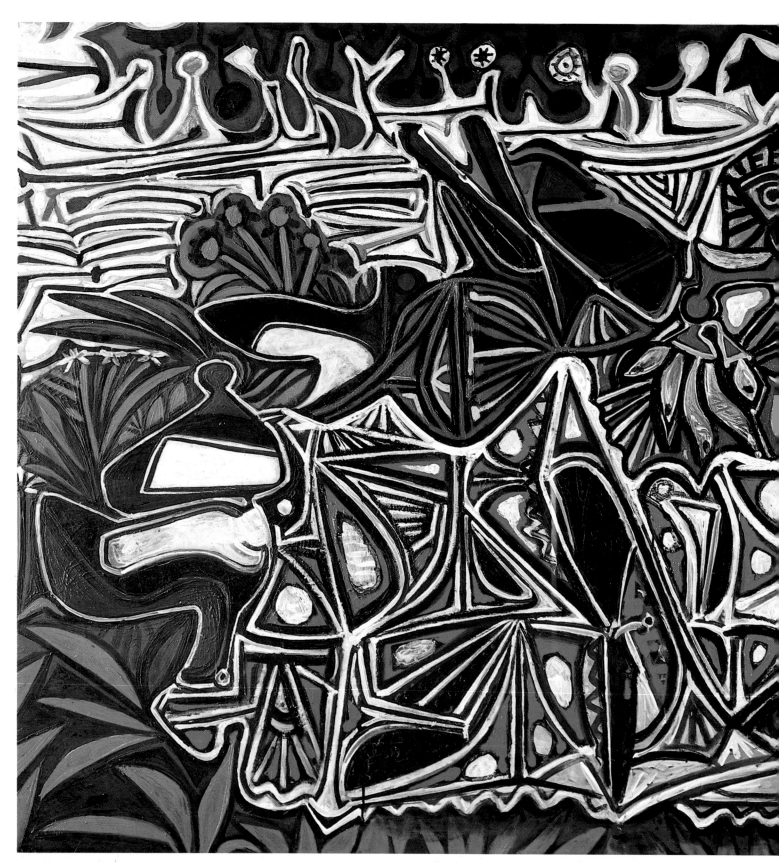

Gustave Courbet
Young Women on the Banks of the Seine, 1857
Les Demoiselles des bords de la Seine
Oil on canvas, 173.5 x 206 cm
Paris, Musée du Petit Palais

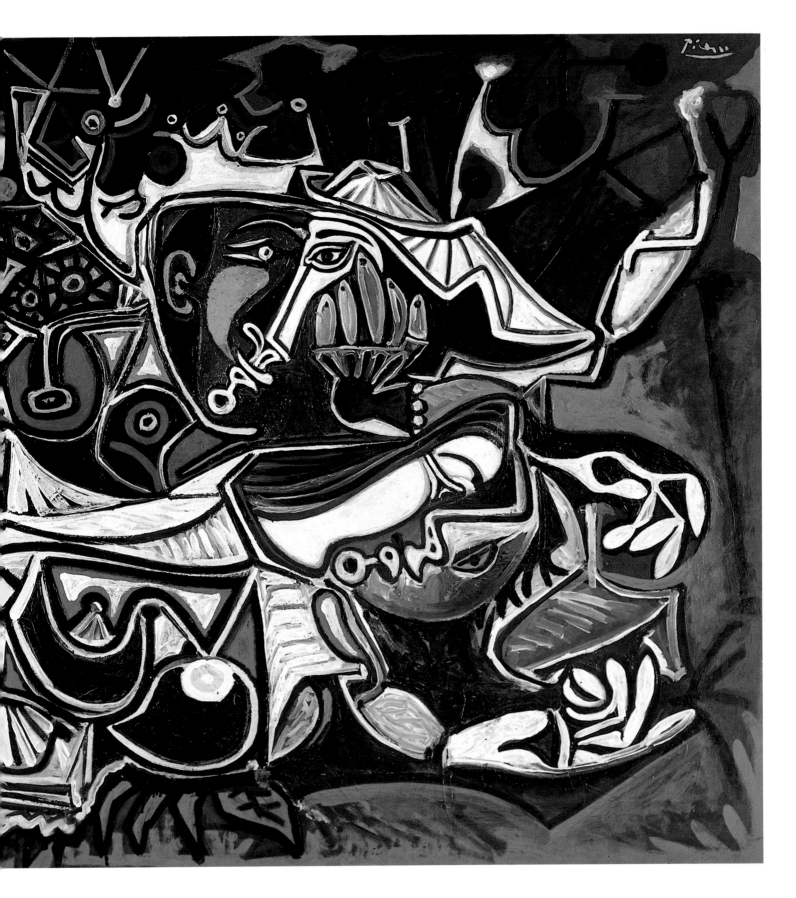

***Young Women on the Banks of the Seine
(after Courbet)***, 1950
*Les Demoiselles des bords de la Seine
(d'après Courbet)*
Oil on plywood, 100.5 x 201 cm
Basel, Öffentliche Kunstsammlung Basel,
Kunstmuseum

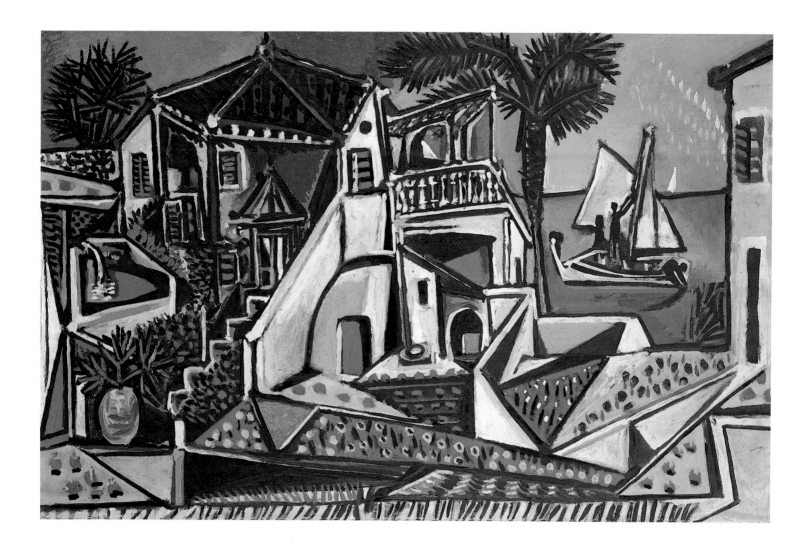

Mediterranean Landscape, 1952
Paysage méditerranéen
Ripolin on shipboard, 81 x 125 cm
Private collection

Essentially, the Communist Party was using Picasso for propagandist reasons. His commitment to the Communist cause was necessarily no more than an episode in the immediate post-war years. Still, Picasso persisted in expressing his general humanitarian and political concerns in his work. During the period when he was questioning Party sovereignty in the arts, he was painting two huge murals (p. 164 f.) on the subject of war and peace for a deconsecrated 14th-century chapel at Vallauris. They were completed that December, though they were not installed till 1954. War is symbolized by a kind of frieze in which a horse-drawn chariot is taking the field. By contrast, the other mural (*Peace*) affords a prospect of unsullied happiness. The frieze shows mothers and playing children, around the central figure of Pegasus, pulling a plough at the bidding of one child and so personifying the fertile world of peace.

Political commitment was only one aspect of Picasso's creative efforts at that time. The distinctive dichotomy in his activities was not least a result of particular artistic interests. This is clearest in the sculptures he did between 1943 and 1953. One of his most famous and characteristic, done in 1943 during the darkest period of the occupation, when Picasso felt utterly isolated, was the *Head of a Bull* (p. 168). The skeletal head and horns of a bull are conveyed by two found objects which in themselves are meaningless, a bicycle saddle and handlebars. Picasso subsequently had this assemblage cast in bronze, thus reassessing the original materials, eliminating the contrasts and opening out the ambivalence of form. It was a continuation of what he had done in *The Glass of Absinthe* (p. 91), that famous product of synthetic

Cubism. The absolute economy of the *Head of a Bull* was breathtaking, and remains stunning to this day. And from then on Picasso retained the basic principle of metamorphosis of formal meaning and interpretation in all his sculptural work.

Baboon and Young (p. 176), done in October 1951, achieved a comparable popularity. It was immediately cast in bronze in a limited edition of six. Picasso was inspired by two toy cars which the art dealer Kahnweiler gave to his son Claude, and used them for the head of the ape, bottom to bottom so that the gap between the two becomes the slit of the baboon's mouth, the radiator the whiskers, the roof the receding forehead, and the two front windows the eyes – to which Picasso added two plaster balls as pupils. Picasso then used coffee cup handles as ears and an immense jug for the body. The arms and the remainder of the baboon's body, and her young, were modelled in plaster. Finally, the outstretched tail was another found item: a car suspension spring curled at one end. Picasso proceeded similarly with his 1950 *Nanny Goat* (p. 179) and *Girl Skipping* (moulded the same year but not finished till 1954; p. 178).

Smoke Clouds at Vallauris, 1951
Fumée à Vallauris
Oil on canvas, 59.5 x 73.5 cm
Paris, Musée Picasso

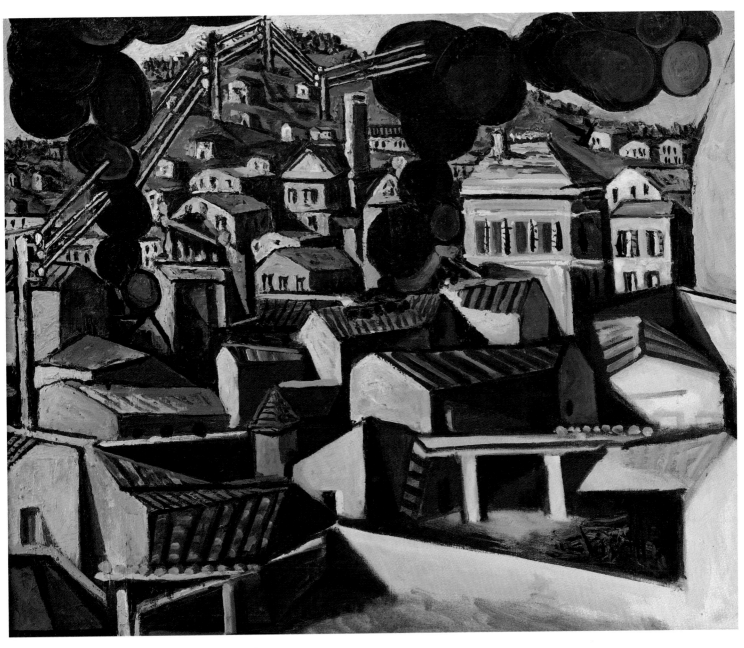

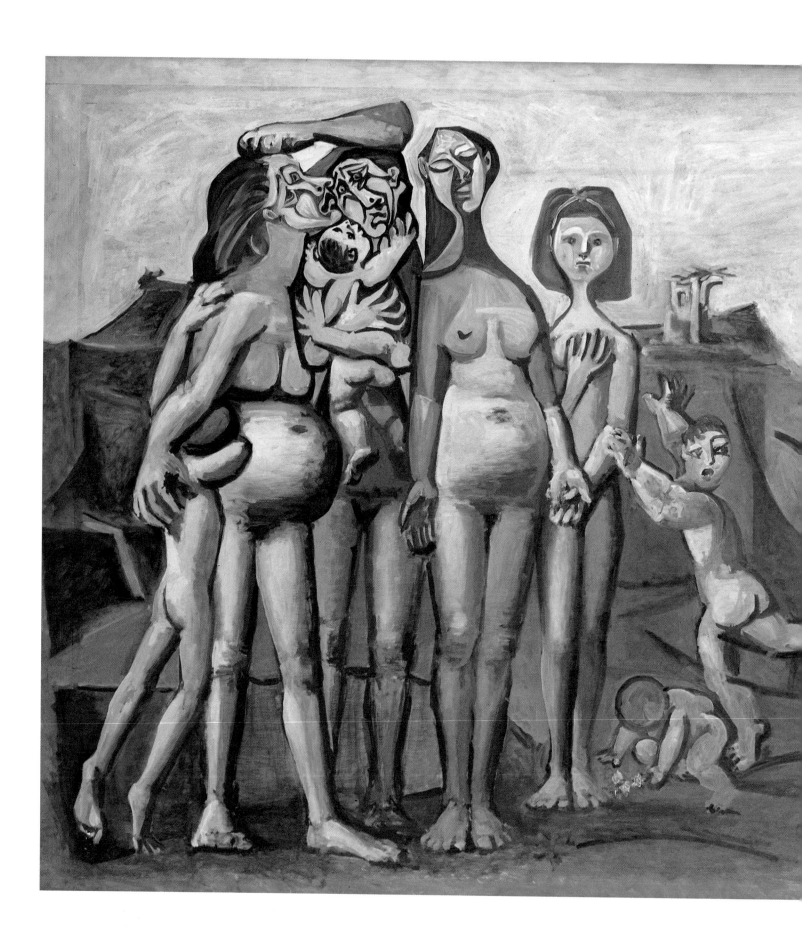

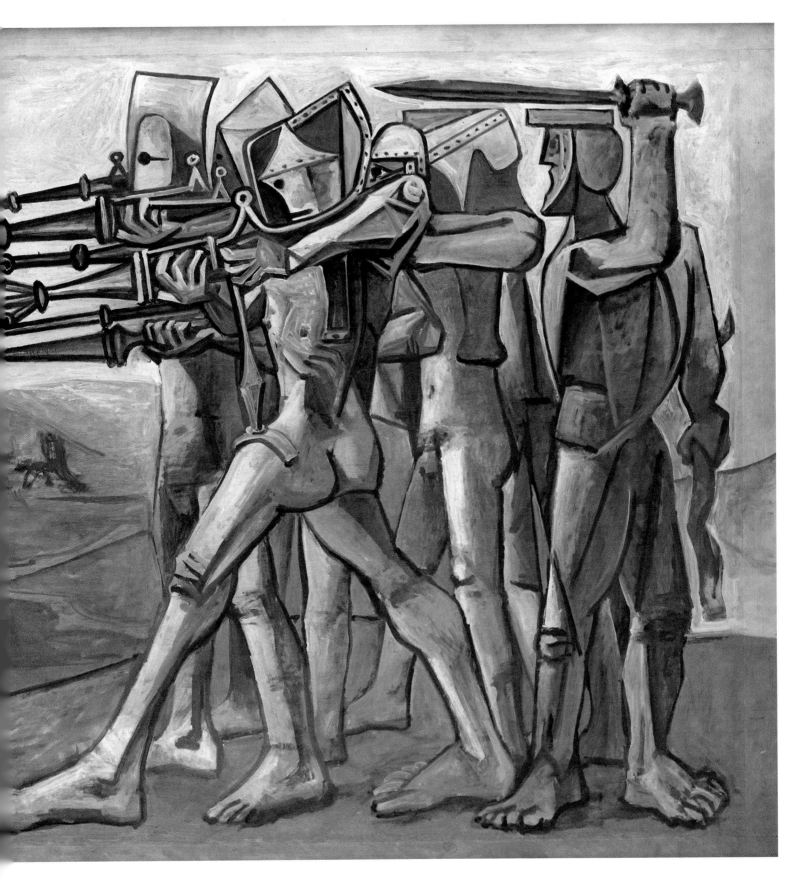

Massacre in Korea, 1951
Massacre en Corée
Oil on plywood, 109.5 x 209.5 cm
Paris, Musée Picasso

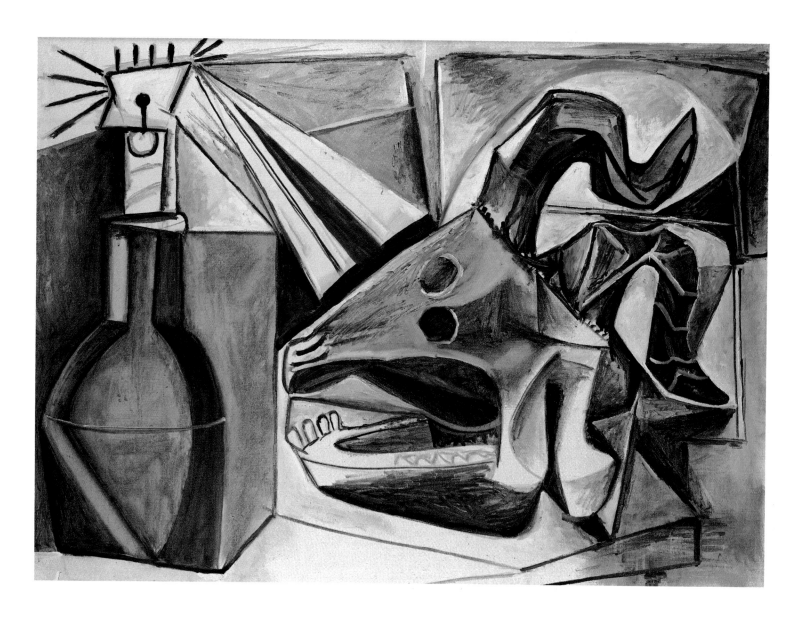

Goat Skull, Bottle and Candle, 1952
Crâne de chèvre, bouteille et bougie
Oil on canvas, 89 x 116 cm
Paris, Musée Picasso

There are few better places than his sculptural work to see the intellectual vigour of Picasso's art. Every detail is sophisticated in conception. In the *Girl Skipping*, for instance, we see a small child still unsure of how to use the rope: her awkwardness is expressed in the instability of the sculpture, but especially by the outsize shoes – and by the fact that she is wearing them on the wrong feet.

As they came into existence, these works defined new areas of meaning, playing with visual form, three-dimensionality and surface structure. Qualities of plasticity, though not unimportant, were distinctly of secondary significance. The best illustration of this is the large-scale sculpture *Man with Sheep* (p. 167), done in early 1943. Unlike the objets trouvés and the assemblages, the figure was wholly modelled in clay on an iron frame, in conventional style, and then moulded in plaster for subsequent bronze casting. A large number of detail and compositional studies document Picasso's protracted irresolution whether to use the idea as a painting or a sculpture. Even the finished group still reveals this indeterminacy. *Man with Sheep* is strictly speaking a failure. But we must bear Picasso's attitude to sculpture in mind. Compared with the intellectual act of evolving the concept, the work of producing the final object was a negligible business. What counted was the art-

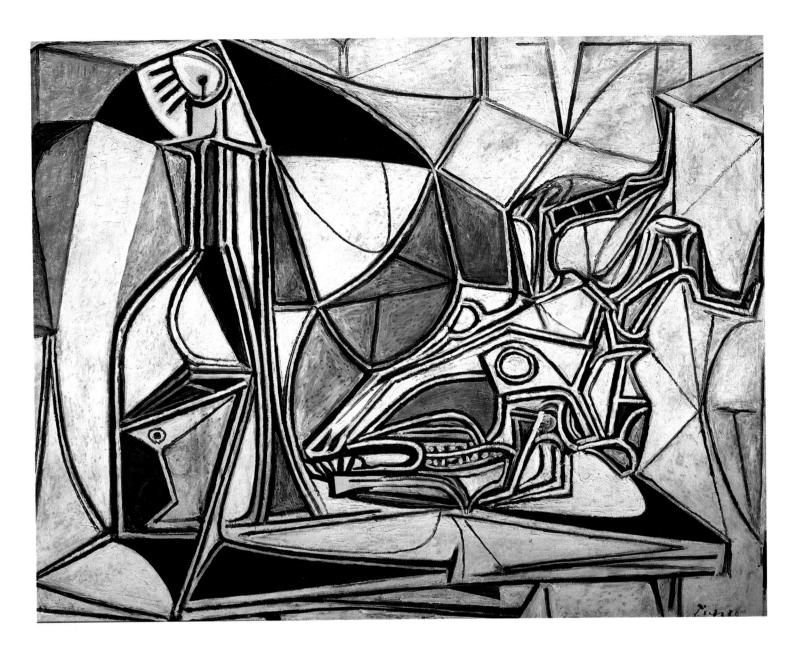

ist's mind and will. He saw the artist's command of the various aspects of technique his art involved as absolute.

The Vallauris years from 1947/48 to 1954 marked Picasso's most intensive work with ceramics. He acquired both the potter's and the ceramic painter's skills. His ceramic work includes painted plates and vases, but also sculptures made by joining preformed pieces, as well as moulded objects. Clay as a material met Picasso's aims, which centred upon types of formal metamorphosis, very well. It was capable of being moulded into infinitely various forms, remained pliable throughout the process, and was thus at the constant disposal of the artist's ideas. Thus, for example, a compact vase became a kneeling woman, and the body, stem and spout of one vessel became a bird. The decorative images were complemented with careful use of relief – added strips of clay and indentations. Picasso used paint to reinforce and decoratively highlight the form and function of the ware, but also deployed its illusionist effects to redefine forms: jugs became stagey scenarios suggestive of spatial depth, or were transformed into human or animal shapes.

Picasso's playful mastery of new techniques can also be seen in his revived commitment to printed graphics, and in particular lithography. Origin-

Goat Skull, Bottle and Candle, 1952
Crâne de chèvre, bouteille et bougie
Oil on canvas, 89 x 116 cm
London, Tate Gallery

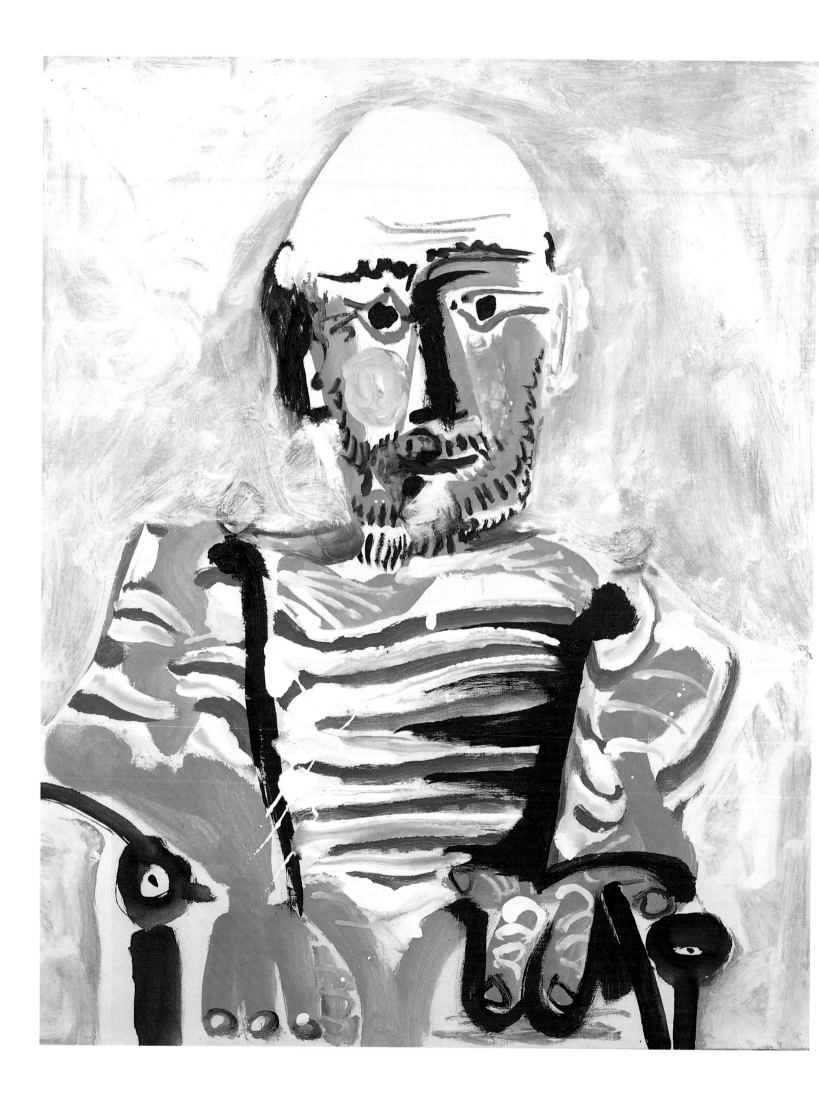

7 The Man and the Myth 1954–1973

Picasso's work from the later 1950s onwards typically drew upon personal material and also worked with constant repetition of his own motifs and compositions. Picasso was now scarcely concerned to mirror the outside world. Instead, he took his own work as the centre of the creative universe. As in the Twenties and Thirties, this self-reflexive vein led him to the studio itself, and archetypal scenes of the artist at work with his model (cfl. p. 217), as subjects.

In 1955 Picasso bought La Californie, a sumptuous 19th-century villa splendidly situated on the hills above Cannes, affording sweeping views all the way across to Golfe-Juan and Antibes. He established a studio on the upper floor, and in the numerous studio scenes dating from 1955–1956 motifs from that studio blend with the villa's architectural features. La Californie's opulent art nouveau decor, the garden with its palms and eucalyptus trees, the furniture, the tools of the artist's trade, all prompted detailed, assured and harmonious paintings, among the finest of Picasso's old age, combining simple representation with the techniques of his Cubist period in sophisticated ways (cf. p. 201). An overall formal unity was supplied by the prevailing linearity of La Californie's interior. The cupboards, windows, walls, easels and paintings constituted a loose ensemble, the elements of which lent weight to each other. In the picture done on 30 March 1956, Picasso used a simple but witty device to underline his own creative inventiveness, placing at the centre of the studio scene a fresh, virgin canvas awaiting the artist. The pure, white, empty space contrasts with the rest of the picture and is also its prime subject. The picture within a picture was one of Picasso's traditional motifs; through it, he grants us access to the very essence of the creative process. Picasso is showing us his power. He can make a world out of nothing.

But as Picasso well knew, creative power such as his had its less happy side: freedom accompanied by a sense of compulsion, the virgin canvas crying out to be painted on, for the artist to supply constant proof of his power. But still his studio picture is optimistic, showing that Art can vanquish the void: beside the blank canvas, two others in varying degrees of completion are on the floor. Not that work already done can serve as a substitute for present work; it is no more than proof of past productiveness. This insight may explain the frenetic output of Picasso's late years. At times he painted three, four, even five pictures in a single day, driven by the compelling urge to prove himself anew over and over again.

In his old age, Picasso transferred to his art the task of expressing the vitality which was ebbing from his life. Hence, for instance, the new graphic

The Sculptor, 1964
Le Sculpteur
Aquatint and gouge, 38 x 27.5 cm

Seated Man (Self-portrait), 1965
Homme assis (Autoportrait)
Oil on canvas, 99.5 x 80.5 cm
Estate of Jacqueline Picasso
Courtesy Galerie Louise Leiris, Paris

193

 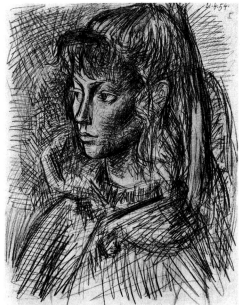

Portrait of Sylvette David (II), 1954
Portrait de Sylvette David
Pencil on paper, 32 x 24 cm
Paris, Musée Picasso

Portrait of Sylvette David (I), 1954
Portrait de Sylvette David
Pencil on paper, 32 x 24 cm
Paris, Musée Picasso

Portrait of Sylvette David (III), 1954
Portrait de Sylvette David
Pencil on paper, 32 x 24 cm
Private collection

Portrait of Sylvette David in a Green Armchair, 1954
Portrait de Sylvette David au fauteuil vert
Oil on canvas, 81 x 65 cm
New York, Private collection

PAGE 194:
Claude Drawing, Françoise and Paloma, 1954
Claude dessinant, Françoise et Paloma
Oil on canvas, 116 x 89 cm
Paris, Musée Picasso

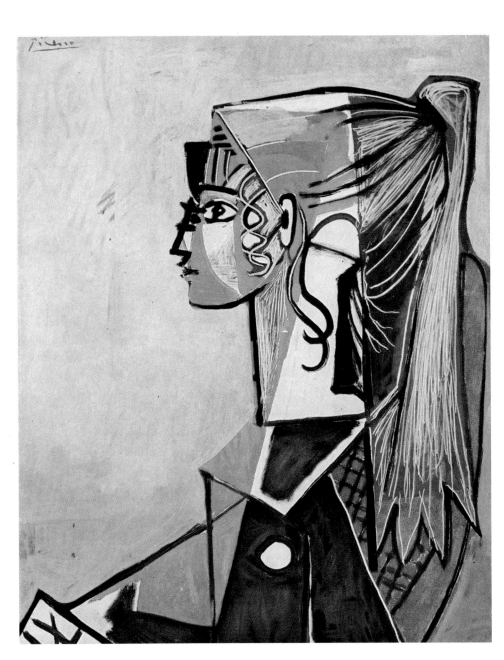

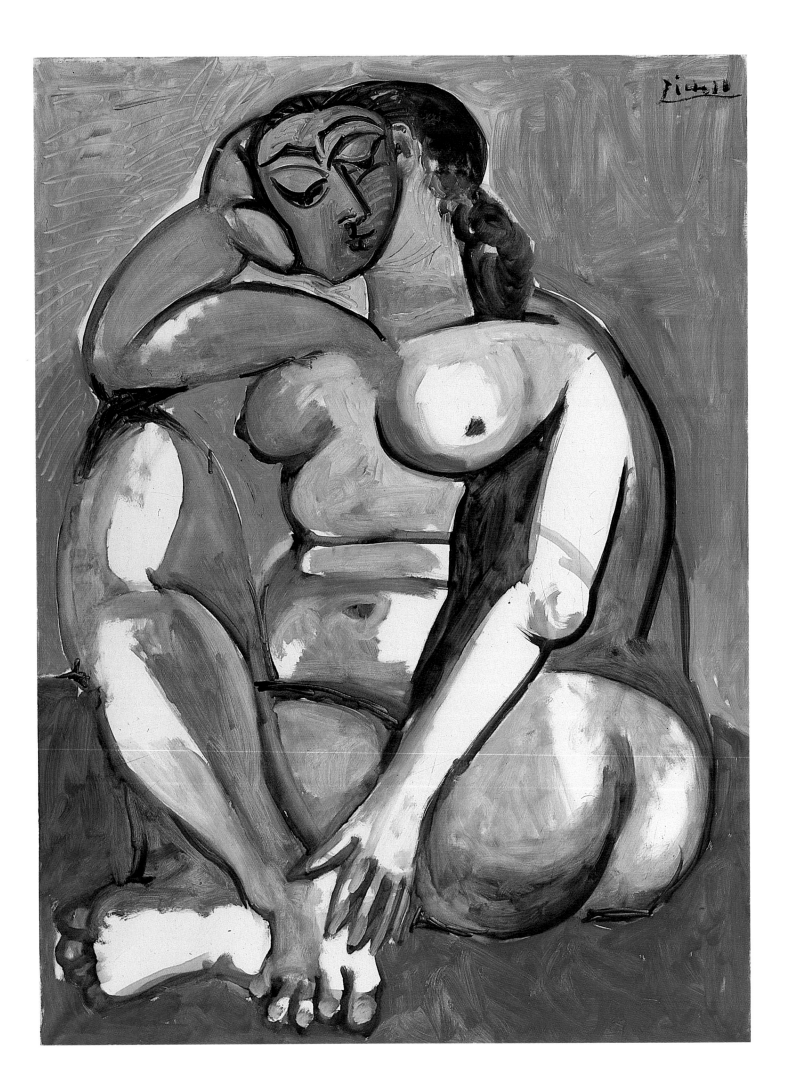

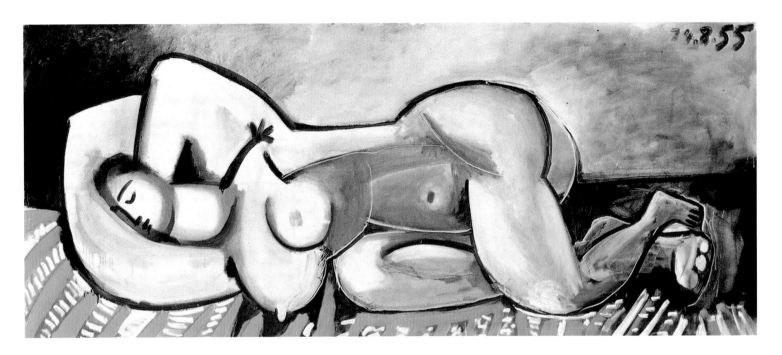

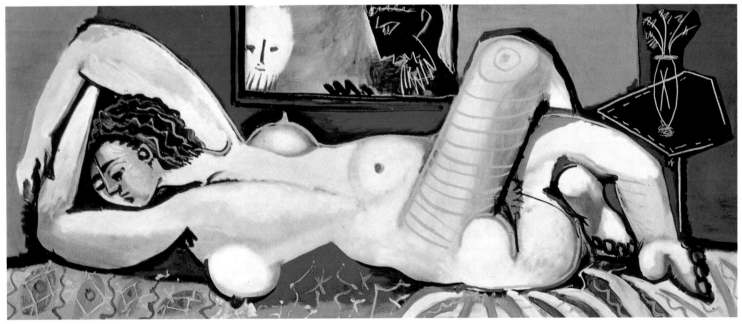

Great Reclining Nude with Crossed Arms, 1955
Femme nue allongée
Oil on canvas, 80 x 190 cm
Estate of Jacqueline Picasso

Great Reclining Nude (The Voyeurs), 1955
Femme nue allongée (Les Voyeurs)
Oil on canvas, 80 x 192 cm
Estate of Jacqueline Picasso

Seated Nude, 1956
Femme nue accroupie
Oil on canvas, 130 x 97 cm
Paris, Galerie Louise Leiris

works which, when successful, articulated lifelong fascinations in a succinct and impeccably judged manner – for instance, the 1957 etching series *La Tauromaquia*. All of the etchings are precise records of carefully-observed scenes, using just a few dabs and strokes, quickly but perfectly done (p. 204). All but the title leaf were aquatint etchings, which enabled Picasso to use solid-printed blocks. The complexity of the process is essentially at odds with spontaneity or the snapshot recording of bullfight scenes, and it is this incongruity that lends Picasso's series its particular genius. Using the most economical of means he succeeds in achieving a maximum of effect. A handful of lines mark the extent of the arena and grandstand; dabs represent the spectators; and grey and black patches add up to the precision-placed image of a torero, say, driving his banderillas into the neck of an attacking bull. Picasso's stylistic approach succeeds particularly well in conveying the physical bulk of the bull, its dynamic presence, and its nimble movements.

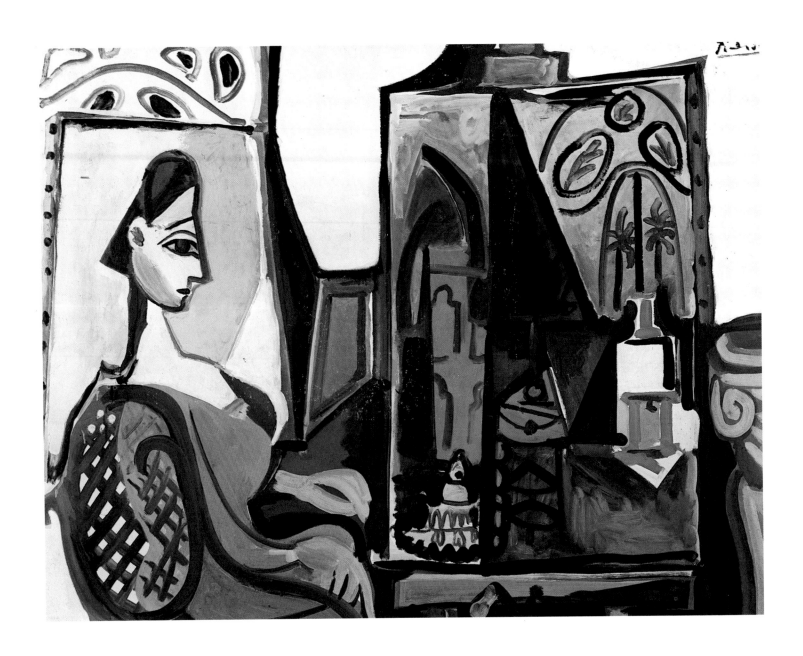

Jacqueline in the Studio, 1956
Jacqueline dans l'atelier
Oil on canvas, 114 x 146 cm
Lucerne, Picasso Collection, Donation
Rosengart

PAGE 201:
The Studio at "La Californie", Cannes, 1956
L'Atelier de "La Californie" à Cannes
Oil on canvas, 114 x 146 cm
Paris, Musée Picasso

The renderings may appear hasty, but in fact Picasso's images are the product of many years of interest in the subject. It was an interest that united personal experience and art history. Picasso was taking his bearings from Goya, transposing the older painter's classic treatment of the bullfight theme into modern terms and, in the process, proving himself Goya's equal. Similar proof was provided by over a hundred sheet-metal, collapsible sculptures done between 1959 and 1963. The extent to which Picasso was drawing on his own work in these sheet-metal sculptures can be demonstrated down to details of motif.

The 1961 *Football Player* (p. 211) is a perfect example of this. The figure, seen in mid-game, has his left arm raised, his right swung down in an arc. There is a classical contrapposto in the position of the legs. The footballer is plainly about to put his full force into a kick. However, no player would strike quite this attitude. The unstable position recalls a dancer; and in fact the artist was drawing on studies he had drawn of the Ballets Russes in 1919 and which he had worked on further in the Twenties. Calling the figure a football player is sleight of hand. The trick is made plausible purely by the painted shirt, shorts and boots. Sculpture such as this is not intended as a mimetic representation of reality; rather, it sets out to play with

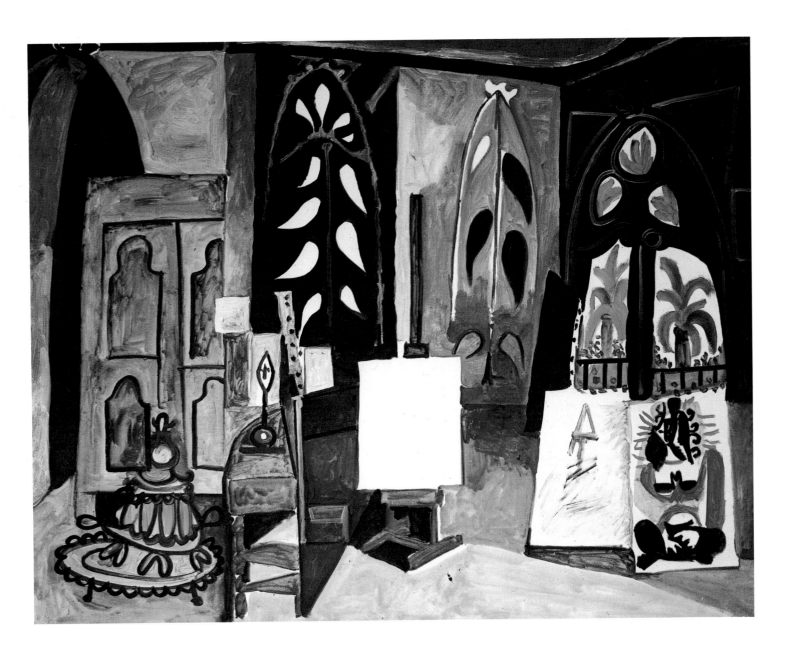

the basics of visual experience. And deception is the fundamental principle of this art. At times, Picasso's habitually self-referential mode can seem hermetic.

His self-referential habit distinguished the Picasso of old age fundamentally from earlier Picassos. He was no longer in the contemporary mainstream of developments in art. Be it in the USA or in France, the prevailing mode was abstract art, of one kind or another. The tragedy of late Picasso was that these currents in art dominated, indeed smothered the scene till 1960. To the general public, he became a figure to be identified with, almost a guardian of tradition – quite the opposite of what he intended. Compared with the brusque unfamiliarity of a new art that made no concessions, Picasso's work came to seem comprehensible and accessible, and to afford a familiar point of orientation amidst the chaos. Tellingly, his *Sylvette* pictures (p. 195) were immensely popular. In 1954 he had met a young woman, Sylvette David, who sat for him. He did over forty drawings and oils of her; they were very quickly published and seen in reproductions all over the world. Two factors influenced the fame and impact of the series. One was the look of the girl herself, her hair in the pony tail then fashionable, the hallmark of an entire generation of young women.

PAGES 202/203:
The Bathers, 1956
Les Baigneurs
Six figures: wooden original
Stuttgart, Staatsgalerie Stuttgart
from left:
The Diver (La Plongeuse)
264 x 83.5 x 83.5 cm
Man with Clasped Hands
(L'Homme aux mains jointes)
213.5 x 73 x 36 cm
The Fountain Man
(L'Homme fontaine)
227 x 88 x 77.5 cm
The Child (L'Enfant)
136 x 67 x 46 cm
Woman with Outstretched Arms
(La Femme aux bras écartés)
198 x 74 x 46 cm
The Young Man (Le Jeune Homme)
176 x 65 46 cm

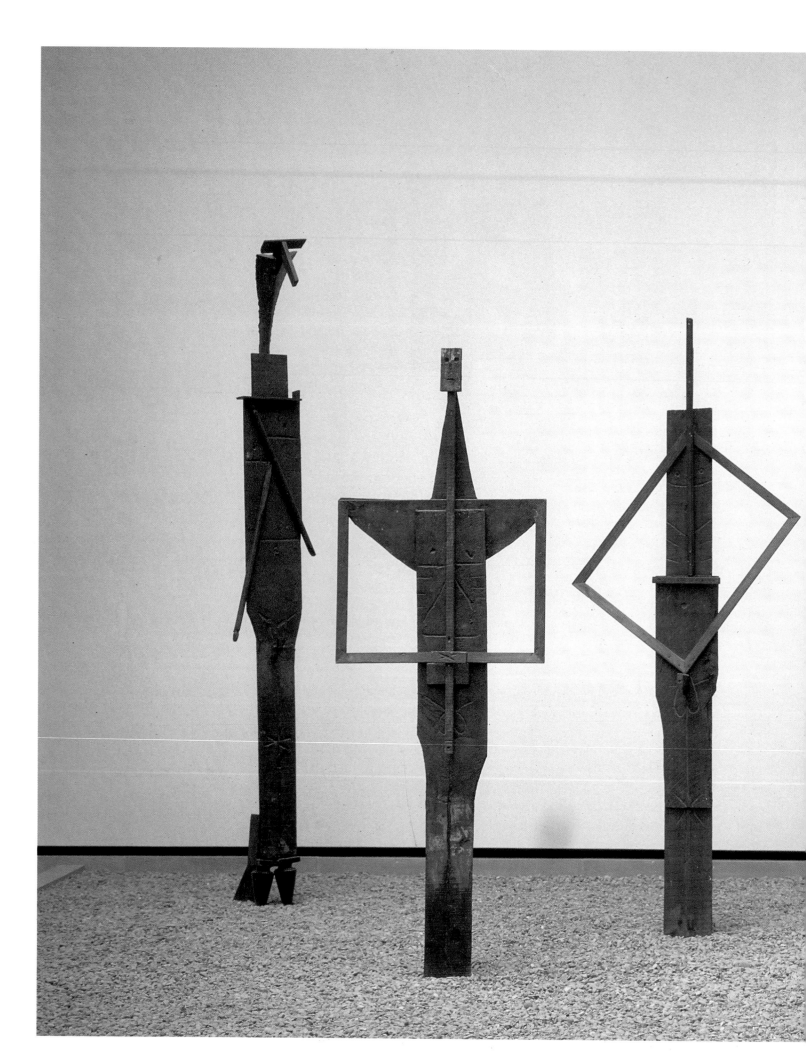

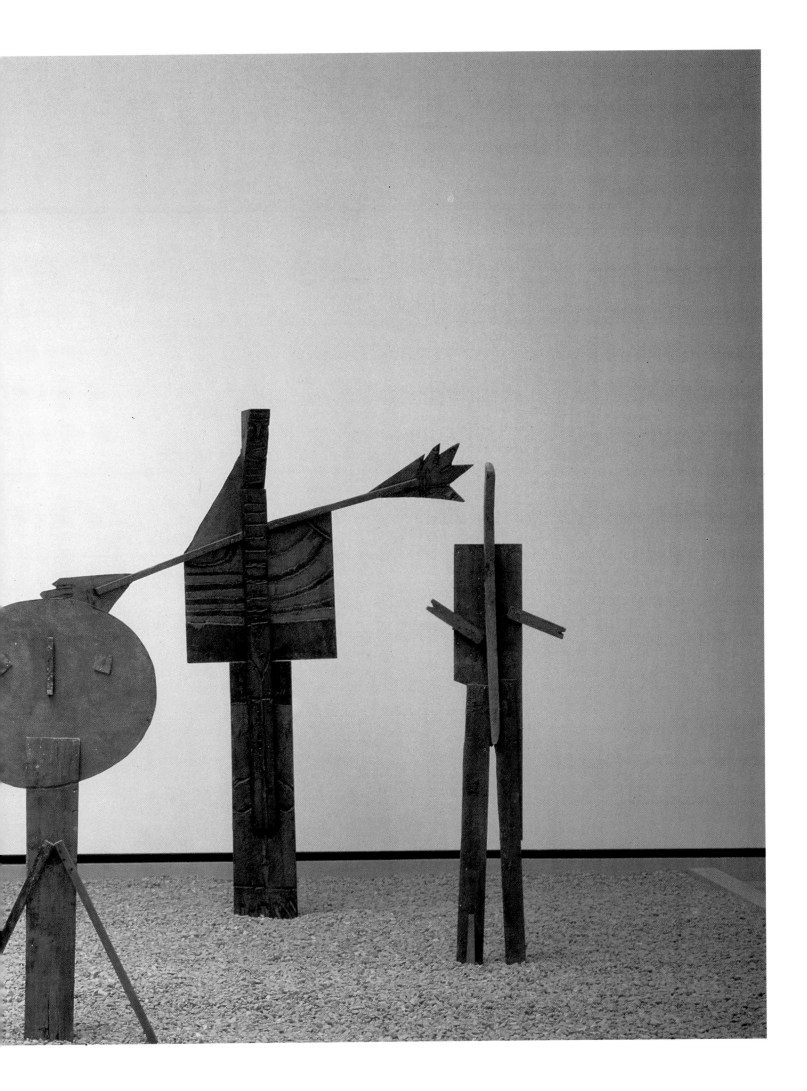

The Bullfighters Enter the Arena ("La Tauromaquia", 3), 1957
Paseo de cuadrillas. Etching, 20 x 30 cm

The Banderillas Go In ("La Tauromaquia", 14), 1957
Clavando un Par de banderillas. Etching, 20 x 30 cm

Capework ("La Tauromaquia", 17), 1957
Suerte de muleta. Etching, 20 x 30 cm

Aiming the Deathblow ("La Tauromaquia", 19), 1957
Citando a matar. Etching, 20 x 30 cm

The Torero Proclaims the Death of the Bull
("La Tauromaquia", 21), 1957. *Después de la Estocada el torero señala la muerte del toro* Etching, 20 x 30 cm

Bullfighting on Horseback ("La Tauromaquia", 26), 1957
Alanceando a un Toro. Etching, 20 x 30 cm

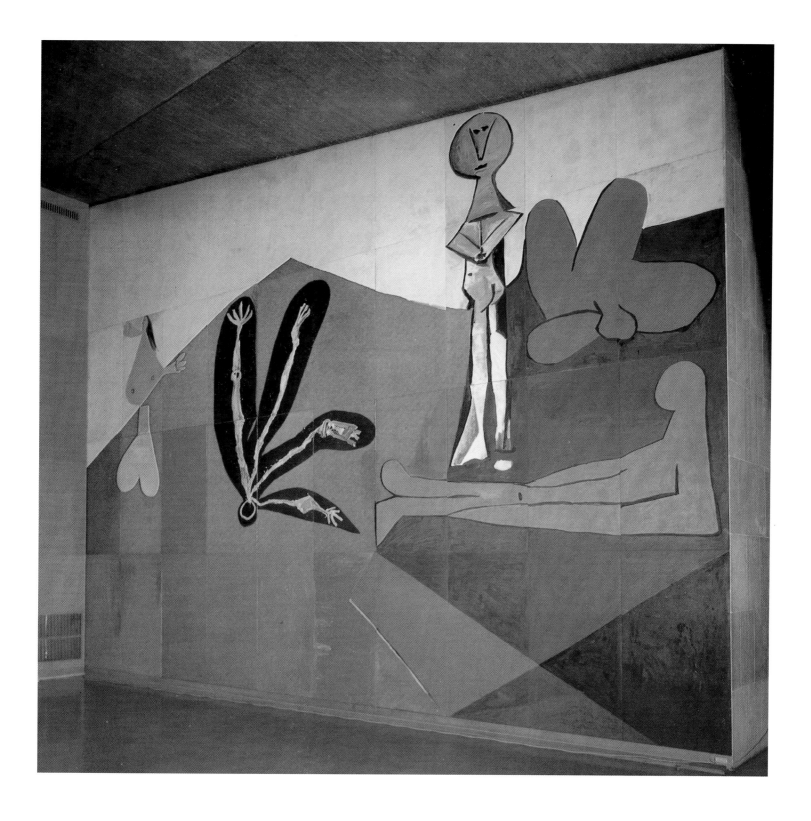

The other was that the "Picasso style" rendered the defamiliarization tactics of modern painting accessible. Picasso did both naturalist representations of his sitter and abstractive, schematic, anti-figural renderings of the real image. Even those who disliked deformed figures had to acknowledge and respect Picasso's artistry. He had become the great go-between, easing relations between the shockingly new and established tradition. Everything he did was hailed with rapture. He was now exempt from even the smallest criticism, public comments on Picasso, paeans and panegyrics, tending to make a demi-god of him.

Picasso's isolation from the art scene, and the cult that attached to his own person, only served to confirm traits that were already his. His work took on

The Fall of Icarus, 1958
La Chute d'Icare
Mural, 8 x 10 m
Paris, Palais de l'UNESCO, Delegates' Lobby

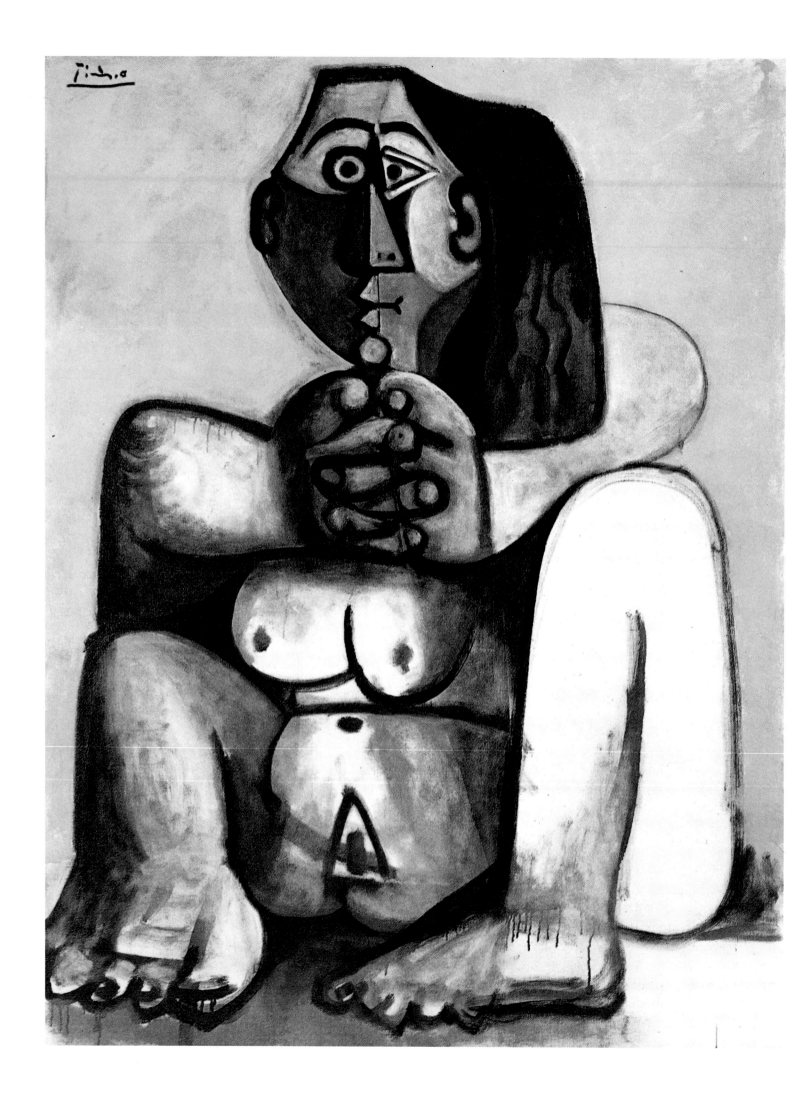

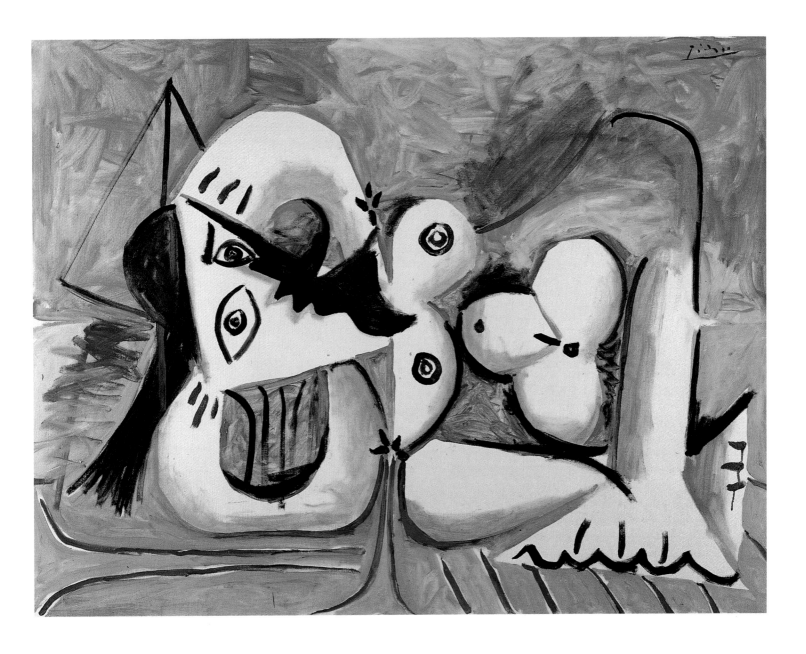

an avowedly universal character. He made engravings on celluloid, and
turned to linocuts. He also agreed to paint a work for the delegates' foyer at
UNESCO headquarters in Paris, his first commission to do a mural since
Guernica. What he painted, in 1958, was a seaside scene with standing and
reclining figures and one dark figure plunging with outstretched limbs into
the great blue waters: *The Fall of Icarus* (p. 205). The central figure evolved
from a child's plaything, a swallow made of folded paper. Picasso was evi-
dently deeply indebted to the simple technique of folding paper; it also gov-
erned his work in sheet-metal sculpture. Picasso returned to this motif in a
stage set design he did in 1962 for a Paris Opera House production of a bal-
let, *The Fall of Icarus*.

 Picasso returned not only to his own work but also to that of old masters.
Starting from a single original, he would produce entire series of variations.
From 13 December 1954 to 14 February 1955 he did fifteen oil variations
on Eugène Delacroix's *The Women of Algiers* from 1832 (cf. p. 199). The
exotic brightness of the Orient was handled contrastively and colourfully: Pi-
casso combined subtle illusionist approaches with abstractive methods. Over
the next few years he extended his paraphrase series considerably. In 1957
he did over fifty variations on Diego Velázquez's *Las Meninas* (cf. p. 214).

Reclining Nude on a Blue Divan, 1960
Femme nue couchée sur un divan bleu
Oil on canvas, 89 x 115.5 cm
Paris, Musée National d'art Moderne,
Centre Georges Pompidou, Gift of
Louise and Michel Leiris

Seated Nude, 1959
Femme nue accroupie
Oil on canvas, 146 x 114 cm
Private collection

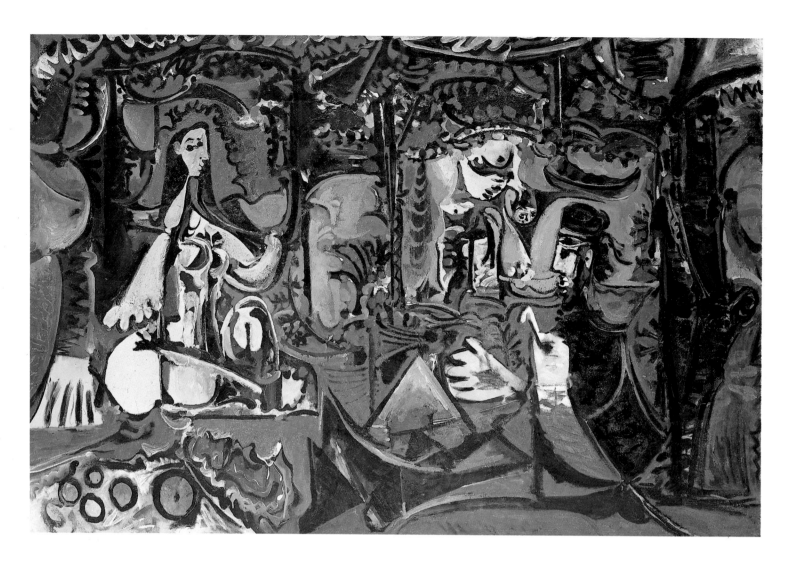

Le Déjeuner sur l'herbe (after Manet), 1960
Le Déjeuner sur l'herbe (d'après Manet)
Oil on canvas, 129 x 195 cm
Paris, Musée Picasso

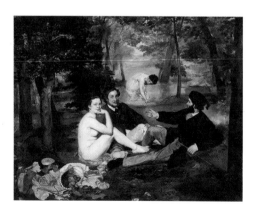

Edouard Manet
Le Déjeuner sur l'herbe, 1863
Oil on canvas, 208 x 264.5 cm
Paris, Musée d'Orsay

They were followed by over 150 sketches and drawings, and 27 paintings, done after Manet's *Le Déjeuner sur l'herbe* (cf. p. 208) from 1959 to 1962. Finally, he did a number of larger works adapting Jacques-Louis David's *Rape of the Sabine Women* (cf. p. 212 f).

The series of 58 very different large-scale oils related to *Las Meninas*, painted by the Spanish artist Diego Velázquez in 1656–1657 and so titled after the two maids at court included in it, dealt with Picasso's central theme of painter and model. Velázquez's painting (p. 214) is incomparable in its meditation upon the historical and societal preconditions of artistic activity. The vertical-format rectangular picture shows a gloomy room lit only from windows at the side: the artist's studio. Ten figures are in this space, making a somewhat lost impression: a Spanish princess and her retinue, consisting of two maids-of-honour, two court dwarfs, and a peaceful dog; the painter himself; two servants; and at the very rear, visible through an open door, the chamberlain of the court. Different though the postures and attitudes of these people are, they are almost all giving their attention to the same place, to some vis-à-vis. The mirror at the rear reveals that this is the king and queen. Thus the painting unambiguously, albeit subtly, expresses the facts of every-day life for Velázquez, painter at court. Life at court was strictly hierarchical. The composition preserves that hierarchy, and marginalizes the painter. Velázquez showed himself in this work to be the "true painter of reality", as Picasso put it.

Picasso now set about restructuring that reality (p. 214, 215). In contrast to his previous procedure when paraphrasing Delacroix's *Women of Algiers*

(p. 199), the largest full-scale composition came first this time, and not last. It was conceived programmatically, as an exposé of the new subject. Picasso revised the format and upgraded the status of the painter. Everything in this new version has become unambiguous. The figures are frontally positioned or in clear profile. One will has borne all before it: Picasso's. He is lord of his world, empowered to do whatsoever he chooses. The rival royal power has ceased to matter. The paintings that followed the large-scale opening version of 17 August either deal with parts and details or produce variations on the horizontal format.

Picasso tried to render the chiaroscuro factor in the original Velázquez through contrasts of darker and lighter shades of colour, but the overall result was not convincing. In the end, his variations on *Las Meninas* came to nothing. It is true that he succeeded in articulating the core idea of his new version: that the artist occupies a new, changed position in modern, liberal society. The large composition that opened the series expressed this idea powerfully. Picasso, revising the original in terms of colour too, was aiming to outdo his illustrious forerunner. But to transfer his colourist concepts to

Le Déjeuner sur l'herbe, 1961
Oil on canvas, 60 x 73 cm
Private collection

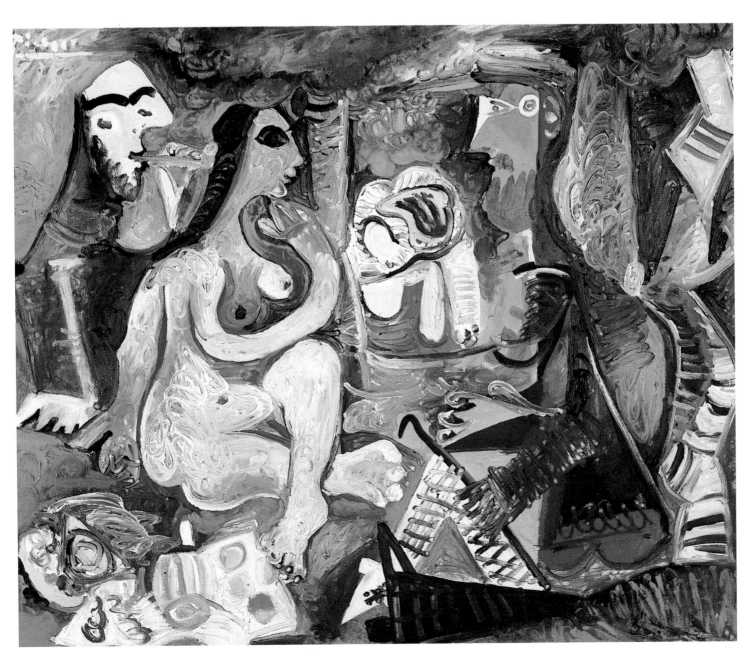

Woman with Outstretched Arms, 1961
Femme aux bras écartés
Sheet metal and wire, cut and painted,
183 x 177 x 72.5 cm
Paris, Musée Picasso

Football Player, 1961
Footballeur
Cut and painted sheet metal, 58.3 x 47.5 x 14.5 cm
Paris, Musée Picasso

210

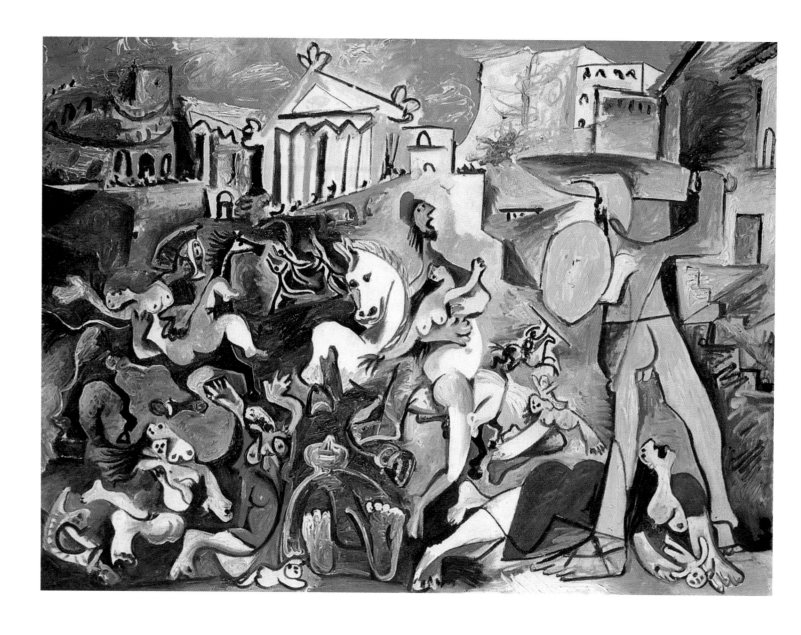

The Rape of the Sabine Women (after David), 1962
L'Enlèvement des Sabines (d'après David)
Oil on canvas, 97 x 130 cm
Paris, Musée National d'Art Moderne,
Centre Georges Pompidou

The Rape of the Sabine Women, 1963
L'Enlèvement des Sabines
Oil on canvas, 195.5 x 130 cm
Boston (MA), Museum of Fine Arts

the overall composition was a more complex undertaking. And in the end Picasso conceded defeat. Colour remained of secondary importance, subordinated to form.

The difference to earlier periods in Picasso's work is striking, to say the least. Taking his bearings from the art of the past, for Picasso, always implied locating incentives and ideas – be it the odalisques of Ingres for early Cubism or ancient sculpture and baroque paintings for the late Rose Period and his so-called Classicism. This ongoing and extremely fruitful process peaked in Picasso's late years in his ceramic art of the Forties and Fifties. His ware, and the artwork with which it was decorated, was no imitation of a classical original (cf. pp. 174 and 175). It was not a copy of ancient storage, cultic or drinking vessels, nor did the decorative style have anything in common with the technique or form of black and red vase paintings. Picasso varied the first principles and translated into a modern idiom whatever was capable of analogy. His thick-bellied vases with sheer conical necks were decorated with figures organically adapted to the shapes of the vessels. Maenads, nymphs and fauns, generously and tellingly outlined and economical in detail, people the surfaces of the ware. In its modernity, Picasso's ceramic art was one of classical harmony, in compositions of great beauty.

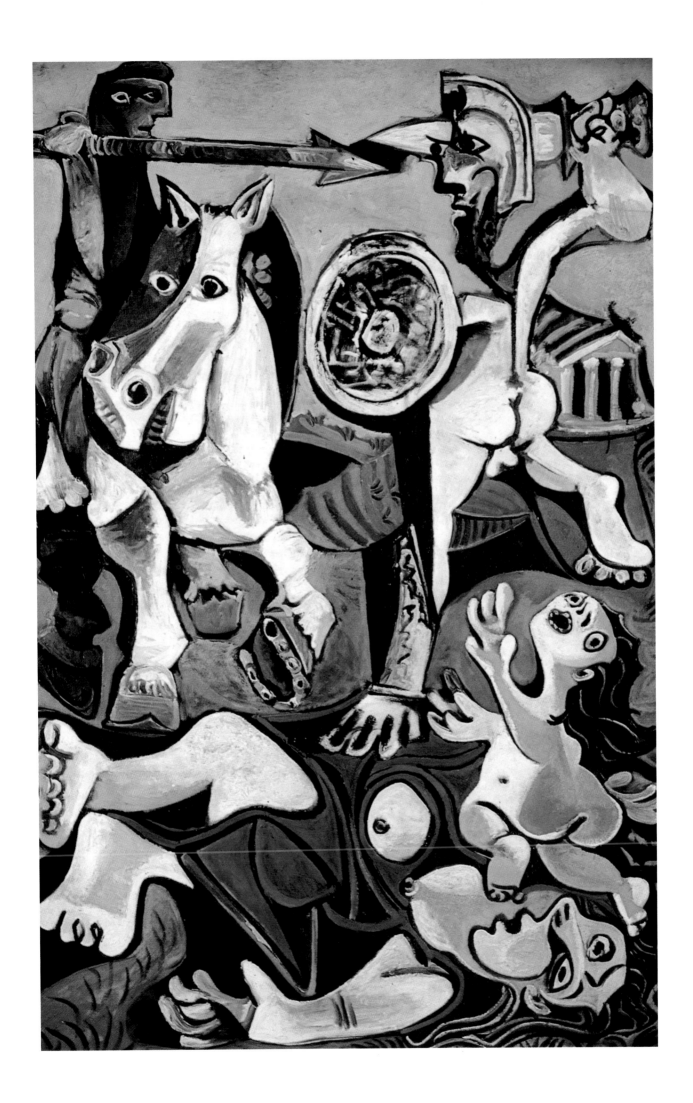

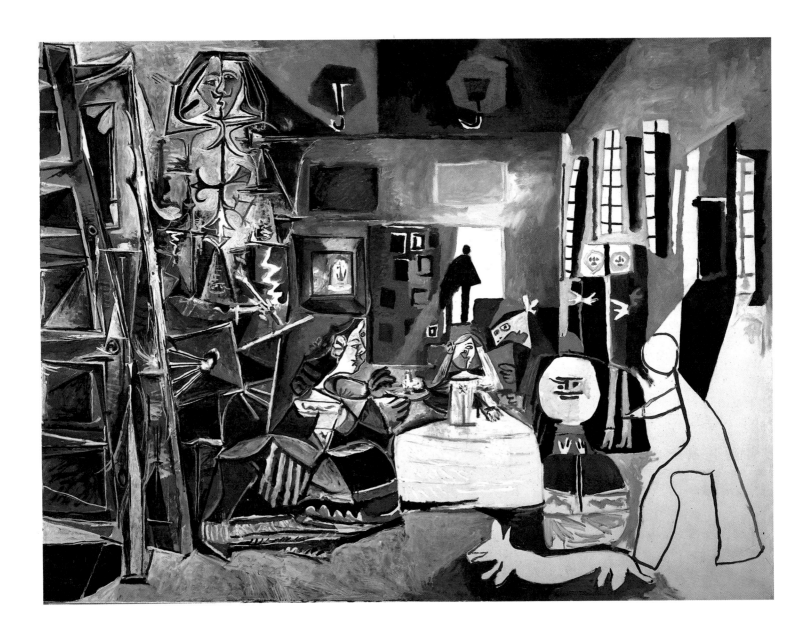

Diego Rodriguez de Silva y Velázquez
Las Meninas, 1656–1657
Oil on canvas, 318 x 276 cm
Madrid, Museo Nacional del Prado

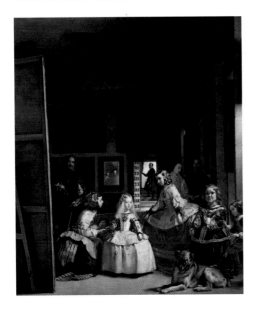

Picasso did other variations of old masters in the Forties. Even as the fighting was raging around Paris in 1944, he was at work on an adaptation of Poussin's *Bacchanal* (1630). In 1947, among other things, he modelled a lithographic series on Lucas Cranach's painting *David and Bathsheba*. In 1950 he painted versions of Gustave Courbet's *Young Women on the Banks of the Seine* (p. 182) and El Greco's *Portrait of a Painter* (p. 180). These were followed between 1955 and 1957 by portraits of Jacqueline as *Lola of Valence* (after Manet's painting), an etching copy of Rembrandt's *Man in the Golden Helmet* (c. 1650), an India-ink drawing after Cranach's *Venus and Cupid* (1509), and a painting after portraits of El Bobo, the court dwarf, by Velázquez and Bartolomeo Esteban Murillo. Essentially these works remained within the parameters laid down in 1917 with *The Peasants' Repast* (p. 96), after Le Nain's original, adapting compositions and subjects by concentrating attention on particular aspects of them. The variations are modern in that they bring the past works up to date, and in this Picasso was entering a tradition stretching from Delacroix's copies of Rubens to van Gogh's paintings after Gustave Doré: one early 20th-century masterpiece of this kind was Matisse's 1915 *Variation on a Still Life by Jan Davidsz. de Heem*.

The paraphrases do, however, have the effect of highlighting the increasingly tautological and almost autistic tendency of Picasso's collage-guided

PAGE 214:
Las Meninas (after Velázquez), 1957
Les Ménines (d'après Velázquez)
Oil on canvas, 194 x 260 cm
Barcelona, Museu Picasso

31

32

33

The Whole Group, 18 September 1957
Study for *Las Meninas* (31)
Oil on canvas, 129 x 161 cm

The Whole Group, 19 September 1957
Study for *Las Meninas* (32)
Oil on canvas, 162 x 130 cm

The Whole Group, 2 October 1957
Study for *Las Meninas* (33)
Oil on canvas, 162 x 130 cm

The Whole Group, 3 October 1957
Study for *Las Meninas* (34)
Oil on canvas, 129 x 161 cm

Isabel de Velasco, 9 October 1957
Study for *Las Meninas* (35)
Oil on canvas, 65 x 54 cm

María Augustina Sarmiento, 9 October 1957
Study for *Las Meninas* (36)
Oil on canvas, 65 x 54 cm

María Augustina Sarmiento and Infanta
Margarita María, 10 October 1957
Study for *Las Meninas* (37)
Oil on canvas, 92 x 73 cm

María Augustina Sarmiento, 10 October 1957
Study for *Las Meninas* (38)
Oil on canvas, 73 x 55 cm

María Augustina Sarmiento, 10 October 1957
Study for *Las Meninas* (39)
Oil on canvas, 115 x 89 cm

The Piano, 17 October 1957
Study for *Las Meninas* (40)
Oil on canvas, 130 x 97 cm

Nicolasico Pertusato, 24 October 1957
Study for *Las Meninas* (41)
Oil on canvas, 61 x 50 cm

Isabel de Velasco, María Bárbola, Nicolasico
Pertusato and the Dog, 24 October 1957
Study for *Las Meninas* (42)
Oil on canvas, 130 x 96 cm

Isabel de Velasco, María Bárbola, Nicolasico
Pertusato and the Dog, 24 October 1957
Study for *Las Meninas* (43)
Oil on canvas, 130 x 96 cm

Isabel de Velasco, María Bárbola, Nicolasico
Pertusato and the Dog, 24 October 1957
Study for *Las Meninas* (44)
Oil on canvas, 130 x 96 cm

Isabel de Velasco and María Bárbola,
8 November 1957
Study for *Las Meninas* (45)
Oil on canvas, 130 x 96 cm

34

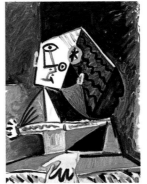

35

36

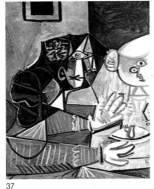

37

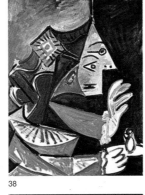

38

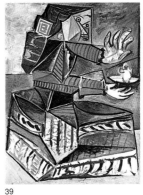

39

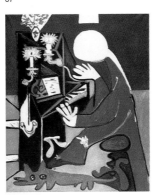

40

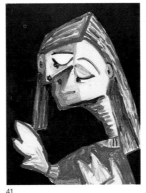

41

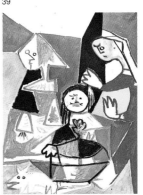

42

43

44

45

215

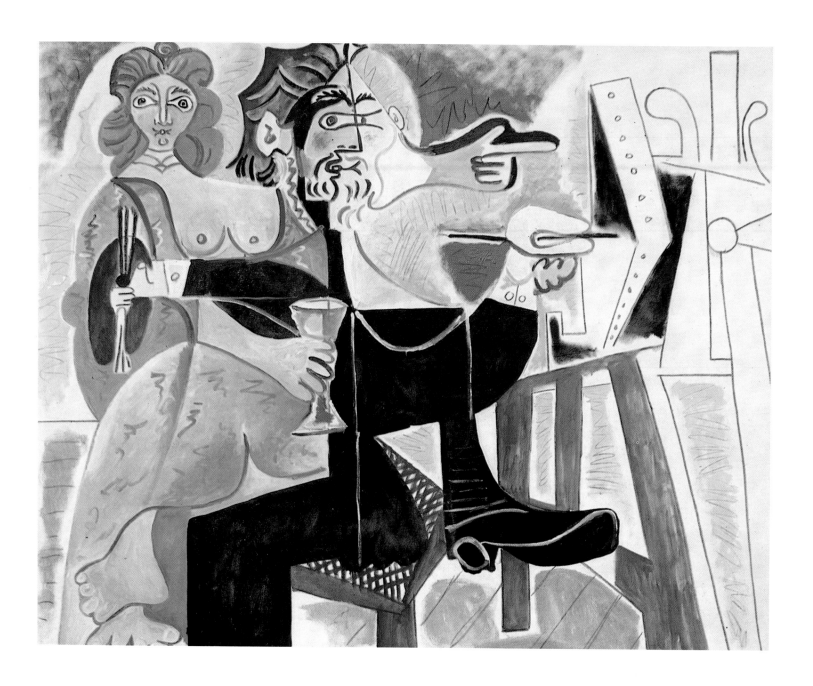

art to repeat itself in the late Fifties. Simply to metamorphose a picture was not in itself invariably adequate as the informing concept behind hundreds of works. The high standard Picasso had set in matching form and content could not always be maintained. In many of the paintings and studies of the period, he was plainly satisfied with having filled the canvas. It was a trivial reversal of the priorities of the artist: what ought to have been the sine qua non had become the raison d'être.

Picasso had long become a classic of modern art, but still attempted to influence the public reception of his work. For instance, when the Museu Picasso in Barcelona was opened in 1970, prominent members of the Franco regime tried to use the occasion as a means of legitimation. However, their plans for a state ceremony were brought to nothing by Picasso, who vetoed all such ideas, wary of affording political enemies any purchase. The art scene had meanwhile undergone a complete change. The Sixties were a period of great upheaval and transition in the Western world, not least in the visual arts. The new departure of the Sixties was dominated by Pop Art and the New Realism, while the actionist legacy of Surrealism was continued in new socially critical forms such as the happening.

Rembrandt and Saskia, 1963
Rembrandt et Saskia
Oil on canvas, 130 x 162 cm

The Artist and His Model, 1963
Le Peintre et son modèle
Oil on canvas, 130 x 162 cm
New York, Private collection

The Artist and His Model, 1963
Le Peintre et son modèle
Oil on canvas, 130 x 195 cm
Madrid, Museo Nacional Centro de Arte Reina Sofía

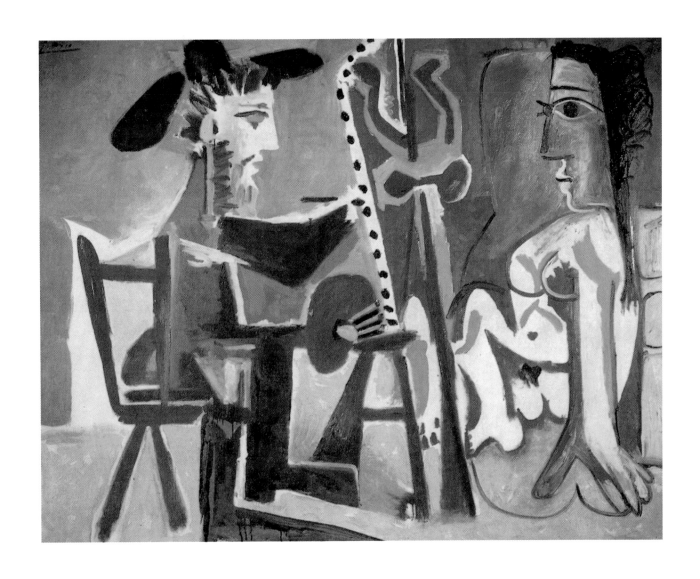

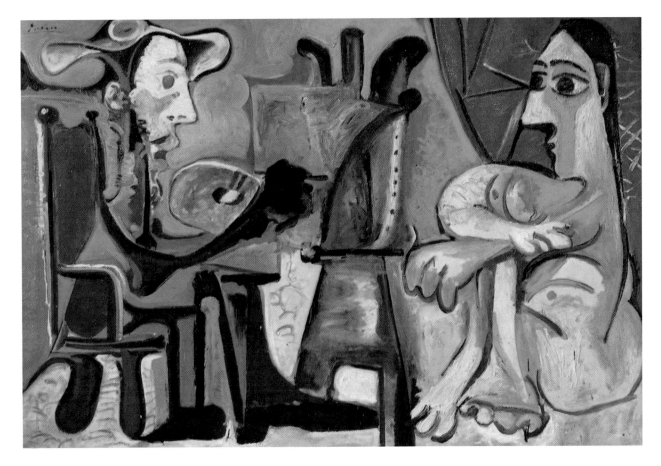

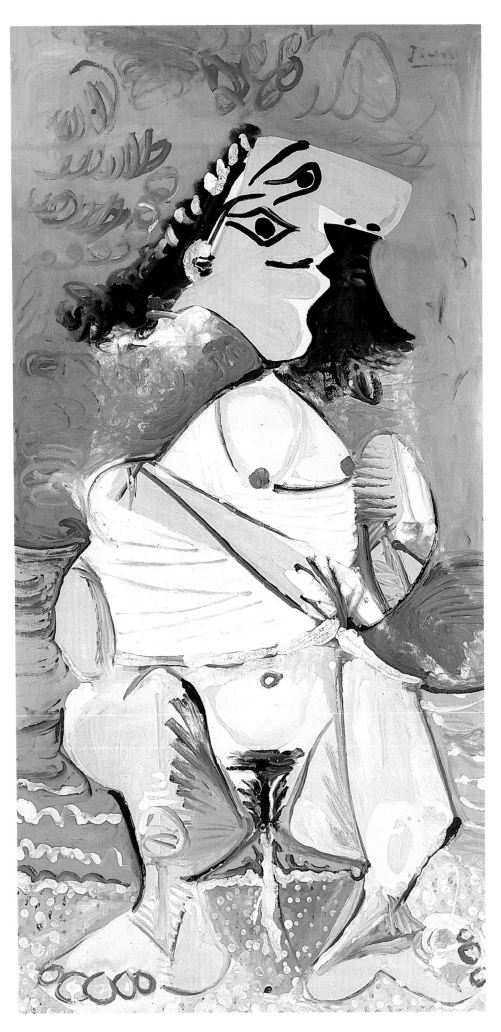

PAGE 220:
Woman Pissing, 1965
La Pisseuse
Oil on canvas, 195 x 97 cm
Paris, Musée National d'Art Moderne,
Centre Georges Pompidou, Gift of
Louise and Michel Leiris

PAGE 221:
Seated Nude in an Armchair, 1965
Femme nue assise dans un fauteuil
Oil on canvas, 166 x 89 cm
Courtesy Galerie Louise Leiris, Paris

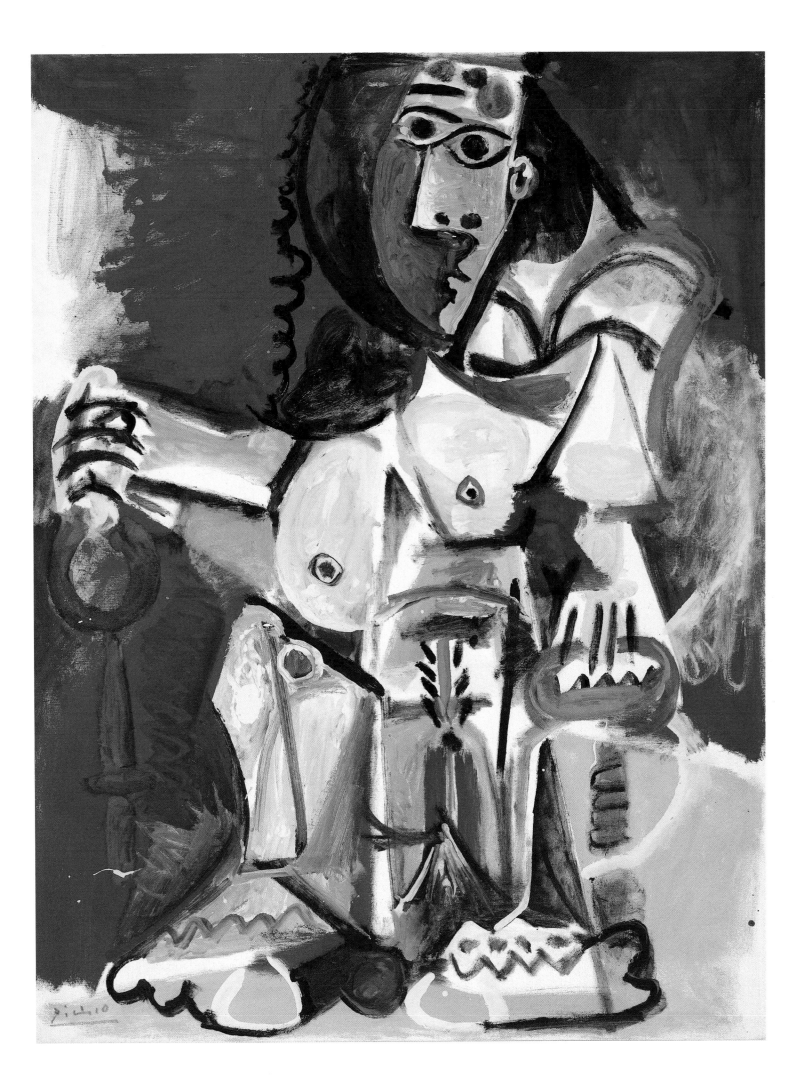

The heart of Picasso's concerns in his late work was to destroy the concept of the finished work. Series were no longer intended as attesting evolution towards a work; they merely documented the basic options available to creative work. Technique was pared to a minimum; caprice reigned triumphant. We are witnessing a creative spirit free of technical constraint and asserting that the traditional concept of art is null and void. Consistently enough, Picasso does not communicate content in his pictures now. However, the principle of metamorphosis and costume transformation is

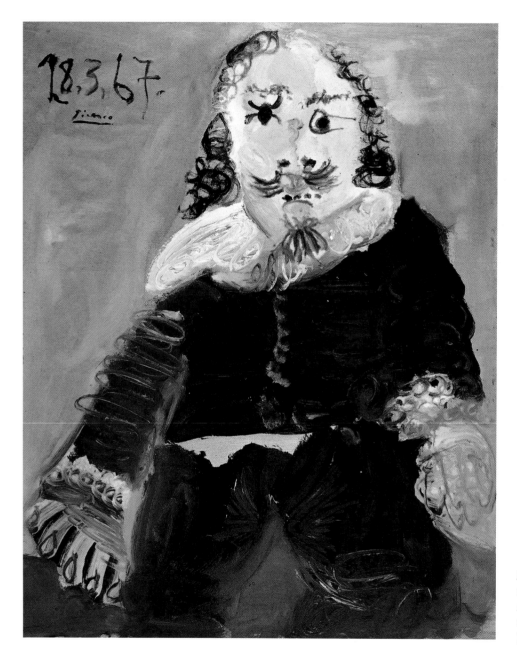

Musketeer (Domenico Theotocopulos van Riyn da Silva), 1967
Mousquetaire
Oil on plywood, 101 x 81.5 cm
Budapest, Ludwig Collection

illustrated, especially in paintings from 1963 and 1969. In *Rembrandt and Saskia* (13/14 March 1963; p. 216), Picasso has done the lower part of the male figure two-dimensionally, providing a strong block of black in the centre of the painting. On 18 and 19 February 1969 he varied the same pose in two paintings showing men smoking, with a small Cupid (p. 228 and 229). The brushwork has undergone radical change. In the 18 February picture, linearity of form is foregrounded, and the colour blocks are therefore filled with broad brushstrokes.

Musketeer with pipe, 1968
Mousquetaire à la pipe
Oil on canvas, 162 x 130 cm
Paris, Galerie Louise Leiris

222

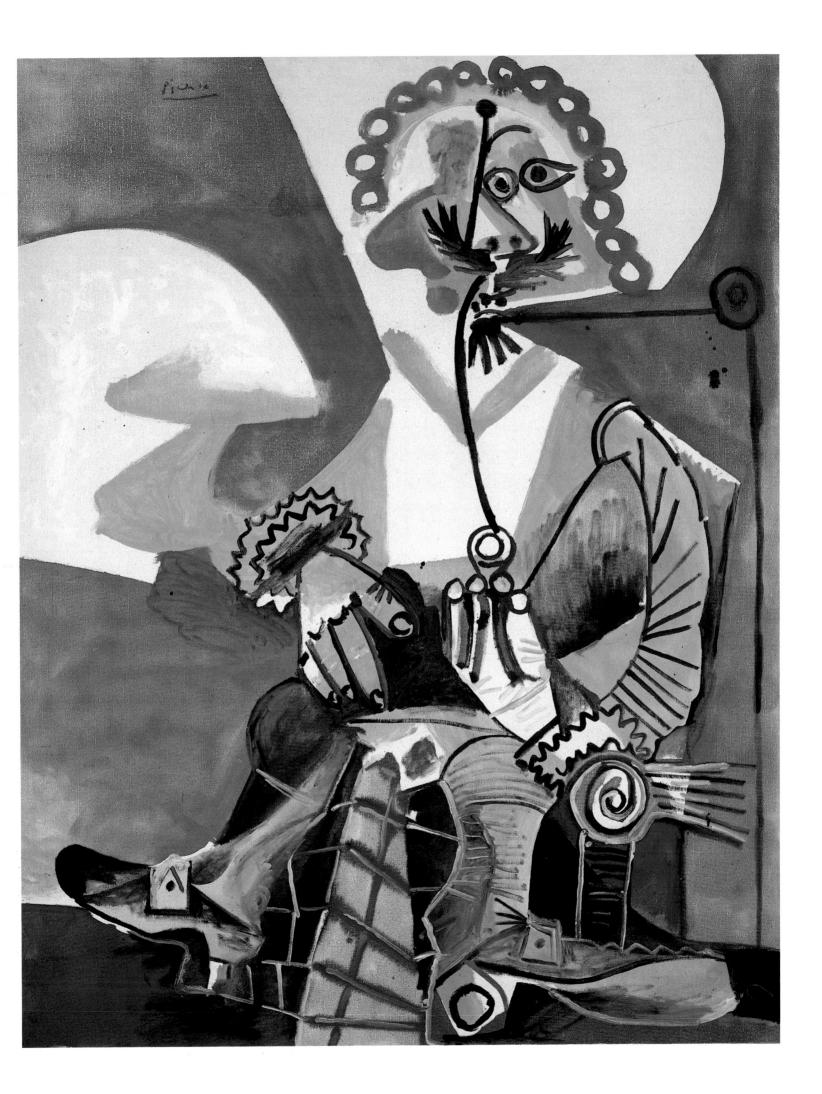

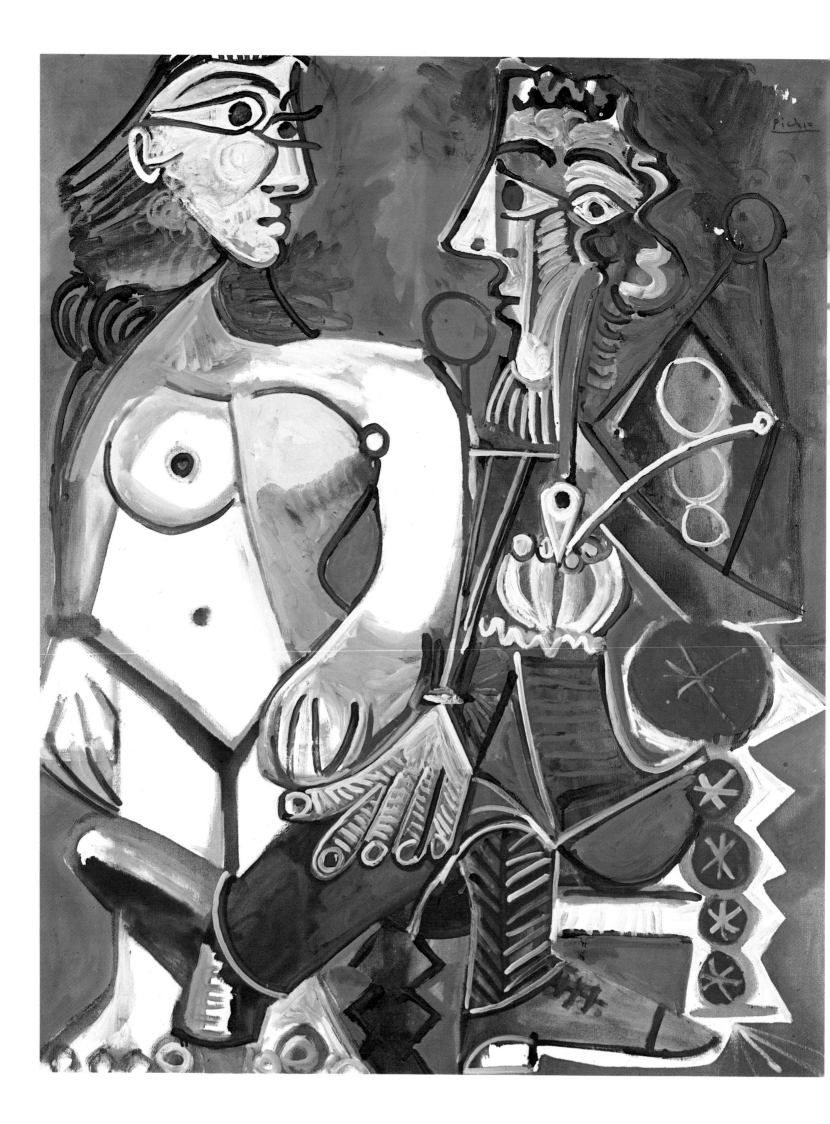

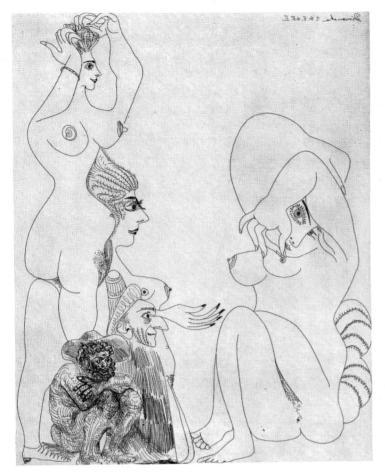

In that of 19 February, the blocks of colour are themselves stressed once again – though with the crucial difference that now the act of painting, the imprecise movement of the hand, is being emphasized. The two paintings are complementary. While the motifs in that of 18 February are linear and the colours of secondary importance, Picasso proceeds in that of 19 February in exactly the contrary fashion. He fills the canvas with undefined bright colours, then, the good draughtsman, indicates forms that translate the colour composition into a figural painting. The vigorous brushwork and the seemingly expressive style are masks, to deceive us: they are there to confuse, to subvert perception.

Things make a similar impression in the graphic work. Never before had Picasso done as many etchings as he did in the last years of his life. The command of Picasso the craftsman was plainly undiminished. This may be the best place to identify Picasso's subtle intentions. Many of the etchings betray formal inconsistencies, with carefully worked areas appearing alongside negligently scrawled details, and there are visible gaps in Picasso's handling of compositional questions. But the sheer number of his supposed slips is enough to preclude all possibility of spontaneity in his work.

The main subject is sexuality. It is so obsessive that Picasso seems to have been getting a dirty old man's fantasies out of his system. But in fact the truth of the matter is far more intractable. Picasso's explicit pictures were part of the Sixties rebellion against taboos. In almost all Picasso's erotic pictures, the voyeurist element is dominant. The artist and his female nude model are almost invariably being observed by ugly old men in various kinds of costume (p. 225). The painter always remains the creator. This fact

"Suite 347", Plate 6
Mougins, 24 March 1968
Etching, 42.5 x 34.5 cm

"Suite 347", Plate 8
Mougins, 25 March 1968
Etching, 42.5 x 34.5 cm

Nude and Smoker, 1968
Femme nue debout et homme à la pipe
Oil on canvas, 162 x 130 cm
Lucerne, Galerie Rosengart

225

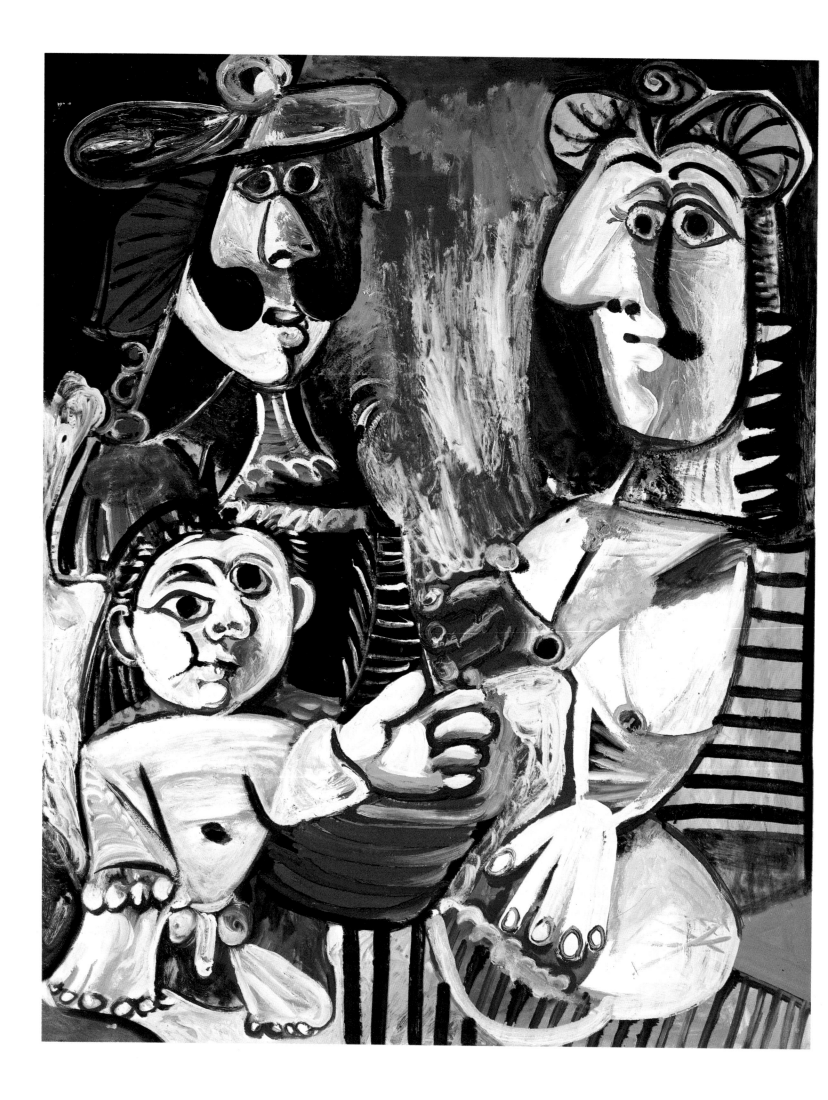

expresses Picasso's view of art as an act of (pro)creation presented to a public itself incapable of creative endeavour. In view of the intimacy of the act of (pro)creation, it is tantamount to shamelessness if the urge to expose is constantly being satisfied, the private secrets revealed. Picasso rarely expressed the role of the modern artist, under constant observation by the omnipresent mass media, with such illuminating force. The painter under public scrutiny (i.e. Picasso himself) is obliged constantly to play new roles. He is the knight and the sailor, the circus artiste and the nobleman, but above all he is the "new Rembrandt". He was returning to the time-honoured idea of the productive, creative person as genius.

The mythologization of Picasso into a titanic Hero of Modern Art has tended to obscure his work. Time after time, the old heroic image of Picasso continues to be perpetuated. Modernist innovation is attributed to him far beyond what is historically verifiable. He is stylized into the major figure in a cult of genius that remains with us to this day. It is of course true that in his long life Picasso produced a formidable quantity of work. His thematic range, however, was slight. Again and again we encounter the artist and his model, bullfights, bathers, figures from classical mythology, or portraits. His ability to ring the changes was astounding, but there was a limit to variation in his work. What invariably prevailed was form: his work always evolved from the line, from the principles of the draughtsman. For Picasso, sculpture, painting and graphics were not primary categories in their own right. There is no autonomy of colour in Picasso; nor do spatial values have any real independence in his work. His sculptural work developed from drawings, establishing spatial presence through illusionist effects.

Picasso's works were links in a chain of experiments. Views of Picasso thus depend largely on the criteria involved in the viewing. If we were to judge him by conventional standards, the vastly ambitious scale of his productivity and versatility would be cut down by the fact that the many thousands of studies led to relatively few final works of any substantial complexity. The concept of what constitutes a work of art has itself undergone change. We no longer check to see whether prior intentions have been enacted according to plan. Anything can be a work of art. Yet even by these new criteria, Picasso's unusual ouvre is unique in extent, if not in diversity.

The view of Picasso as the pre-eminent genius of the century is due not least to his willingness to fulfil public expectations of artists. In Henri Georges Clouzot's revealingly titled film "The Mystery of Picasso" (1956), for instance, the artist demonstrates his working methods to the camera, and thus to millions: it is an eloquent proof of his approach to the myth. The artist as magus was a role Picasso quite deliberately played.

In the work of his old age in particular, Picasso presented himself to a shamelessly voyeuristic public as a man of unfailing potency: a compulsively, feverishly productive artist wholly immersed in his work. This was both a mask and a vital means of self-preservation. His work, forever expanding into new genres, substantiated his image as a universal genius. Of greater interest in relation to Picasso's status in art history is the clearly apparent factor of conscious strategy. In Picasso's ouvre we plainly see a rational, logical, consistent method. At core he was an intellectual artist. In a real sense, Picasso transferred ideas into art, and created unified harmonies of idea and artwork, form and content, which are fundamentally traditional in nature and highlight his classical character.

Head of a Man, 1964
Tête d'homme
Oil on canvas, 61 x 50 cm
Private collection

The Family, 1970
La Famille
Oil on canvas, 162 x 130 cm
Paris, Musée Picasso

PAGE 228:
Musketeer and Cupid, 1969
Mousquetaire et Amor
Oil on canvas, 195.5 x 130 cm
Cologne, Museum Ludwig

PAGE 229:
Rembrandtesque Figure and Cupid, 1969
Personnage rembranesque et Amour
Oil on canvas, 162 x 130 cm
Lucerne, Picasso Collection, Donation Rosengart

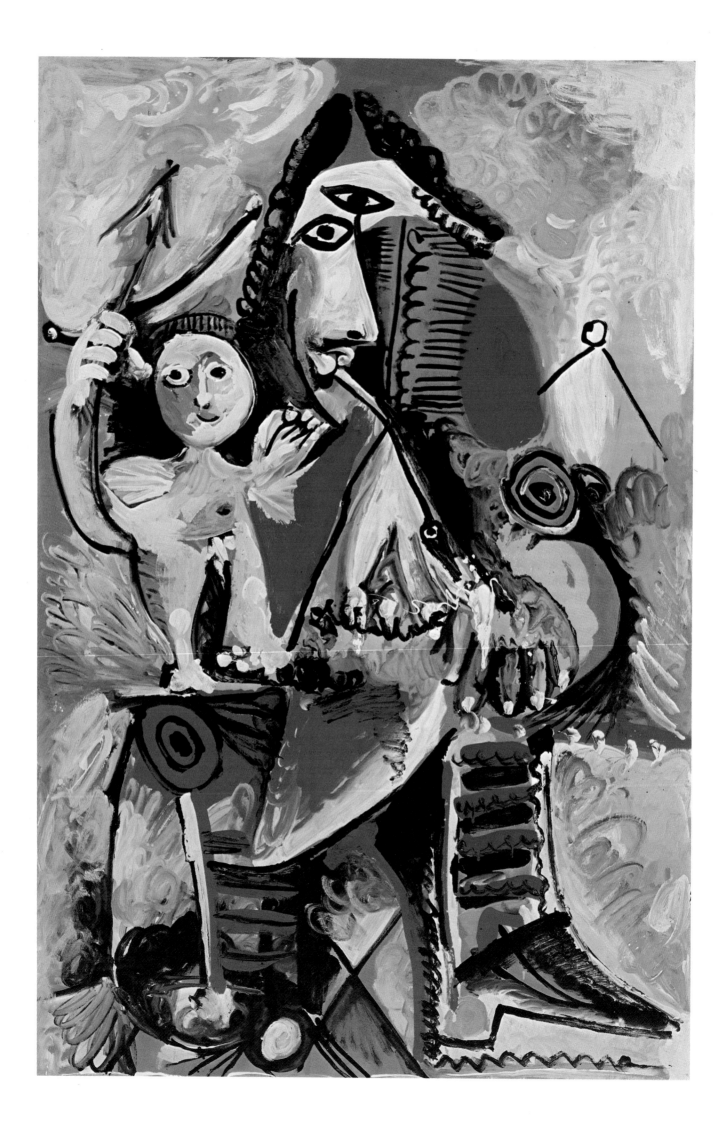

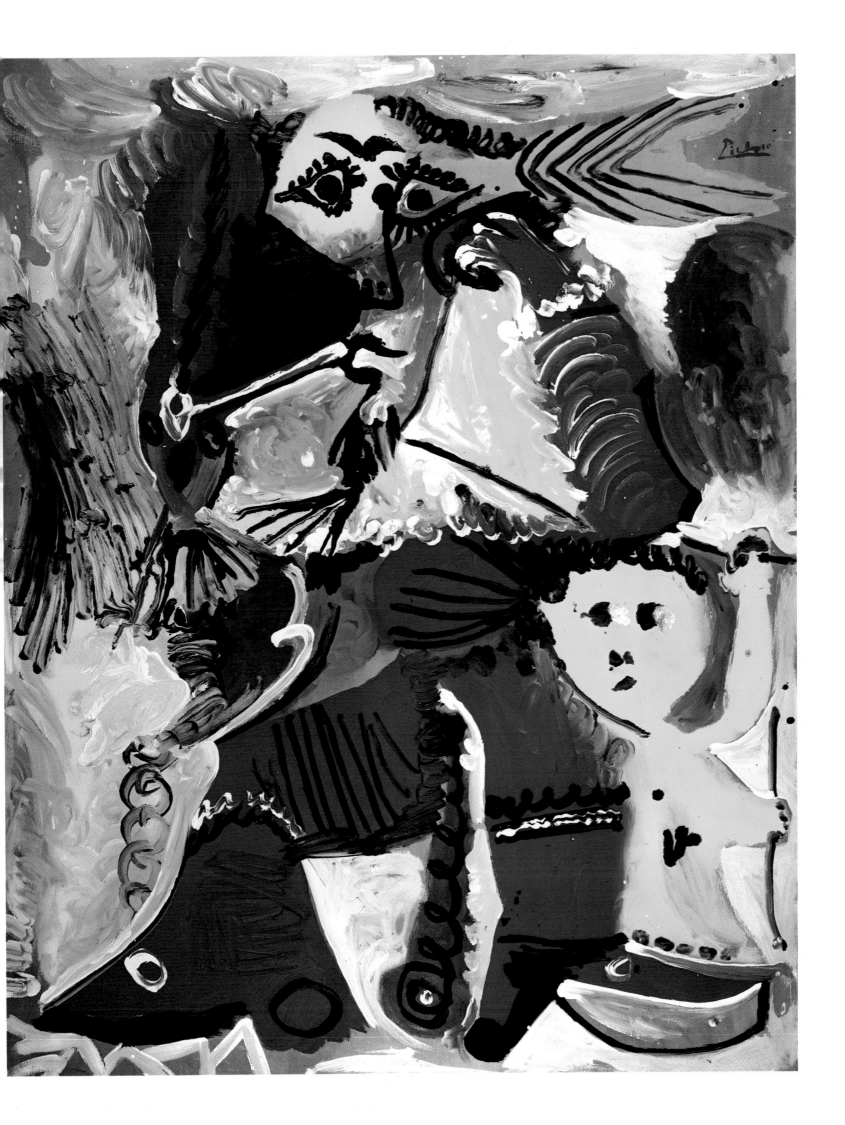

Reclining Nude and Head, 1973
Femme nue couchée et tête
Oil on canvas, 130 x 195 cm
Private collection

The painting above, *Reclining Nude and Head,* is the last Picasso worked on. He applied the creamy white, to brighten the impression, on the evening of 7 April 1973. The following day, 8 April, he died shortly before midday. For this information, given to me in May 1973, I am indebted to one of the curators of the exhibition "Picasso 1970–1972" at the Palais des Papes, Avignon, where the last oils Picasso painted were shown. He received the picture, not yet dry, immediately before Picasso's death, to prepare it for hanging in the exhibition, which was opened on 23 May 1973. Picasso's widow Jacqueline later confirmed the information. To date, no oils from 1973 have been exhibited or published. Probably Picasso only drew, and perhaps did a little work in watercolour, in the final months of his life. I. F. W.

In this respect he was essentially different from modern concept art, in which the concept precedes and accompanies the work, which in turn refers to the concept. A verbal key or explanation is required if the whole is to be grasped. Picasso's work, by contrast, shows. The statement is made visible. His work is inherently comprehensible. There is no gap between abstract content and concrete form. Uniquely in the 20th century he was capable of radical innovation on the one hand but on the other of continuing traditional lines. Thus in *Les Demoiselles d'Avignon* he vanquished the representational picture, while in *Guernica* he revived the genre of historical painting in a new form.

Picasso's true greatness and significance lie in his dual role as revolutionary and traditionalist at once. He gave a new vitality to art even as he preserved the creative presence (outside the museums) of its history. For this reason he became the pre-eminent figure in 20th-century art.

Head, 1972
Tête
Chalk and crayon on paper, 66 x 50,5 cm
Lucerne, Galerie Rosengart

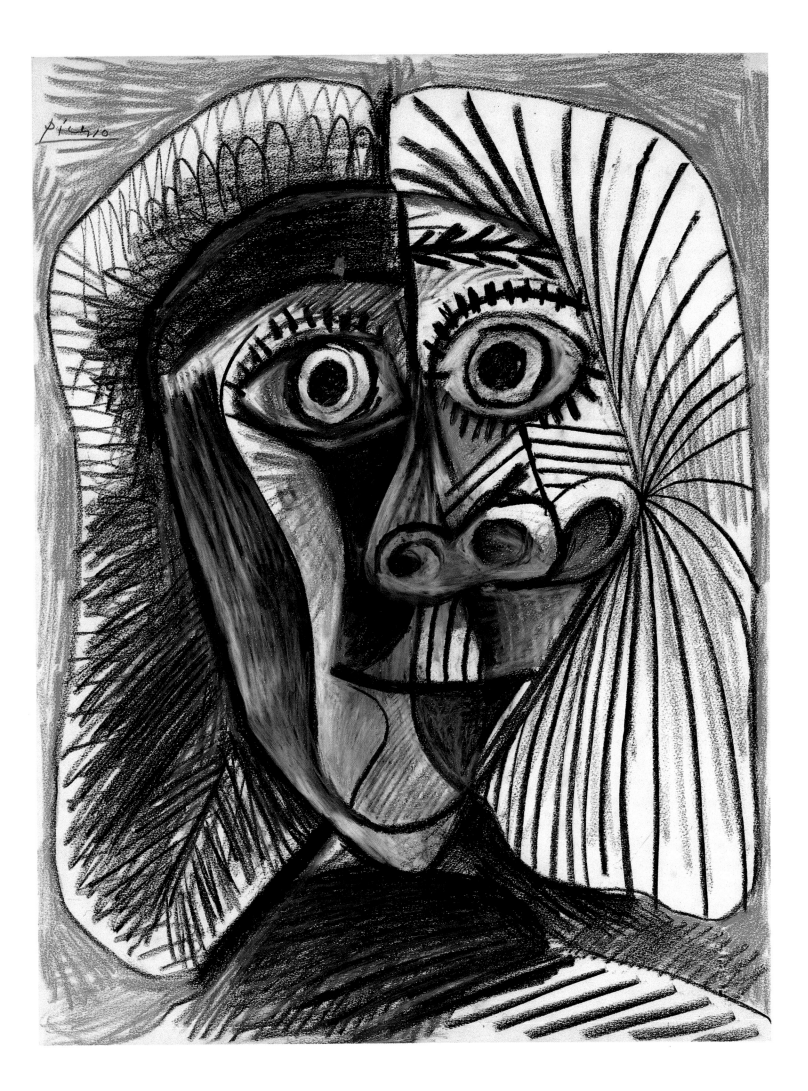

Pablo Picasso: A Chronology

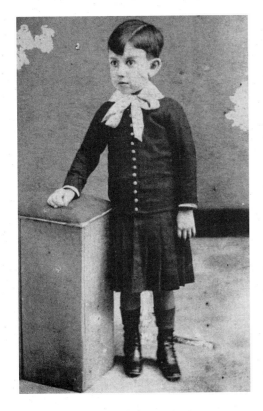

Pablo Picasso at the age of four, 1885

1881 Pablo Ruiz Picasso born 25 October in Málaga, Spain, first son of Don José Ruiz Blasco (1838–1913) and Doña María Picasso López (1855–1939). His father, a painter, comes from the north and teaches drawing at the local School of Fine Arts and Crafts, "San Telmo". His mother is Andalusian.

1884 Birth of his first sister Dolorès (1884–1958), known as Lola.

1887 Birth of his second sister Concepción (1887–1891), known as Conchita.

PAGE 232:
Pablo Picasso, Cannes 1956
Photograph: Lucien Clergue

1888/89 Helped by his father, he begins to paint; at the age of eight he paints his first oil.

1891 Picasso's father accepts a position as art teacher in La Coruña, where he moves with his family. Death of Conchita. Starts local grammar school. Helps his father with paintings.

1892 Admitted to the School of Fine Arts in La Coruña and is taught by his father.

1894 Writes and illustrates journals. His father recognizes Pablo's extraordinary talent, hands him brush and palette and declares that he will never paint again.

1895 Moves to Barcelona and enrols in the "La Lonja" School of Fine Arts, where his father teaches. Skips the early classes and passes the entry examination for advanced classes with distinction.

1896 First studio in Barcelona. His first large "academic" oil, *The First Communion* (p. 14), appears in an exhibition.

Picasso's birthplace in Málaga, Plaza de la Merceded

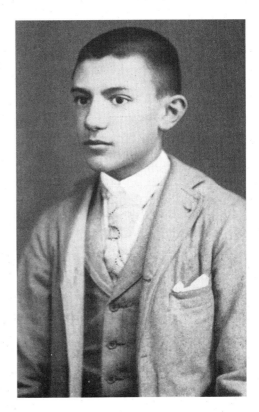

Pablo Picasso shortly after his arrival in Barcelona in 1896, aged 15

1897 Paints *Science and Charity* (pp. 16/17), his second large oil; it receives an honourable mention in the national exhibition of fine art in Madrid and is awarded a gold medal in a competition at Málaga. His father's brothers send money so that Pablo can study in Madrid. Passes entrance examination for advanced courses at the Royal Academy of San Fernando in Madrid, but abandons it in the winter.

1898 Ill with scarlet fever and returns to Barcelona. Spends a long time with his friend Manuel Pallarés in the village of Horta de Ebro and regains his health. Sketches of landscapes.

1899 Returns to Barcelona. Begins to frequent the café "Els Quatre Gats" (The Four

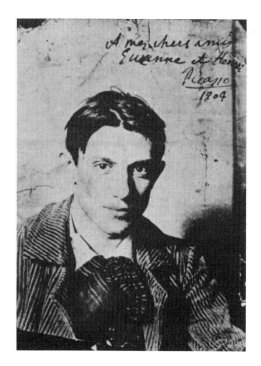

Picasso in Paris, 1904. The words on the photograph are: "A mes chers amis Suzanne et Henri [Bloch]."

Cats) and makes friends with artists and intellectuals, including the painters Carles Junyer-Vidal, Isidre Nonell, Joaquim Sunyer and Carlos Casagemas, the sculptor Hugué, the brothers Fernández de Soto, and the poet Jaime Sabartés (later to be his secretary and lifelong close friend). Becomes acquainted with the work of Théophile Steinlen and Henri de Toulouse-Lautrec. Newspaper illustrations and first etchings.

1900 Shares studio with Casagemas in Barcelona. Exhibits about 150 drawings at "Els Quatre Gats". At the beginning of October Picasso and Casagemas leave for Paris and open a studio in Montmartre. Visits art dealers, where he sees works by Cézanne, Toulouse-Lautrec, Edgar Degas, Emile Bonnard et al. Art dealer Pedro Mañach (p. 18) offers him 150 francs a month in exchange for pictures. Berthe Weill buys three pastels of bull-fights. Paints his first Paris picture, *Le Moulin de la Galette* (p. 22). Departs for Barcelona and Málaga with Casagemas in December.

1901 Casagemas commits suicide in Paris. Picasso moves to Madrid, where he becomes co-editor of the magazine *Arte Joven*. Second move to Paris in May. Sets up a studio at 130, Boulevard de Clichy. First Oaris exhibition at Ambroise Vollard's gallery; sells 15 pictures before the opening. Begins to sign his pictures simply "Picasso", his mother's name. Paints life in

Paris (*The Absinthe Drinker*, p. 33), with poverty, old age and loneliness as a more and more frequent theme. Uses almost exclusively blue and green. Beginning of his Blue Period.

1902 End of his contract with Mañach. Returns to Barcelona. Exhibition at the Berthe Weill gallery in Paris. Further development of blue monochrome paintings. Returns to Paris for third time in October. Lives with poet Max Jacob. Has to confine himself to drawing because he lacks the money to buy canvas. Weill exhibition of "blue" canvases.

1903 Returns to Barcelona in January. Paints over fifty pictures within 14 months, among them *La Vie* (p. 39). Uses intensive shades of blue to depict the misery of physical weakness and old age.

1904 Picasso's final move to Paris. Studio at 13, Rue Ravignan (until 1909), in the "Bateaux-Lavoir". Meets Fernande Olivier who is to be his mistress for the next seven years. Makes etching *The Frugal Repast* (p. 42). Pays frequent visits to the Circus Médrano (where he gets ideas for his pictures of jugglers and circus artistes) and the "Lapin agile". End of Blue Period.

1905 Meets Guillaume Apollinaire and Leo and Gertrude Stein. Frequently paints circus themes, such as *The Family of Saltimbanques* (p. 49). Beginning of Rose Period. Summer holiday in Schoorl, Holland. First

Picasso at the Bateau-Lavoir, 1908, with sculptures from New Caledonia behind him

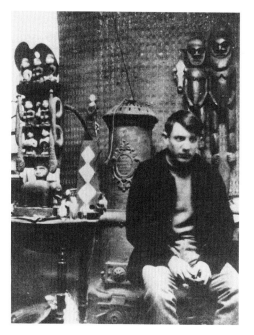

Picasso in his studio at 11, Boulevard de Clichy, winter 1910/11

sculptures. Series of etchings called *The Acrobats*.

1906 Picasso is impressed by exhibition of Iberian sculpture at the Louvre. Meets Henri Matisse, André Derain and the art dealer Daniel-Henry Kahnweiler. Vollard buys most of his "rose" pictures, thus for the first time enabling Picasso to lead a life free of financial worries. Takes Fernande to his parents in Barcelona, then to Gosol in the north of Catalonia, where he paints *La Toilette* (p. 55). Influence of Iberian sculpture on *Portrait of Gertrude Stein* (New York, The Metropolitan Museum of Art) and *Self-Portrait with Palette* (p. 6).

1907 *Self-portrait* (p. 60). With numerous studies and variations, he prepares his large canvas *Les Demoiselles d'Avignon* (p. 67), which he finishes in July: his first cubist painting, even before the beginning of cubism. Sees African sculptures at ethnographic museum, which impress and influence him. Visits two Cézanne retrospectives. Meets Georges Braque. Kahnweiler is enthusiastic about his *Demoiselles* and becomes his exclusive dealer.

1908 Paints numerous "African" nudes. Spends summer with Fernande at La Rue des Bois, north of Paris. Paints figures and landscapes there. Braque shows his first cubist pictures, his L'Estaque works, at

Kahnweiler's gallery. In November he gives a large banquet in his studio, honouring Henri Rousseau, one of whose paintings he has bought recently.

1909 Paints *Loaves and Bowl of Fruit on a Table* (p. 73). Beginning of his "analytical" cubism (i.e. gives up central perspective, splits up forms in fragmented, stereometric shapes). In May he takes Fernande to see his parents and friends in Barcelona. Goes on to Horta de Ebro, where he has the most productive period of his career: landscapes and townscapes (*The Reservoir, Horta de Ebro*, p. 8) in analytical cubist style. Portraits of Fernande (*Woman with Pears*, p. 69). Moves to 11, Boulevard de Clichy, near Place Pigalle in September, next door to Braque. Sculpture of Fernande (p. 61); still-lifes. First exhibition in Germany (Galerie Thannhauser, Munich).

1910 Completes his famous cubist portraits of the art dealers Vollard (p. 77) and Kahnweiler (Chicago, The Art Institute of Chicago) as well as the art critic Fritz Uhde (private collection). Spends summer with Fernande in Cadaqués near Barcelona, where they are joined by Derain and his wife.

1911 First New York exhibitions. Spends summer with Fernande and Braque in Céret (Pyrenees). Introduces printed letters into his pictures for the first time. Has to hand two Iberian sculptures back to the Louvre, because he has unwittingly bought them

Picasso with his son Paul in Dinard, 1922

from a thief. Crisis in his relationship with Fernande; enters a liaison with Eva Gouel (Marcelle Humbert), whom he calls "Ma Jolie". Paints *Mandolin Player* (Paris, Musée Picasso).

1912 First construction in sheet metal and wire. First collage (*Still Life with Chair Caning*, p. 81), with a piece of oil-cloth imitating a cane pattern. Takes Eva to Céret, Avignon and Sorgues, where they meet Braque. Makes first "papiers collés" collages of newspaper headlines, labels, advertising slogans with charcoal drawings on paper. Moves from Montmartre to 242, Boulevard Raspail, Montparnasse in September. Three-year contract with Kahnweiler.

1913 Spends spring with Eva in Céret, where they meet Braque and Derain. His father dies in Barcelona. Picasso's "papiers collés" lead to synthetic cubism, with large, schematic patterning, such as *The Guitar* (p. 88). He and Eva fall ill, return to Paris and move to 5, Rue Schoelcher.

1914 *Family of Saltimbanques* (p. 49) sells for 11,500 Francs at an auction. Spends June with Eva in Avignon; meets Braque and Derain. Paints "pointillist" pictures. Braque and Derain are drafted into the army on the outbreak of war.

Kahnweiler goes to Italy, his gallery is confiscated. Picasso's pictures become sombre.

1915 Realistic pencil drawings of Max Jacob and Vollard. Paints *Harlequin* (p. 93).

1916 Jean Cocteau brings the Russian impresario Sergei Diaghilev and the composer Eric Satie (cf. p. 100) to meet Picasso and asks him to design the decor for *Parade*, a ballet to be performed by the Ballet Russe (cf. pp. 97–99). Moves to 22, Rue Victor Hugo in Montrouge.

1917 Travels to Rome with Cocteau and spends his time with Diaghilev's ballet company. Works on decor for *Parade*. Meets Igor Stravinsky and the Russian dancer Olga Koklova. Visits Naples and Pompeii. Accompanies ballet group to Madrid and Barcelona because of Olga. Olga stays with him. Back to Montrouge in November. Paints "pointillist" pictures.

1918 Contacts with high society through the ballet result in a change of lifestyle. Paul Rosenberg becomes his new agent. Marries Olga. Honeymoon in Biarritz. Apollinaire's death. The Picassos occupy two floors at 23, Rue La Boétie.

1919 Meets Joan Miró and buys one of his pictures. Spends three weeks in London with the Ballet Russe. Begins to work on decor for *Le Tricorne*; drawings of the dancers. Spends summer in Saint-Raphaël on the Riviera with Olga. Paints *Sleeping Peasants* (p. 102) and cubist still-lifes.

Picasso, 1917

Picasso working on *Guernica*, 1937

1920 Begins to work on decor for Stravinsky's ballet *Pulcinella*. Kahnweiler returns from exile. Spends summer in Saint-Raphaël and Juan-les-Pins with Olga. Gouaches with themes from the Commedia dell'arte.

1921 Birth of his son Paul (Paolo). Recurrent Mother and Child theme. Further sketches for ballet decors. Uhde's and Kahnweiler's collections, which were confiscated by the French during the war, are sold at auction. Spends summer at Fontainebleau with Olga. Paints *Three Musicians* (p. 114) and several compositions with monumental figures.

1922 The collector Doucet buys the *Demoiselles d'Avignon* (p. 67) for 25,000 Francs. Spends summer in Dinard, Brittany, with Olga and Paul, where he paints *Women Running on the Beach* (p. 107). Designs drop curtain for Cocteau's *Antigone* in winter.

1923 Harlequin portraits in neo-classicist style. Summer at Cap d'Antibes. A visit from his mother Maria. Paints *The Pipes of Pan* (p. 106) and studies of bathers. Portraits of Olga and Paul in Paris.

1924 Several large still-lifes in the decorative cubist mode, and further ballet decor. Holiday with Olga and Paul in Juan-les-Pins. Portrait of *Paul as Harlequin* (p. 112). Publication by André Breton of *Manifeste du Surréalisme*.

1925 Accompanies ballet company and Olga and Paul to Monte Carlo in spring. Paints *The Dance* (p. 115), reflecting the first signs of tension in his marriage. Summer in Juan-les-Pins, where he paints *Studio with Plaster Head* (p. 116), a composition built around Paul's puppet theatre. Contributes to first surrealist exhibition in November.

1926 Series of assemblages on Guitar theme, using objects such as a shirt, a floorcloth, nails and string. Holidays in Juan-les-Pins and Antibes. Takes Olga to Barcelona in October.

1927 Meets seventeen-year-old Marie-Thérèse Walter in the street. She becomes his mistress shortly afterwards. Death of Juan Gris. Series of pen-and-ink drawings of aggressively sexual bathing women.

1928 First sculpture since 1914. Meets sculptor Julio González. Summer in Dinard with Paul and Olga. Meeting Marie-Thérèse secretly. Small paintings with intense colours and schematic forms. Several wire constructions as studies for Apollinaire monument (p. 118).

1929 Works on sculptures and wire constructions with González. Series of aggressive paintings with women's heads signals marriage crisis. Summer in Dinard.

1930 Metal sculptures in González's studio. Paints *Crucifixion* (p. 132), after Matthias Grünewald. Buys Château Boisgeloup near Gisors, north of Paris. Holiday in Juan-les-Pins. 30 etchings to illustrate Ovid's *Metamorphoses*. Installs Marie-Thérèse in flat at 44, Rue la Boétie.

1931 Sculpture *Head of a Woman* (Paris, Musée Picasso) using colanders. Sculptor's studio at Boisgeloup. Series of sculptures of large heads and busts. Holiday in Juan-les-Pins. Cycles of etchings are exhibited at Skira's and Vollard's.

1932 Series of seated or recumbent women, for which the model is Marie-Thérèse. Major retrospective in Paris (236 works) and Zurich. Christian Zervos publishes first Picasso catalogue.

1933 Etchings on the theme of the Sculptor's Studio for the *Suite Vollard* (p. 225) and studies on the Minotaur theme. Summer holiday in Cannes with Olga and Paul, then car trip to Barcelona, where he meets

old friends. Tries in vain to prevent a book of memoirs by Fernande Olivier from being published, for fear of Olga's jealousy.

1934 More etchings. Sculptures at Boisgeloup. Trip to Spain with Olga and Paul to see bull-fights in San Sebastian, Madrid, Toledo and Barcelona. Numerous works on the bull-fight theme in various media.

1935 Paints *Interior with a Girl Drawing* (p. 140). No more paintings between May 1935 and February 1936. Etches *Minotauromachy* (p. 138), his most important cycle. Marie-Thérèse is pregnant; separates from Olga and Paul; divorce has to be postponed because of problems with the distribution of their property. Picasso: "The worst time of my life." 5 October: birth of Picasso's second child, Maya. His old friend Sabartés becomes his secretary.

1936 Touring exhibition of his pictures in Barcelona, Bilbao, Madrid. Travels secretly to Juan-les-Pins with Marie Thérèse and Maya. Works on the Minotaur theme. 18 July: beginning of Spanish civil war. Opposes Franco; Republicans recognize his support and nominate him director of the Prado. Spends August in Mougins, near Cannes. Meets Dora Maar, Yugoslavian photographer. Makes over Boisgeloup to Olga in autumn and moves into Vollard's house. Marie-Thérèse follows with Maya.

1937 Etches *The Dream and Lie of Franco*. Moves into new studio at 7, Rue

Picasso in his studio at the Rue des Grands Augustins, 1944

Picasso in Toulouse, 1945; inscribed to his friend Jaime Sabartés

des Grands Augustins. Following the German air raid on Guernica on 26 April he paints his gigantic mural for the Spanish pavilion at the Paris world exhibition: *Guernica* (pp. 148/149). In summer portrait of Dora Maar at Mougins. Meets Paul Klee in Berne. The Museum of Modern Art in New York buys *Les Demoiselles d'Avignon* for $ 24,000.

1938 Paints several pictures of Maya with toys (pp. 158, 159). Makes a wallsize collage *Women at Their Toilet* (pp. 162/163). Spends summer in Mougins with Dora. Severe attack of sciatica in winter.

1939 Death of Picasso's mother in Barcelona. Paints Marie-Thérèse and Dora in the same pose and on the same day. Spends July in Antibes with Dora and Sabartés. Death of Vollard. Paints *Night Fishing at Antibes* (p. 157), then Dora with bicycle and ice-cream. Takes Dora and Sabartés to Royan on the outbreak of the Second World War, where Marie-Thérèse and Maya join them. Stays there, with interruptions, until August 1940. Major retrospective at the Museum of Modern Art in New York, with 344 works, including *Guernica*.

1940 Commutes between Royan and Paris. In Royan he paints *Nude Dressing Her Hair* (p. 156). German troops invade Belgium and France, occupying Royan in June. Returns to Paris. Gives up flat in Rue La Boétie and moves into studio at Rue des Grands Augustins. Hands out photos of

Guernica to German officers. When asked, "Did you do this?" he replies, "No, you did."

1941 Writes surrealist farce, *Desire Caught by the Tail*. Marie-Thérèse and Maya move to Boulevard Henri IV; Picasso visits them at weekends. He is not allowed to leave Paris to work at Boisgeloup. Provisional sculptor's studio in bathroom.

1942 Paints *Still Life with Steer's Skull* (p. 169). He is attacked by Vlaminck in a magazine article. *Portrait of Dora Maar* wearing a striped blouse (New York, Hahn Collection).

1943 Assemblage *Head of a Bull* (p. 168). Sculptures. Meets young painter Françoise Gilot who visits him frequently at his studio. Resumes painting.

1944 Max Jacob is arrested and dies in a concentration camp. Large sculpture *Man with Sheep* (p. 167). Readings are held of *Desire Caught by the Tail*, with Albert Camus, Simone de Beauvoir, Jean-Paul Sartre, Raymond Queneau et al. taking part. Joins Communist Party after liberation of Paris. Contributes 74 paintings to the Salon d'Automne.

1945 Paints *The Charnel House* (p. 166) as a pendant to *Guernica*. Series of still-lifes. Spends July in Antibes with Dora. Rents room for Françoise in the vicinity, but she goes to Brittany. Buys Dora a house in the village of Ménerbes and pays for it

The master's left hand, 1947

Picasso at the Congress of Intellectuals for Peace in Wroclaw, August 1948

with a still life. Begins working with lithography at Fernand Mourlot's Paris studio, producing 200 works by 1949.

1946 Takes Françoise to Nice to see Matisse. Françoise becomes his mistress and moves in with him. Makes paintings and lithographs of her. Takes her to Ménerbes in July, where they stay at Dora's house. Françoise is pregnant. Picasso is given permission to work at the museum of Antibes and after four months donates numerous pictures to it. The museum is soon renamed Musée Picasso. First brief visit to Vallauris.

1947 Lithographs at Mourlot's workshop. Gives ten pictures to the Musée National d'Art Moderne in Paris. On 15 May Françoise gives birth to Claude, Picasso's third child. Begins to make ceramics at the Madoura pottery, the workshop of the Ramiés and creates about 2000 pieces between 1947 and 1948 (pp. 174, 175).

1948 Moves to La Galloise, a villa in Vallauris, with Françoise and Claude. Takes part in Congress of Intellectuals for Peace in Wroclaw, Poland, where he also visits Cracow and Auschwitz. Ceramics exhibition in Paris. Portrait of Françoise.

1949 *Dove* lithograph becomes motif for poster announcing World Peace Congress in

Paris. 19 April: birth of Picasso's fourth child, Paloma (Spanish word for "dove", named after the poster motif). Rents old perfume factory in Vallauris as a studio and store-room for ceramics. More sculptures.

1950 Paints *Young Women on the Banks of the Seine*, after Gustave Courbet (pp. 182/183). Sculptures *The Nanny-Goat* and *Woman with Baby Carriage*, made from junk and cast in bronze (p. 179). Travels to World Peace Conference in Sheffield. Receives Lenin Peace Prize. Given the freedom of Vallauris.

1951 Paints *Massacre in Korea* (pp. 186/187) in protest at the American invasion. Gives up flat in Rue La Boétie and moves to 9, Rue Gay-Lussac. Ceramics in Vallauris. Sculpture *Baboon and Young* (p. 176). Retrospective in Tokyo.

1952 Two large mural paintings called *War* and *Peace* (pp. 164, 165) for the new Temple of Peace in Vallauris. Relationship with Françoise deteriorates.

1953 Works in Vallauris (*Seated Woman*, p. 190). Major exhibitions in Rome, Lyons, Milan and São Paulo. Portrait of Stalin on the occasion of his death is received with disapproval by Communist Party. Series of busts and heads of Francoise. Takes Maya and Paul to Perpignan, where he meets Jacqueline Roque. Françoise and children move to Rue Gay-Lussac.

Picasso with his children Paloma and Claude at Vallauris, 1953

Pablo Picasso, 1955

1954 Meets Sylvette David, a twenty-year-old girl who poses for portraits (p. 195). Portraits of Jacqueline. Spends some time in Vallauris with Françoise and children, as well as with Jacqueline. Takes Maya and Paul to Perpignan. Separates from Françoise, and Jacqueline moves in with him. Death of Matisse (Picasso: "All things considered, there's only Matisse"). Begins series of paintings based on Eugène Delacroix's *Women of Algiers* (p. 199).

1955 Olga Picasso dies in Cannes. Sojourn with Jacqueline in Provence. Major retrospective in Paris (then in Munich, Cologne, Hamburg). Filming of Clouzot's *Le Mystère Picasso*. Buys La Californie, a villa in Cannes. Portraits of Jacqueline.

1956 Series of studio pictures, including *The Studio at 'La Californie', Cannes* (p. 201) and *Jacqueline in the Studio* (p. 200). Large bronze sculpture *The Bathers* (pp. 202/203), after wooden assemblages. Celebrates 75th birthday with potters in Vallauris. Letter of protest to Communist Party about Russian intervention in Hungary.

1957 Exhibitions in New York, Chicago and Philadelphia. At La Californie he works on 40 variations of Diego Velázquez's *Las Meninas* (pp. 214, 215). He is asked to paint mural for new UNESCO building in Paris.

1958 Completes UNESCO mural, *The Fall of Icarus* (p. 205). Buys Château Vauvenargues near Aix-en-Provence, where he works occasionally between 1959 and 1961.

1959 Paints at Chateau Vauvenargues. Works on variations of Edouard Manet's *Le Déjeuner sur l'herbe* (p. 208). First experiments with lino-cuts.

1960 Retrospective at Tate Gallery, London, with 270 works. Designs large-scale sheet-metal sculpture, constructing maquettes from cardboard.

1961 Marries Jacqueline Roque at Vallauris. Moves to Notre-Dame-de-Vie, a villa near Cannes. Celebrates 80th birthday in Vallauris. Works with painted and corrugated sheet-metal.

1962 Over 70 portraits of Jacqueline. Awarded Lenin Peace Prize for second time. Designs decor for Paris ballet. Numerous lino-cuts.

1963 Variations of Jacqueline's portrait. Series of pictures on the theme of The Artist and His Model (p. 217). Opening of Museu Picasso in Barcelona. Death of Braque and Cocteau.

1964 Publication of Françoise Gilot's memoirs *Life with Picasso* leads to a rift be-

At a bull-fight in Vallauris, 1955. Picasso is sitting between Jacqueline and Jean Cocteau. Behind him his children Maya (with guitar), between Paloma and Claude.

tween him and their children Claude and Paloma. Exhibitions in Canada and Japan. Completes model for giant sculpture *Head of a Woman* to appear in Chicago's new Civic Centre in 1967.

1965 Series of paintings on the theme of The Artist and His Model, landscapes. Stomach operation in Neuilly-sur-Seine. Last trip to Paris.

1966 Resumes drawing and painting, then also produces prints in summer. A major retrospective exhibition at Grand Palais and Petit Palais in Paris shows over 700 works, including many sculptures from the artist's own collection.

1967 Refuses French Legion of Honour. Evicted from studio in Rue des Grands Augustins. Exhibitions in London and New York.

1968 Death of Sabartés. Picasso gives Museum in Barcelona 58 pictures from the series *Las Meninas*. Makes 347 etchings within seven months.

1969 Numerous paintings: faces, couples, still-lifes, nude figures, smokers (p. 89).

1970 Picasso family in Barcelona donates all paintings and sculptures in its possession to Museu Picasso, Barcelona (early works from Barcelona and La Coruña).

1971 Celebrates his 90th birthday.

1972 Draws series of self-portraits. Donates wire construction of 1928 (p. 118) to the Museum of Modern Art, New York.

1973 Dies at Mougin on 8 April and is buried in the grounds of Château Vauvenargues on 10 April.

1979 Picasso's heirs pay their death duties in the form of a large number of works from Picasso's private collection, which become the property of the French state. Exhibition of these works at the Grand Palais in Paris, later to be renamed Musée Picasso.

1980 Largest-ever Picasso retrospective on the occasion of the 50th anniversary of the opening of the Museum of Modern Art, New York.

1985 Opening of the Musée Picasso at the Hôtel Salé in Paris, with 203 paintings, 191 sculptures, 85 ceramics, and over 3000 drawings and prints.

1986 First European exhibition of Picasso's sketchbooks at the Royal Academy of Art, London. On 15 October Picasso's widow Jacqueline commits suicide.

1990 From the Jacqueline Picasso estate, the Musée Picasso receives a further 162 works, including 47 paintings, which are exhibited in Paris, Marseilles, Bordeaux, Strasbourg, Calais and Amiens. Of the 20 most expensive paintings in the world at this date, 6 are van Goghs and 7 Picassos.

Picasso in the garden of La Californie, with the 1936 sculpture *Head of a Woman*.
Photograph: Jacqueline Picasso

Picasso holding the sun in his hand.
Photograph: Jacqueline Picasso

Acknowledgement and Picture Credits

The editor and publisher wish to express their gratitude to the museums, public collections, galleries and private collectors, the archivists and photographers, and all those involved in this work. The editor and publisher have at all times endeavoured to observe the legal regulations on the copyright and also to obtain permission to reproduce photographic works and reimburse the copyright holder accordingly. This may have resulted in a few oversights despite intensive research. In such a case will the copyright owner or representative please make application to the publisher.

The locations and names of owners of the works are given in the captions to the illustrations unless otherwise requested or unknown to the publisher. Below is a list of archives and copyright holders who have given us their support. Information on any missing or erroneous details will be welcomed by the publisher.

The numbers given refer to the pages of the book, the abbreviations a = above, b = bottom, l = left, m = middle, r = right.

Akademische Druck- und Verlagsanstalt, Graz: 144, 146 (ill. 15, 37). – Archiv André Held, Ecublens: 63, 84, 105, 136 a, 136 b, 155, 160, 161. – Archives d'UNESCO, Paris: 205. – Artothek, Peissenberg: 148/149. – Bildarchiv Alexander Koch, Munich: 29, 189, 218.– Cahiers d'Art - Zervos, Paris: 7, 11, 31, 65 a l, 65 a m, 65 a r, 72 l, 72 m, 72 r, 76, 97 l, 97 r, 100 l, 100 r, 147 (4 ill.), 167 l. – © Lucien Clergue, Arles: 232. – Collection William A. M. Burden, New York: 51 r. – Collection Angela Rosengart, Galerie Rosengart and Archive Rosengart, Lucerne: 85, 158, 181, 200, 224, 229, 231. – Galerie Louise Leiris and Archives Photographiques Louise Leiris, Paris: 120, 124, 192, 196, 198, 207, 221, 222, 223. – Hermitage, St. Petersburg: 32, 33, 56 l, 59, 68, 70 b r, 74 a, 75 l, 75 r. – Catherine Hutin-Blay, Paris: 239. – Musée d'Art Moderne de la Ville de Paris, Paris: 35. – Musée National d'Art Moderne, Centre Georges Pompidou, Paris: 87, 98/99, 113, 220. – Musée Picasso, Paris (Photo: Service Photographique de la Réunion des Musées Nationaux): 9, 15, 30, 34 a, 41, 54 l, 57, 80, 81, 82, 83, 86, 88, 89, 94, 96, 101 a, 103, 104 a, 108, 111, 112, 117, 119 a, 119 b l, 119 b r, 122, 123, 125, 127, 132 a, 133, 135, 137 a, 137 b, 138 b, 141, 151, 152, 159, 162/163, 167 r, 168 a, 176, 178, 179, 185, 186/187, 188, 194, 208 a, 210, 211, 226. – Museu Picasso, Barcelone: 11, 12 l, 12 r, 13 l, 13 r, 14, 16/17, 20, 36, 37, 214 a. – National Gallery of Art, Washington: 49. – Öffentliche Kunstsammlung Basel, Kunstmuseum, Basel: 66 a, 79, 182/183. – Philadelphia Museum of Art, Philadelphia: 66 b. – Photographie Giraudon, Paris: 100 a r, 150, 154. – Pushkin Museum, Moscow: 24, 50, 51 l, 58, 70 a l, 71.– Rapho, Paris: 2. – Sammlung Beyeler, Galerie Beyeler and Archive Beyeler, Basel: 131, 173, 184. – Staatsgalerie Stuttgart, Stuttgart: 202/203.

The remaining illustrations used belong to the collections mentioned in the captions or to the editor's archive, the archive of the former Walther & Walther Verlag, Alling and the archive of Benedikt Taschen Verlag, Cologne.